APERTURE

The Idealizing Vision

Fashion offers a constantly shifting notion of an "ideal," but the relationship of fashion photography to art remains unsettled. Many critics feel that the commercial constraints placed on commissioned photography limit the photographer's creative integrity. Through the eyes and words of fashion photographers and writers, *The Idealizing Vision* recognizes the enduring value of fashion photography by showcasing images from around the world, images of clothing, beauty, style, and still life. These four aspects continually emerge and interact within this collection of photographs.

Fashion and its images shape popular culture and fine art as well as borrow from them. As a catalyst of popular culture and the reflection of the tenor of a period, the fashion photograph influences not only dress but also music, film, video, street culture, and art. *The Idealizing Vision* offers a diverse range of photographs from leading artists who set the pace, style, and trends of our time. The photography is conceptual and provocative—touching on cultural, social, and political themes while often blending fantasy and reality. William Ewing writes, "To speak of fashion photography is to consider not only concepts of art but also of glamour, beauty, love, desire, sex, social class, affluence, democracy, envy, narcissism, and greed."

Fashion and art are the focus of an essay by Anne Hollander. Hollander has written that "dress is a form of visual art, a creation of images with the visual self as its medium. People dress and observe other dressed people with a set of pictures in mind—pictures in a particular style."

Erwin Blumenfeld was a pioneer of Dadaist/Surrealist photography. His influence is much talked about among fashion photographers today. During the 1940s Blumenfeld worked closely with *Harper's Bazaar* art director Alexi Brodovitch. Together they created hauntingly mysterious and manipulated fashion imagery. Presented here is a never-before-published portfolio of Blumenfeld's photography and an essay by Richard Martin on the significance and meaning of his work.

A conversation with Karl Lagerfeld offers a glimpse of a man who has achieved fame as both a designer and a photographer. Photographs by Javier Vallhonrat and Enrique Badulescu explore the stylization of gesture while evoking a rich romanticism and a sense of mystery.

The "ideal" exists only in the imagination, is often imitated, and is used as a standard of perfection. Needless to say, there is no one perception of the "ideal." Fashion photography challenges us to examine our self-image and allows us to set new boundaries of fantasy and imagination. What these photographers share is the belief that their photographs should portray life in an extraordinary light. In this sense, fashion photography need not be practical, but idealizing. **THE EDITORS**

4
PREFACE
by Anna Wintour / *Photograph by Bruce Weber*

6
PERFECT SURFACE
by William Ewing / *Photographs by Louise Dahl-Wolfe, Edward Steichen, Baron Adolph de Meyer, Man Ray, George Hoyningen-Huene, Cecil Beaton, Martin Munkacsi, Norman Parkinson, Gösta Peterson, Horst P. Horst, Lillian Bassman, Richard Avedon*

24
BLUMENFELD
by Richard Martin / *Photographs by Erwin Blumenfeld*

32
FASHION ART
by Anne Hollander / *Photographs by Jean-Paul Goude, Sarah Moon, Horst P. Horst, Koto Bolofo, Patrick DeMarchelier, Serge Lutens, Deborah Turbeville, Barry Lategan, Hiro, Cheryl Koralik, Peter Zander, Jean Pagliuso, Paolo Roversi, George Holz, Arthur Elgort*

62
PINK THOUGHTS
by Glenn O'Brien / *Photographs by Nick Knight, Pierre et Gilles, Mario Testino, Jean-Baptiste Mondino, Stephane Sednaoui, Satoshi Saikusa*

80
EROTIC ALLURE
by Valerie Steele / *Photographs by Steven Meisel, Bruce Weber, Bettina Rheims, Herb Ritts, Helmut Newton, Peter Lindbergh, Ellen Von Unwerth*

102
A CONVERSATION WITH KARL LAGERFELD
by Andrew Wilkes / *Photographs by Karl Lagerfeld, Josef Astor, Deborah Samuel, Javier Vallhonrat, Enrique Badulescu, Albert Watson, Max Vadukul, Matthew Rolston*

122
PEOPLE AND IDEAS
VIDEO ENVY by Kenneth Miller UNWRAPPED REALITY by Fred Ritchin

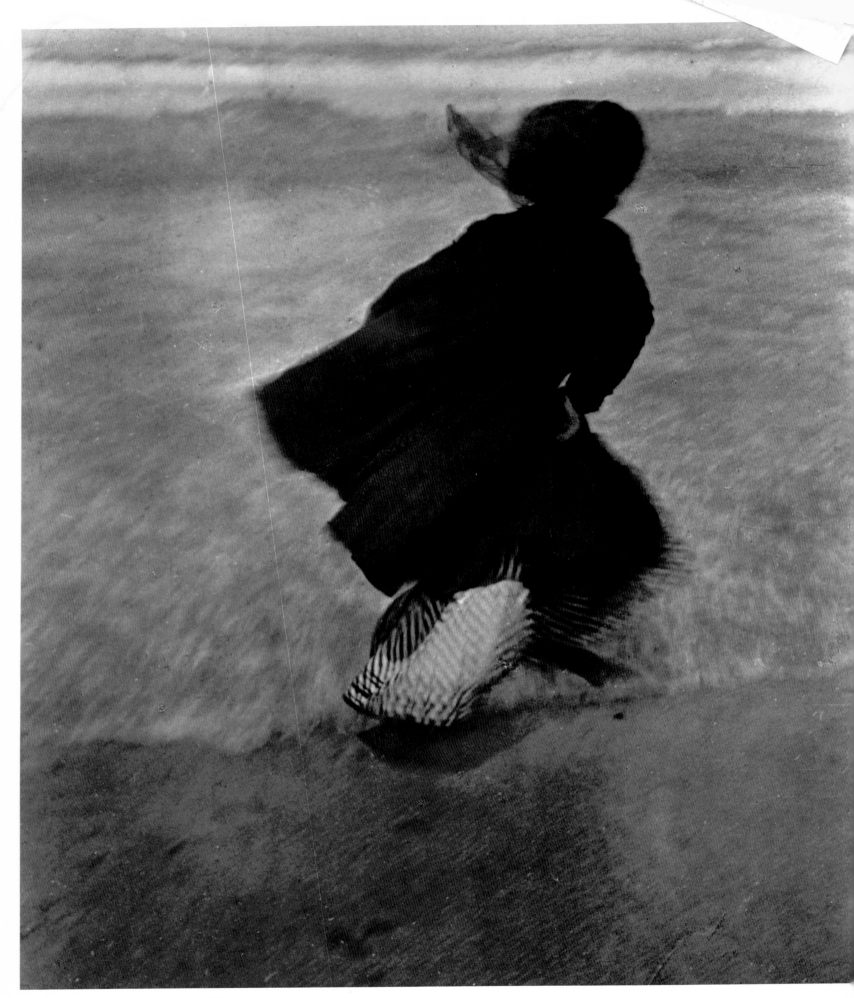

JACQUES-HENRI LARTIGUE, *Guitty,* Biarritz, 1905

The Idealizing Vision

preface

The need for this book, whose subtitle is "The Art of Fashion Photography," springs from paradox. The magazines and editors who nurture and commission fashion photography cannot always be counted on to be friendly to the *art* of fashion.

The job of the fashion editor is to "show" the clothes. That is, after all, why the public buys our magazines. Our needs are simple. We want a photographer to take a dress, make the girl look pretty, give us lots of images to choose from, and not give us any attitude. Photographers—if they are any good—want to create art. An editor's knee-jerk reaction to a photographer who is considered artistic is all too often an unexpressed concern that carefully selected clothes will lie rejected or unused in the studio dressing room; the shoot will be done in black-and-white, even if the fashion concept is color; it will cost a lot; there will be a three-week wait while the photographer edits; and then a single image will be delivered in which you can't see the clothes.

Although Karl Lagerfeld admonishes fashion photographers who "don't like fashion" to "do something else," editors are drawn to a new photographer with an extraordinary or novel technique because, like all journalists, we want our stories to sock the reader in the eye, to be "fresh" and "new." But Karl's warning is on target for a photographer whose style is too idiosyncratic, whose art is more important than fashion, risks being abandoned when his or her style loses its novelty. No one would treat an artist this way. An artist's style is a prized possession, and small variations on a theme, played out over a lifetime, are enjoyed and expected. Fashion photography remains an uneasy mix of art and commerce.

Yet even the most ruthlessly commercial editor knows that it is a combination of clothes and art that makes the memorable photograph we all yearn for. We don't want our magazines to look like catalogs, and in the back of our minds we know that the true surprise, the memorable picture, is more likely to come from photographers who are "difficult," who are interested in the art of fashion. This book provides an opportunity for us to see what photographers, free of the banal demands of editors, really prize. It's helpful to be reminded how often photographers limited by commercial demands succeeded in the past. Magazines such as *Vogue,* working with the likes of Edward Steichen or Irving Penn, have often printed memorable, classic images.

In the early days, these images were created with limited technical means. The classic photographers were probably quite limited in their ability to juggle technology—Man Ray being the exception. Their greatness comes from extraordinary composition, as in Cecil Beaton's "Charles James Evening Dresses," a set piece of frozen conversations and tumbling silk: witty juxtapositions—the chic of Norman Parkinson's "Wenda" is set off, not in a mocking way, by the black and gray background of the tenement and pram or quite simple technical distortions, such as movement in Richard Avedon's classic photographs of Penelope Tree, and Lillian Bassman's corseted figure and dog and driver, or Erwin Blumenfeld's photography through smoke or frosted glass, give these photographers' work an undeniable elegance. In the 1980s—appropriate to a decade that brought us postmodernism—many of the best photographers chose to reinterpret the past. Herb Ritts and Koto Bolofo looked to the thirties and forties for their romantic and heroic poses, shadows, and silhouettes. Sarah Moon and Deborah Turbeville's frozen poses evoked a turn-of-the-century atmosphere, and Steven Meisel adapted the work of the classic photojournalists of the twenties and thirties.

Right now, photographers are creating images that will influence the direction of fashion photography in the next decade. They include Jean-Baptiste Mondino and Max Vadukul, who clearly love fashion and whose work has extraordinary vitality, and Enrique Badulescu and Javier Vallhonrat, who use color in a new and painterly way. Increasingly, there is a fascination with technical wizardry that owes more to MTV and Andy Warhol than to Louise Dahl-Wolf and Cecil Beaton.

These are photographs that fashion editors need to see. They illustrate what can be done at the limits of the field. In all likelihood they presage the kind of image that will appear in prestigious publications over the next few years. The tension between editor and photographer will never disappear. But these photographs show us what we have been missing and point the way forward.

Anna Wintour

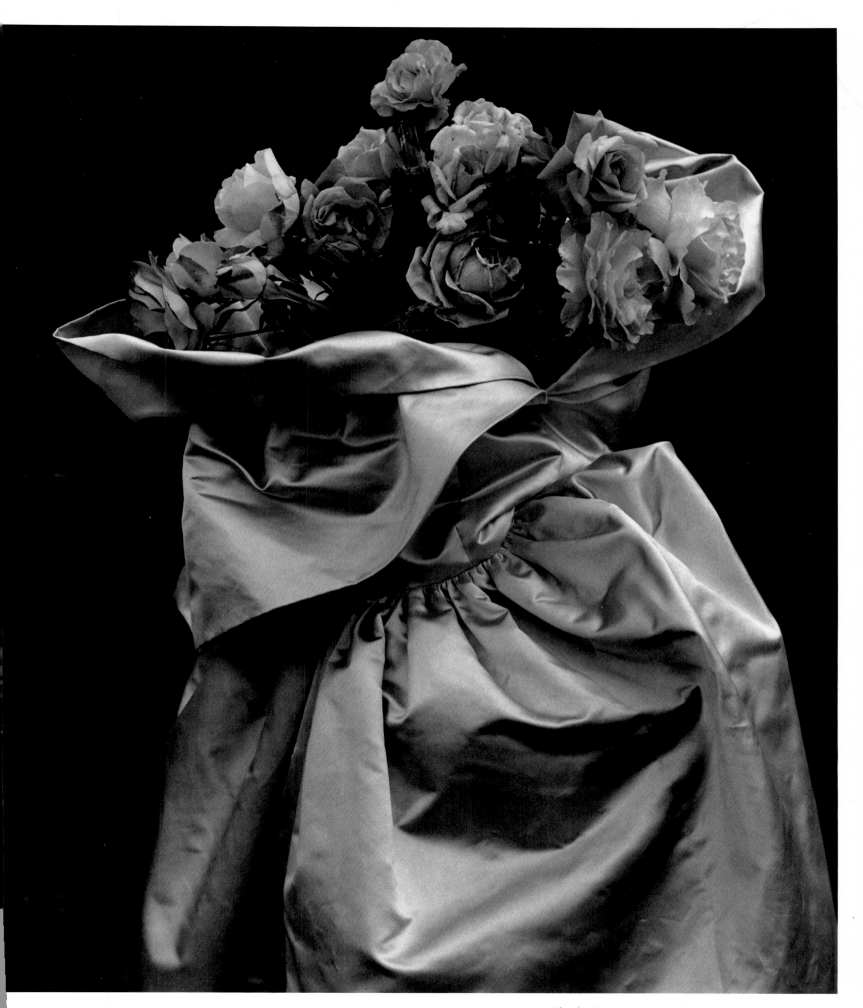

BRUCE WEBER, *Charles James Dress and Roses,* Kent, England, 1986

PERFECT SURFACE

by William Ewing

In January 1876, in what must be one of the earliest essays on the subject of fashion and photography, George Hooper railed against "the scanty, tight-fitting skirts, and want of taste displayed by ladies of the present day." He asked his readers indignantly, "Are elongated waists graceful, are dog collars that cover up a lovely neck desirable, are the extra-high heels any advantage, except to weaken spines and bring on premature consumption?" Assuming that the answer was to be a grumble of disapproving voices—male, of course—Hooper went on to posit the alarming conse-

quences of these unchecked fashion impulses. Would not such photographs be held up in years to come "as evidence that ladies had ignored the harmony of colors and neglected the grace of nature in order to dress themselves up so as to be a spectacle to their own sex, as well as to the astonishment and disgust of all sensible men?" Worse, would not future critics point to these photographs "as proof of the follies and fooleries of this fast-going age?" The author called on his fellow photographers (presumably, "sensible men") to do what they could to stem the tide.

With that business of "harmony of colors," Hooper was allowing his rage to get the better of his judgment. There was no such thing as a practicable method of color photography in 1876, and most critics said there never would be. For this reason, perhaps, the readers of *The Photographic News* may have tended to disregard Hooper's impassioned pleas. In any event, as time would make abundantly clear, many photographers would not only refuse to *condemn* the excesses of fashion but work wholeheartedly to *promote* them.

In fairness to Hooper, it must be said

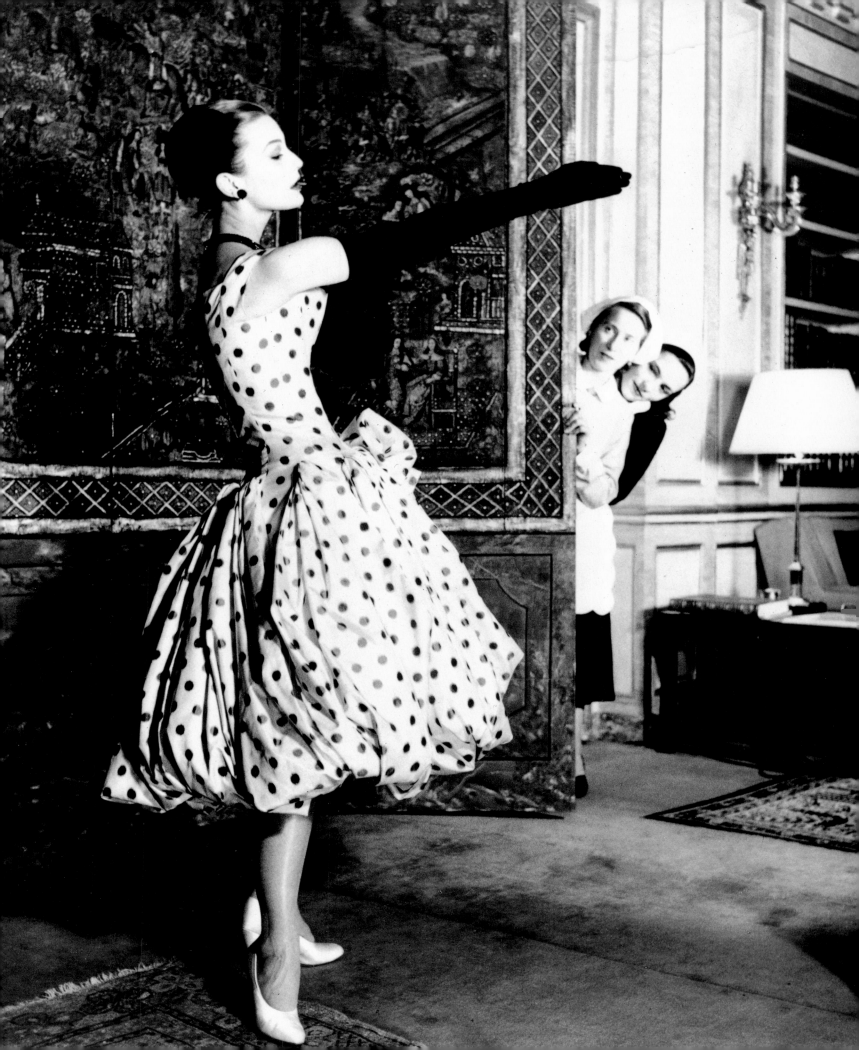

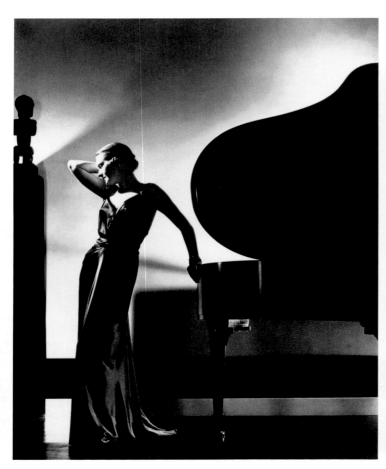
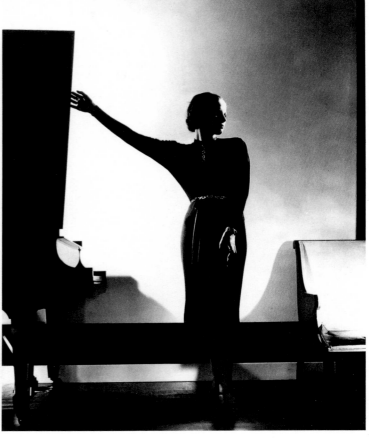

EDWARD STEICHEN, New York, 1935

that he wasn't writing about fashion photography at all—that is, fashion photography as we would comprehend it today, even by the loosest definition. He *was* writing about fashion, and he *was* writing about photography—indeed, the piece was called "Fashion and Photography"—but the true hybrid, the twentieth-century specialization, did not exist even in a proximate form in 1876. The profession would not be fully established for another fifty years, taking as the key date Edward Steichen's 1927 study of Marion Morehouse in a Cheruit gown, the first truly modern fashion photograph. Hooper was actually writing about his own profession, *portrait* photography, and the *fashion* in his title meant the waxing and waning of popular portrait formats. "The fascinating art of photography, like everything else, has its fashion," he reflected, looking back over a quarter-century of portraiture. "Some have passed away, like the old Daguerreotype, with its conventional pose and universal complexion tint, and the Boudoir, the Promenade, and the Imperial."

From this perspective, the author's dia-tribe on the actual fashions themselves can be seen as an aside born of a personal animus rather than a truly professional concern. Or was it? The strength of Hooper's outburst demonstrates the fundamental role played by fashion in nineteenth-century portraiture. Clearly women were paying a great deal of attention to what they wore to their portrait sittings, and the photographer, nominally in control, was powerless to influence them. Here then, in the portrait studio, is where the search for proto–fashion photography should begin. Twentieth-century fashion photography

BARON ADOLPH DE MEYER, *Marthe Letellier*, Paris, circa 19

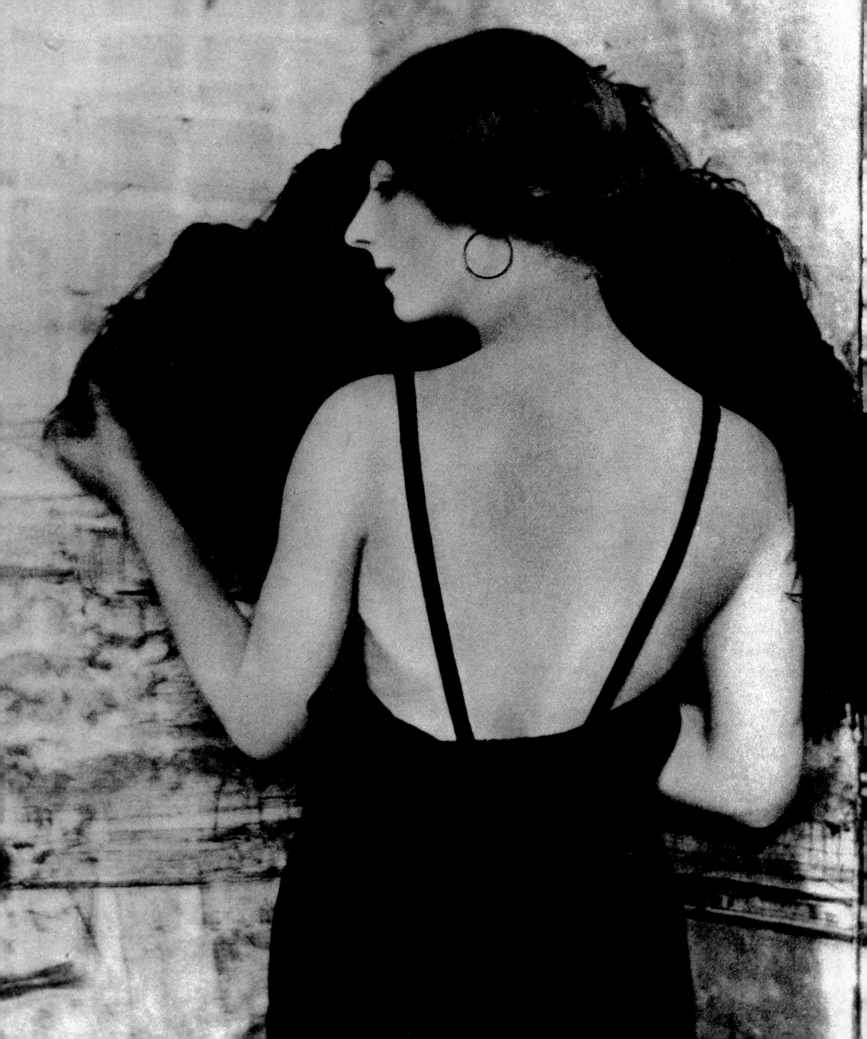

MAN RAY, *Fashions by Radio, Coming Over the Shortwaves,* Paris, 1934

Steichen
told Huene that
a photograph's
essential fashion
requirements
were distinction,
elegance, and chic

did not emerge full-blown in the mid-1920s solely as a consequence of Steichen's modernist ingenuity; the seeds had been sown many years earlier, had sprouted and taken root in the nutrient soil of portraiture.

Ironically, it was a very humble format of portraiture that first nurtured these seeds: the carte de visite was tiny by conventional standards, more or less playing-card size, and nothing more than a paper print stuck to a cardboard mat. Patented in 1854 by André Disderi, it was less a novel invention than a very clever adaptation of

existing glass-plate technology whereby eight smaller images were grouped on the plate instead of one and then contact-printed. The process was faster and cheaper than any previous method, and its format was universally adopted (a 2 $\frac{1}{2}$ × 4 inch card). In the 1850s, it swept the photographic competition from the world stage.

Enterprising photographers began to promote carte portraits of public figures such as royalty, famous dancers, statesmen, and the like. So great was the public's demand for actors and actresses in particu-

lar that specialty studios sprang up to accommodate it. Millions of celebrity cards were made and sold; when the Prince Consort of England died, ten thousand were sold every day for a week. Even a small studio might produce fifty to a hundred thousand a year. According to Gernsheim's *The Rise of Photography,* "Three hundred to four hundred million cartes were estimated to be sold annually in England at the height of the carte de visite period."

What was the appeal? Unencumbered by frames and glass, the cards could be held in the hand and carried around to show friends or perhaps traded. This intimacy of handling was something new to photography. More important, it established a new level of intimacy with the celebrities who were pictured. Previously, people had known them visually only through engravings, which were printed in much lower editions and always idealized. People were used to seeing a famous bal-

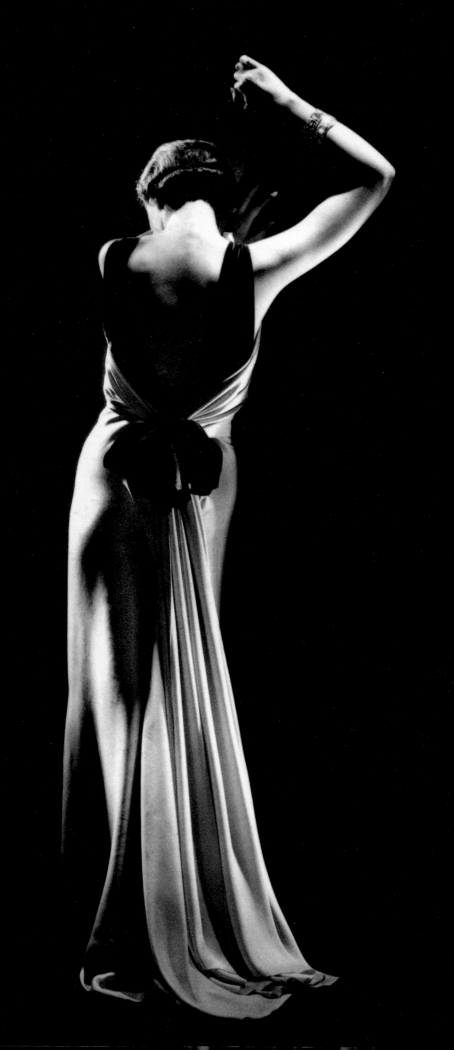

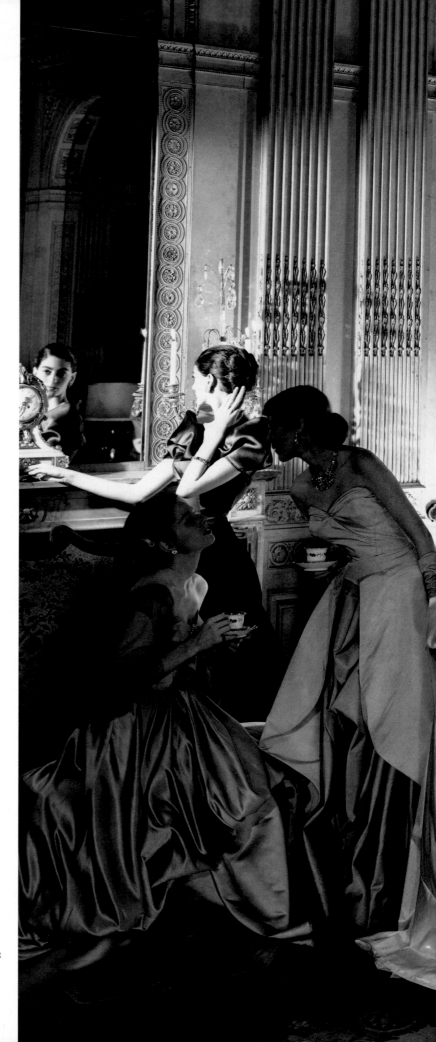

CECIL BEATON, *Charles James Evening Dresses*, New York, 1948

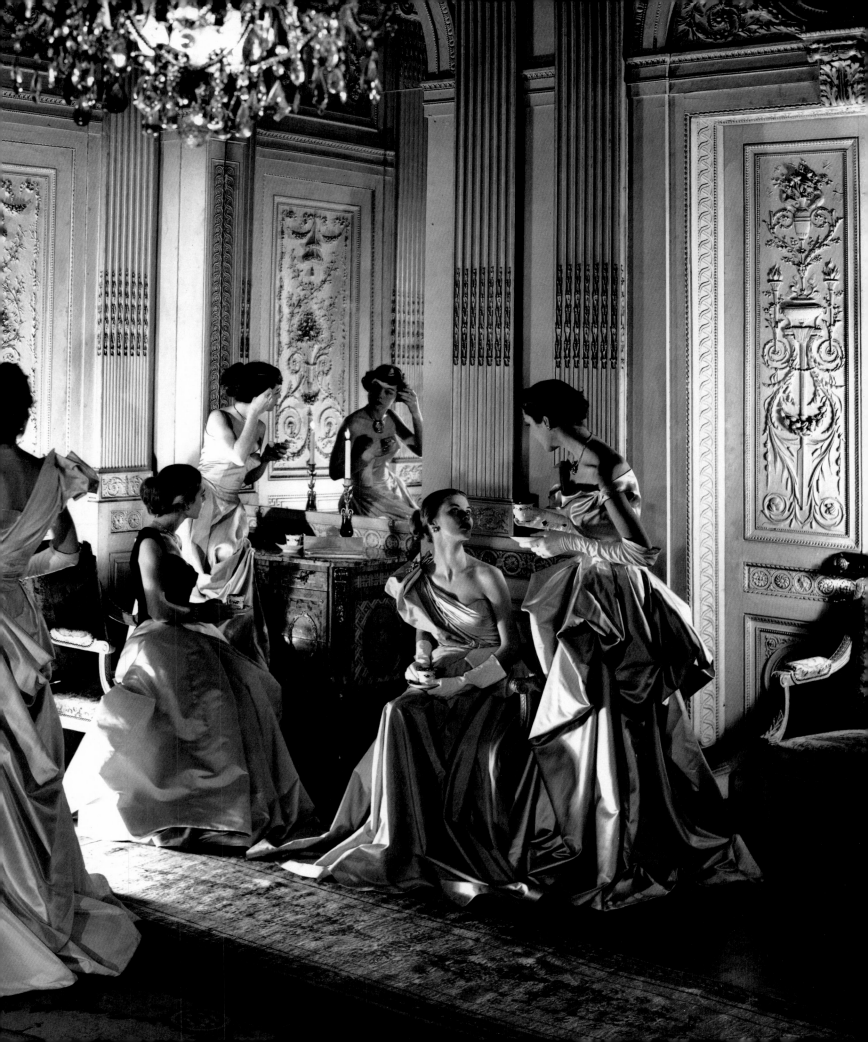

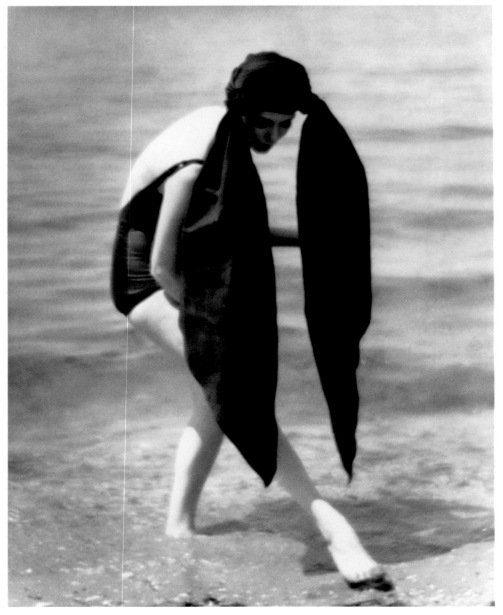

MARTIN MUNKACSI, *Halston Turban*, Sands Point, Long Island, 1962

> Although it was no less contrived than the formal studio pose, the snapshot gave the illusion of spontaneity and therefore absolute credibility

lerina, for example, flying serenely through clouds, trailing thin legs tapering to perfect points.

The cartes de visite brought their subjects down to earth with a thud. Demand was such that there was no time for even rudimentary idealization, such as the conventional retouching that was standard for larger formats. In every respect, the cartes were aesthetically undistinguished. But this made for a more human likeness, a new directness, and an element of democratization; the famous were now less gods and goddesses than supremely gifted hu-

man beings. It is ironic that celebrities were being dethroned while their fame was spreading in ever-widening circles. And now that cartes had brought them within reach, they could be emulated. The dress of an admired actress could be scrutinized. Celebrities became role models in matters of fashion. Jumping ahead one hundred years, what are the pages of *Interview* and *Vanity Fair* if not reincarnated cartes de visite, cloned in vastly greater numbers by the modern printing press?

This is not to say, however, that there was no longer a demand for idealized por-

traiture; elaborately retouched and hand-tinted portraits continued as the norm for the larger formats. For their *own* portraits at least, people demanded idealization. In 1871 the American portraitist Albert Sands Southworth stated flatly, "Nature is not all to be represented as it is, but as it ought to be, and might possibly have been. . . ." One might therefore surmise that these portraits, and not the simple cartes de visite, were the direct ancestors of the fashion photograph, and to an extent they were. However, the cartes were a necessary phase in developing heightened expectations for photographic verisimilitude.

Early issues of *Vogue* adapted to the medium of photography during the late teens and early twenties. To our surprise, fashion photographs are a third priority, behind celebrity reportage and interior decoration. But we find the photographs which we would consider as prototypes of the genre to be typically similar to the kinds

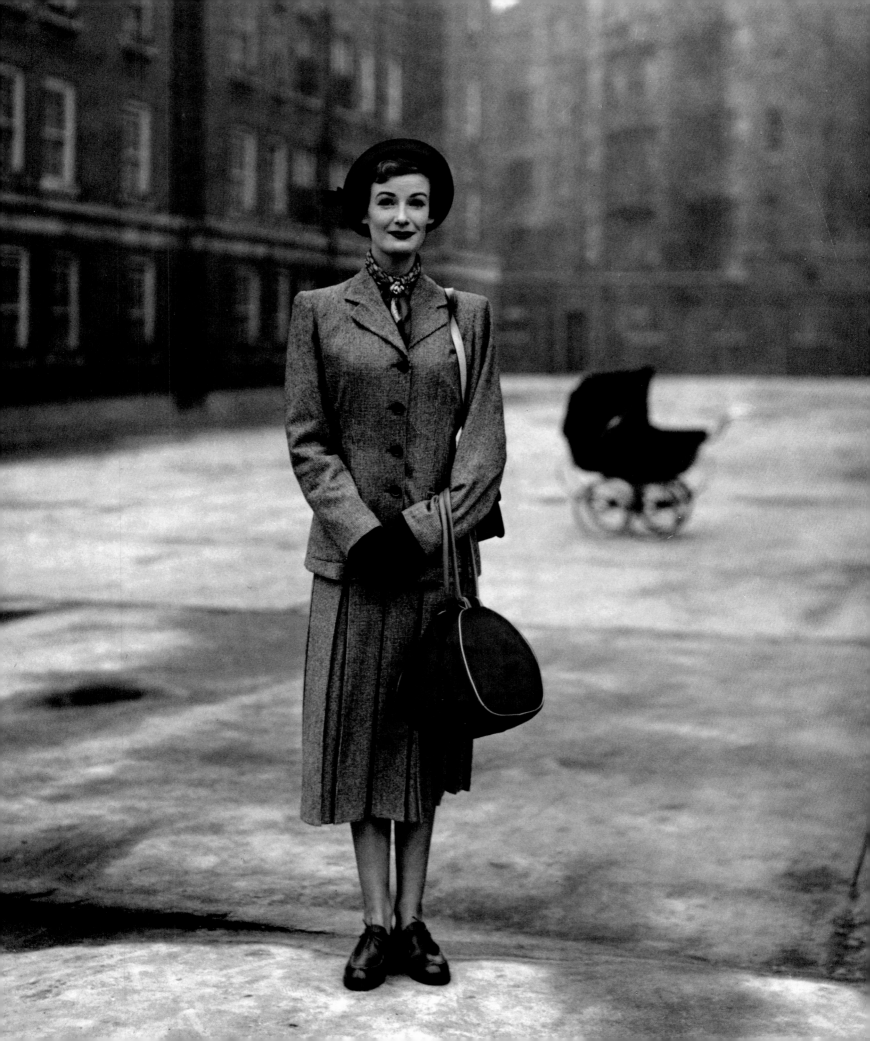

GÖSTA PETERSON, New York, 1966

of portraits we have been discussing. The function may have changed, but the format is the old familiar one: a well-known actress, dancer, or society personage, elegantly dressed, sitting for his or her portrait. The first fashion photograph ever published in *Vogue* shows a nattily attired J. Lee Tailor in a portrait that is indistinguishable from a carte de visite. The clothes he is modeling are in a sense his own—of the kind that a member of his social class would be *expected* to be seen wearing. The authority of the visual image derives from this social aspect and not, as we demand today, from pictorial considerations. For this reason, these early "fashion photographs" seem to our eyes dowdy and unconvincing. And no wonder: in the intervening years we have been treated to a dazzling display of camera pyrotechnics, or—to quote Richard Avedon—"the perfect surface of things as an adventure."

The dramatic change begins with Baron de Meyer's 1914 appointment as chief

photographer for *Vogue* and *Vanity Fair*. De Meyer was not only a member of the Edwardian era's international set but an apostle of its glamorous sheen. *Vogue* saw the appointment, as fashion editor Frank Crowninshield put it, in terms of "fashionable photography" as much as "the photography of fashion." The mode was still essentially portraiture, but it was now the portraiture of painting and not the tired portraiture of photography. Thus we observe more than a touch of Whistler's somber atmospherics, Sargent's confident modeling of women, and a wholehearted reverence for the cult of Beauty. Because de Meyer was recruited from the top echelon of the serious amateur movement known as Pictorialism, he was able to introduce into his professional work a whole new repertoire of aesthetic devices, the hallmark of which was his radiant backlighting. George Hoyningen-Huene, who a decade later would emerge as a distinguished fashion photographer in his own

right, noted how de Meyer's backlighting "had the mysterious air of making every woman look like a vision in a dream." And Cecil Beaton observed how "it was a status symbol to stand against his barrage of backlighting. . . . He was not afraid to reveal too little of his subjects, and sometimes as a portrait *he produced just a blank outline*." Already then, in the work of the first true fashion photographer, a *likeness* is giving way to a picture.

Steichen followed de Meyer at *Vogue* and *Vanity Fair*, his bold, crisp style the antithesis of that of his predecessor. Hoyningen-Huene observed that "in contrast to de Meyer's, Steichen's models were alive, as if about to step out of the pages of the magazine." Steichen told Huene that a photograph's essential fashion requirements were "distinction, elegance, and chic." Soon thereafter, Hoyningen-Huene, Beaton, and a handful of others, largely recruited from the fine arts, brought their distinct sensibilities to bear on fashion as-

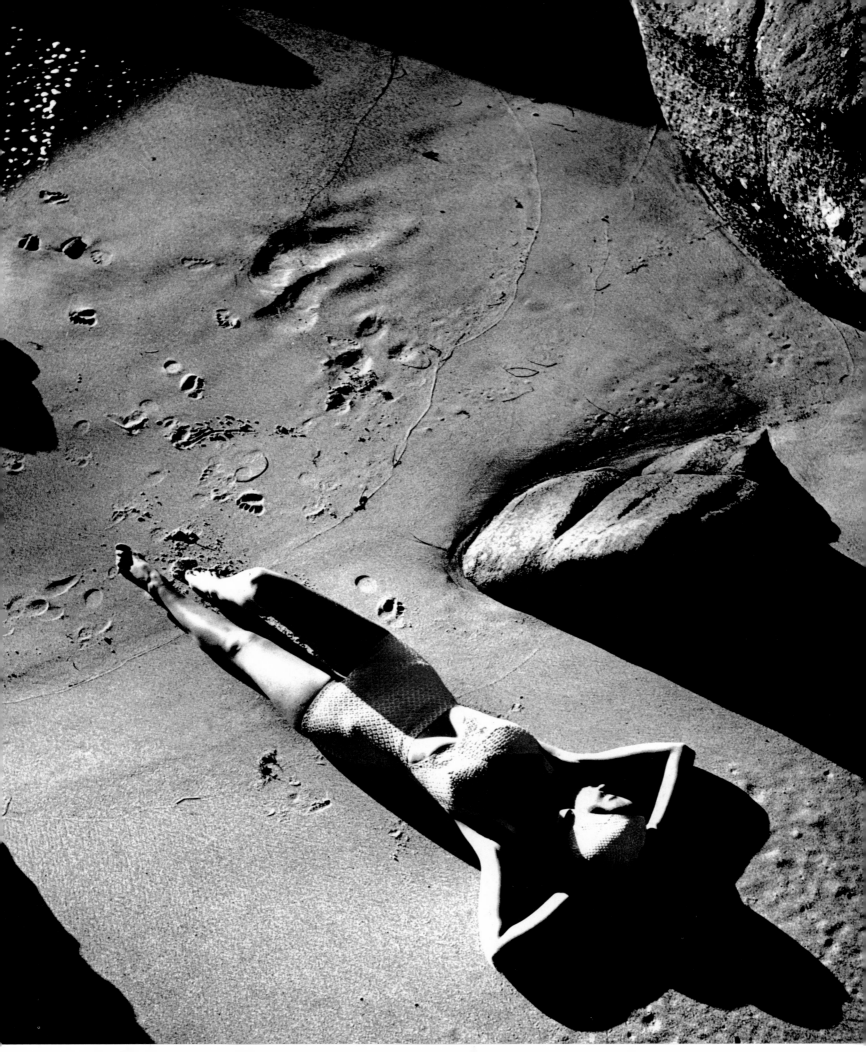

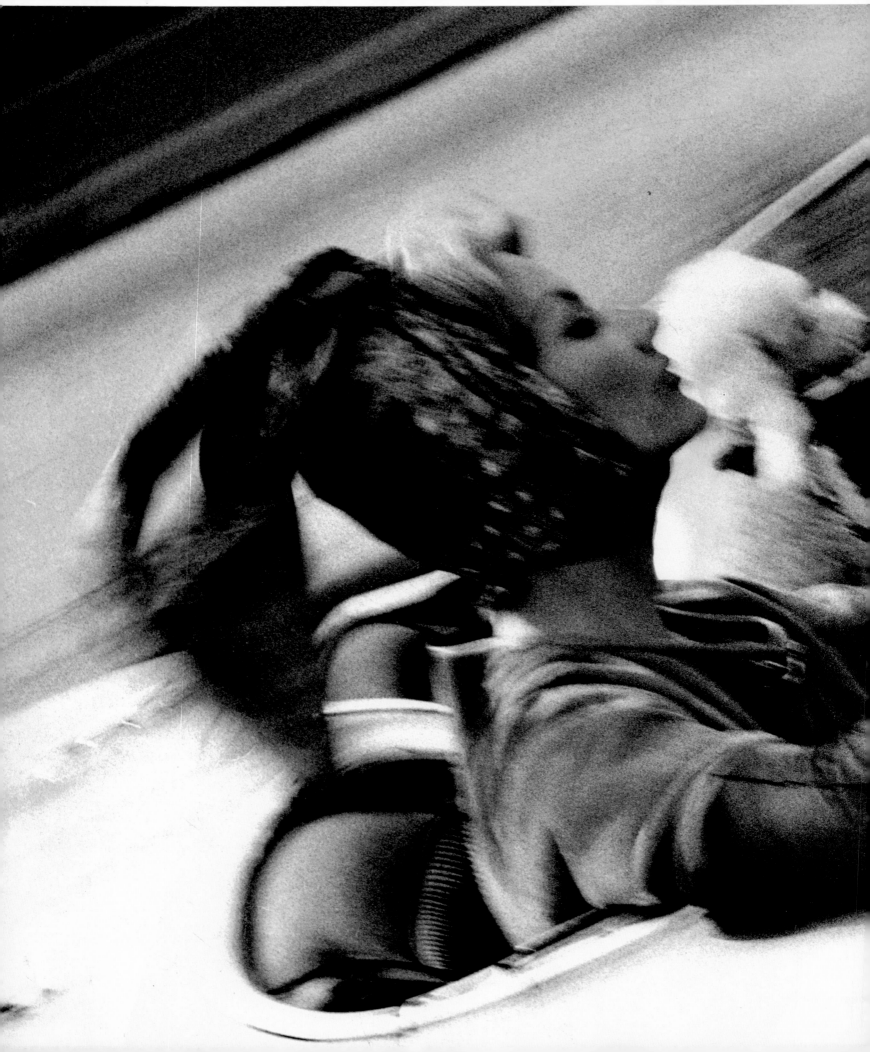

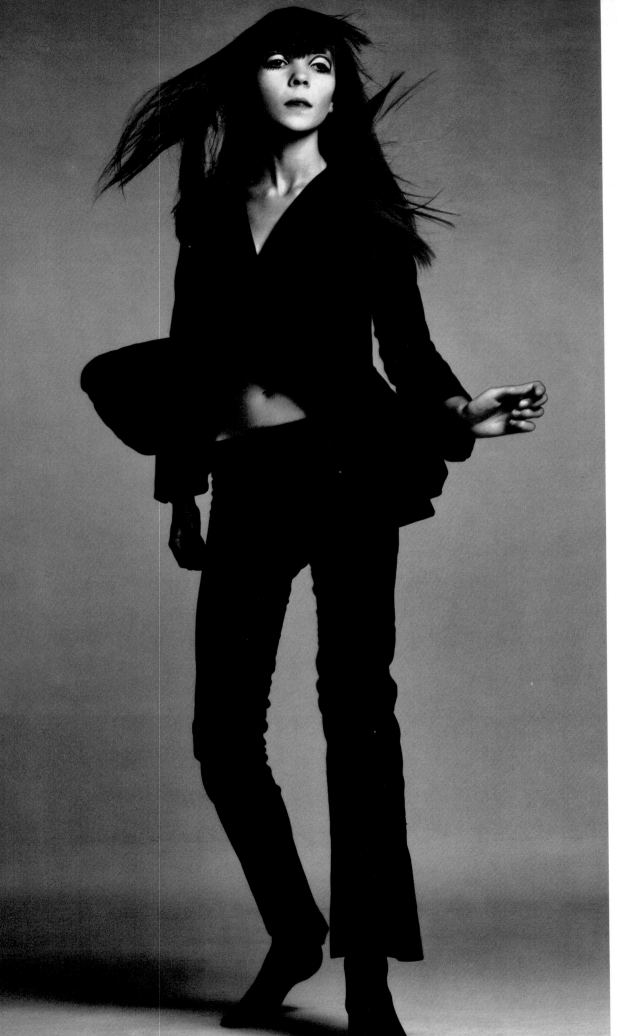

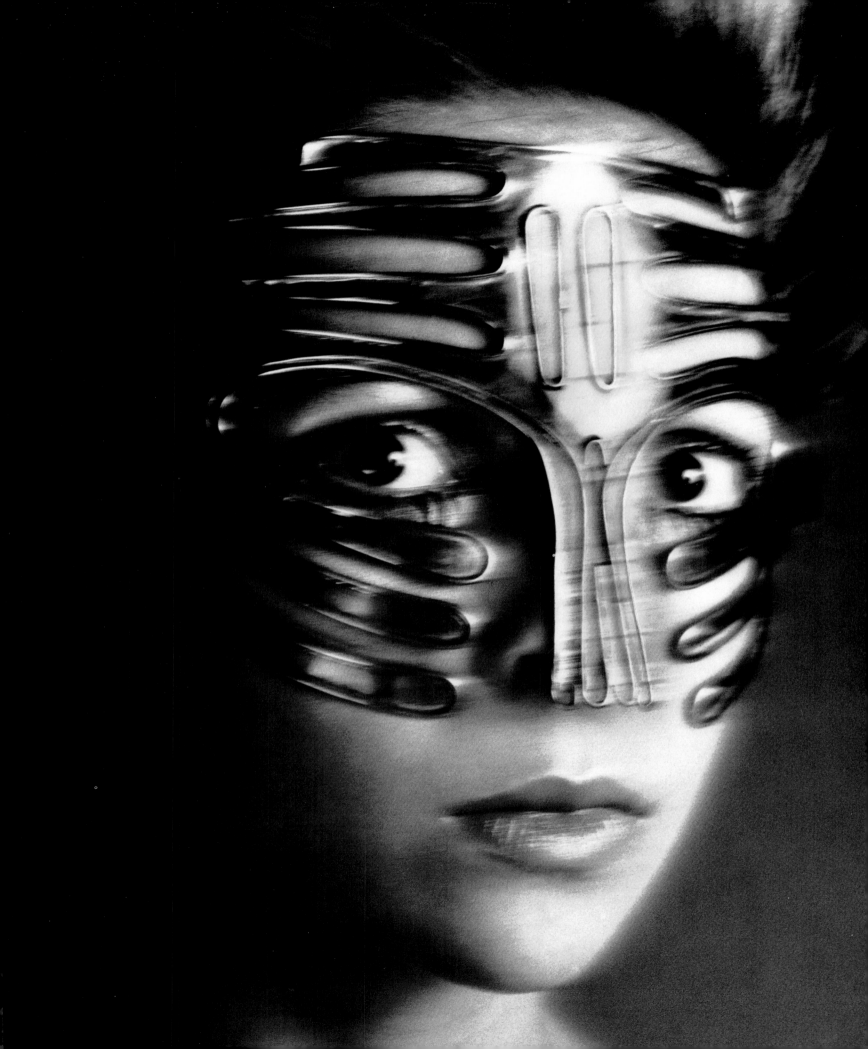

BLUMENFELD

by Richard Martin

In fashion, there is perception and, beyond that, desire, the consumer desire for the garment, the autonomous longing for the apparel, and the sensuous relation between body and dress. Erwin Blumenfeld's photographs of beauty and fashion perceive the figure and dress but achieve their mystery and mastery from the manipulations that distance us from the object of desire, enrich its aura of intangible yet material presence, and render it a world of palimpsest and mirror that haunts both viewer and viewed. Blumenfeld's idiosyncratically invented images do not represent an alternative reality as much as they gauge a deformed world that we otherwise know. Their cunning and abiding fascination today is that so many artists and photographers in the past two decades have followed Blumenfeld's lead in realizing the possibilities of photographs that give perverse pleasure because they are unnatural depictions, both familiar and phantom-ridden. Freaks of illusion and beauties of impression are curiously harmonious.

Born at the close of the nineteenth century, Erwin Blumenfeld (1897–1969) was one of the few men of the twentieth century who perceived photography, even in its commercial roles, as an art that transcended description and shared in the vanguard taunts and tumults of our early century. Blumenfeld knew well European modernism and the unconventional traits and fashion insinuations of Surrealism. His involvement with avant-garde artists in Berlin, where he had been born, and later Amsterdam and Paris, brought to his photographs a breadth of ingenuity evident in his work in the Surrealist publication *Verve* in Paris as well as French *Vogue*. After emigrating to New York in 1941, he collaborated most frequently with *Vogue* in the vital years in which fashion magazines were the international crossroads of concepts and creators in graphic design, illustration, and photography.

The obscured or altered image in fashion photography is a means of clarification and objectification. Though we may seem to see through a glass darkly, we see with intense optical certainty and with self-assured intelligence. Thus, an image of beauty is confirmed as the aggregate of parts that are realized in veiled layers: an arm in the foreground with a rose garland around the wrist and the red nails of the hand in elegant gesture with a cigarette looms as the gestural monument, a Marlene Dietrich before she appears through steam, representative of the figure in the background with rosy sfumato, has reduced her almost to the archetypal Tom Wesselman distillation of the female. But the Pop Art woman was explicit. For Blumenfeld, she is sign and shadow at once, the gestural symbol becoming the outer and expressive tier while the face is relegated, in its familiarity, to a secondary role, more trace than depiction. That we see in the hallmark Blumenfeld photograph an ethereal beauty signifies both the universality of the ideal and the accessibility of the constituent conditions of beauty, that which we might strive for.

In a similar fashion photograph, the smoke of the cigarette creates its own obscurity. In an era when a puffing billboard lured visitors to Times Square, the Blumenfeld image is one of constraint, of the tissued density of smoke and glass that is literally the smoke and mirrors of legerdemain and the phantasm.

To seize beauty is, after all, to arrest and discern an ineffable absolute. Thus, the four heads realized in rotation are the spinning, flickering moment of cinema seen in its Technicolor and dramatic light within a continuous tumble that resembles the cartographer's four winds or ordinals.

All photographs by ERWIN BLUMENFELD, New York, circa 1940s & early 1950s

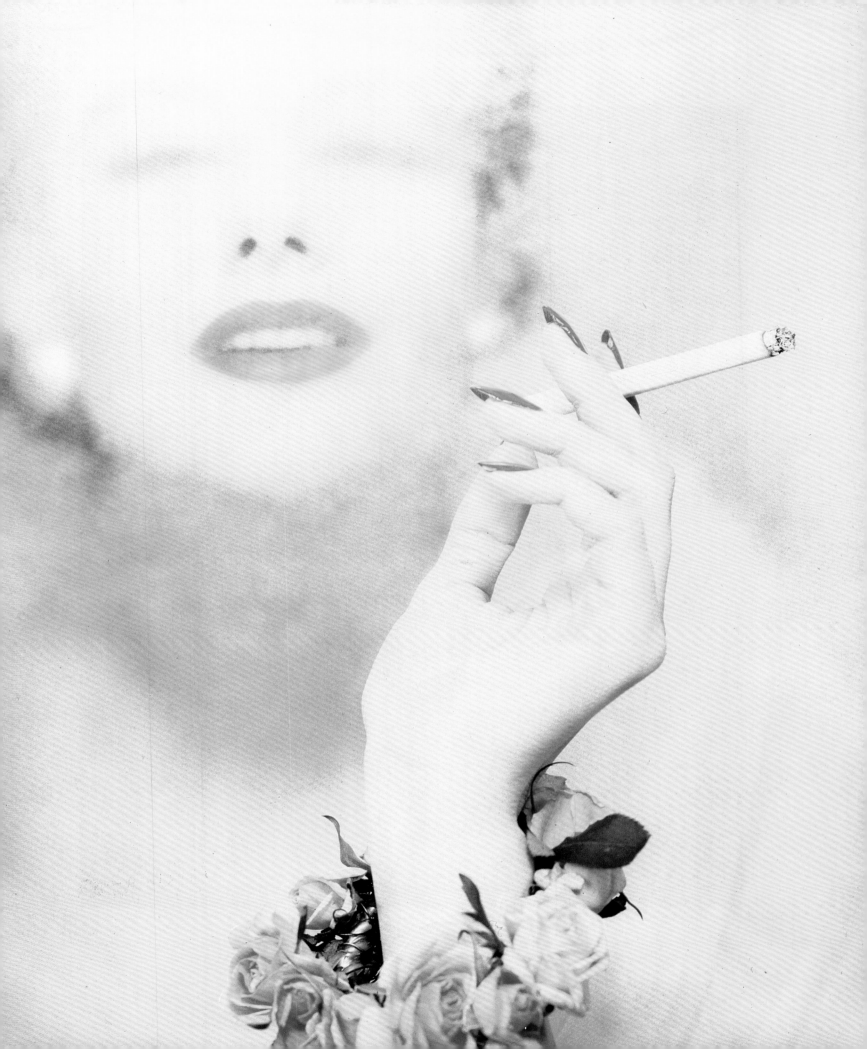

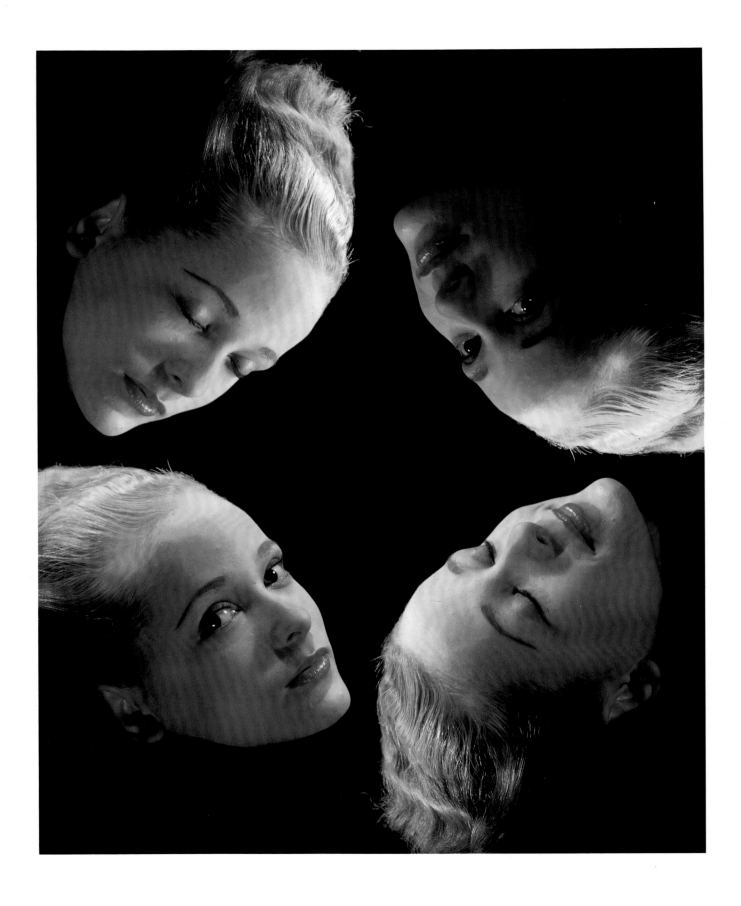

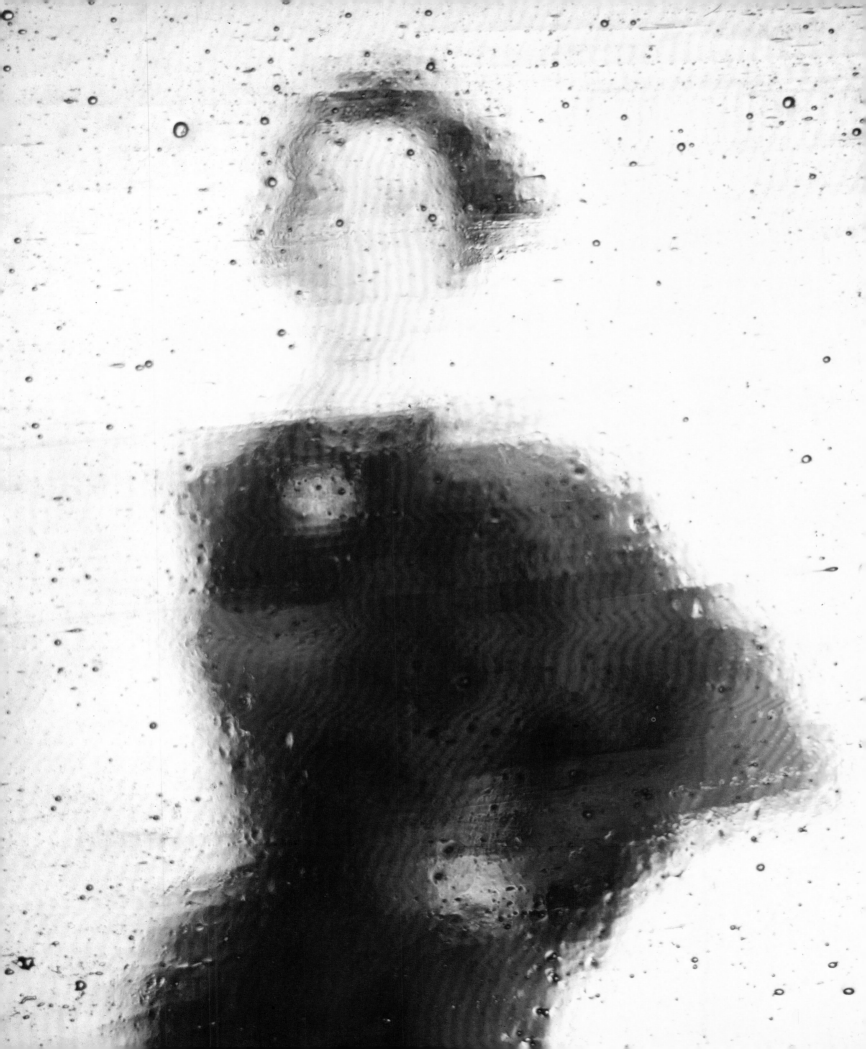

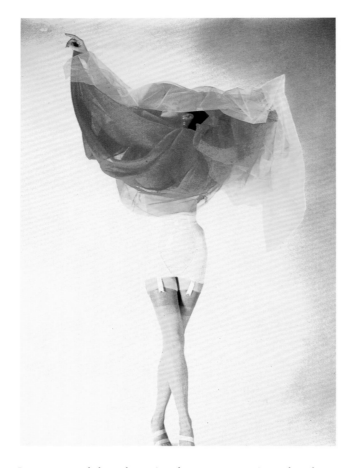

Is any one of these beauties the consummation of such an abstract quest, or is our grail more obviously the aggregate, the putting together of the images from the evidence that Blumenfeld offers, as in the required composite of time and visual place that is modernism's persistent discourse with the viewer? Like a brilliant wheel of fortune, the Blumenfeld beauties are disembodied heads out of the vocabulary of Surrealist photography, but they are also the shadowy and glazed elegance of film, even the masks of an ancient theater of grace and highlighted beauty.

Beauty caught only on the pocked, irregular veneer is the haunted husk and likeness of another beauty, forever the remembrance of image and never quite an icon. Imperfect resemblance is, of course, beauty's flattering transmogrification. When a flecked field is used, as a spattered mirror or a waxy fossil-vestige, the remnant becomes what we have known of the bee in its persisting comb, the tracery of wondrous web as souvenir of the spider. Blumenfeld looked not into a mirror, but at the wall of Plato's cave. The world is, of course, more than any one of us can know. Those shadows that become the images of our collective cave are but frail things like the equivocal image cast, but not sure, in its presence.

Blumenfeld realizes the descriptive shadow rainbow only lately popularized in movies such as *Batman* and *Dick Tracy,* which delight in their spectrum and spectral gels of color. The shadows of German Expressionism in art and cinema are as haunting for Blumenfeld's doubly seen figures. They are allied as well with the Surreal doppelgänger of beauty in its intense and radiant acclamation and the shadow of contrast and death that accompanies it as every mortal's shade. Floating on the dark field of the image, the palindromic faces of effulgence and specter are both fragile and symbiotic. Sans beauty, there is no image but ebony.

Yet beauty is the dainty form kissed by the dark profile of penumbra. Like Magritte's dually inhabited bodies and duplicitous mirrors, Blumenfeld's definition of beauty is always with nefarious ambiguity. A beauty in black limns the strategies of Blumenfeld's beauty: dissected into such rubric elements as the hat for crown of the head, lips in a field of black, and red roses on the white bodice and sliver of a shoulder, we have the heritage of Man Ray and the anticipation of film from Hitchcock to Greenaway. Blumenfeld insists on the synecdoche: the entity can be described with elegant concinnity by articulating only essential points while nonetheless realizing the line.

For Blumenfeld the field of the photograph is, as it was for the great designers of fashion and beauty publications, akin to the uninflected and innocent field of the unwritten page, a tabula rasa for guile and fabrication as the necessary ingenuities in a flat Eden. Hence the ribbons of color are the translucent and contorting lines of force in a Blumenfeld photograph indebted to collage but with its own perverse photographic dimension of the added ribbons that twist the vertical bars into an eccentric lattice.

In a photograph of lingerie, tulle becomes crimson in its dense center as an Isadorable dances with the drapery that becomes form. The dream is not of the Maidenform bra that ventured into improbable realities, but rather an image that we see for its fascination with form and acknowledgment that beauty, even when embodied in woman, is ineluctable, evanescent, and of the genius of the photographer. In seeing through the rose-colored glass of Erwin Blumenfeld, we come face to face with a fugitive, fragile figure that is ever the symbol of beauty. □

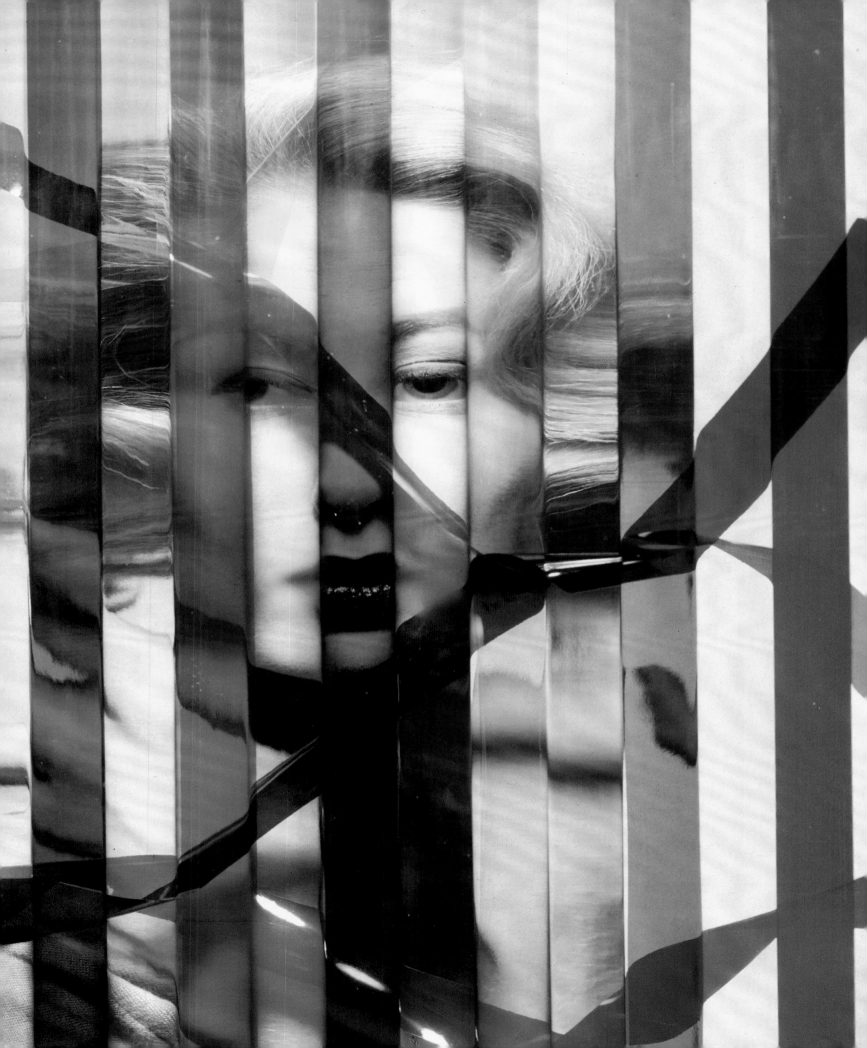

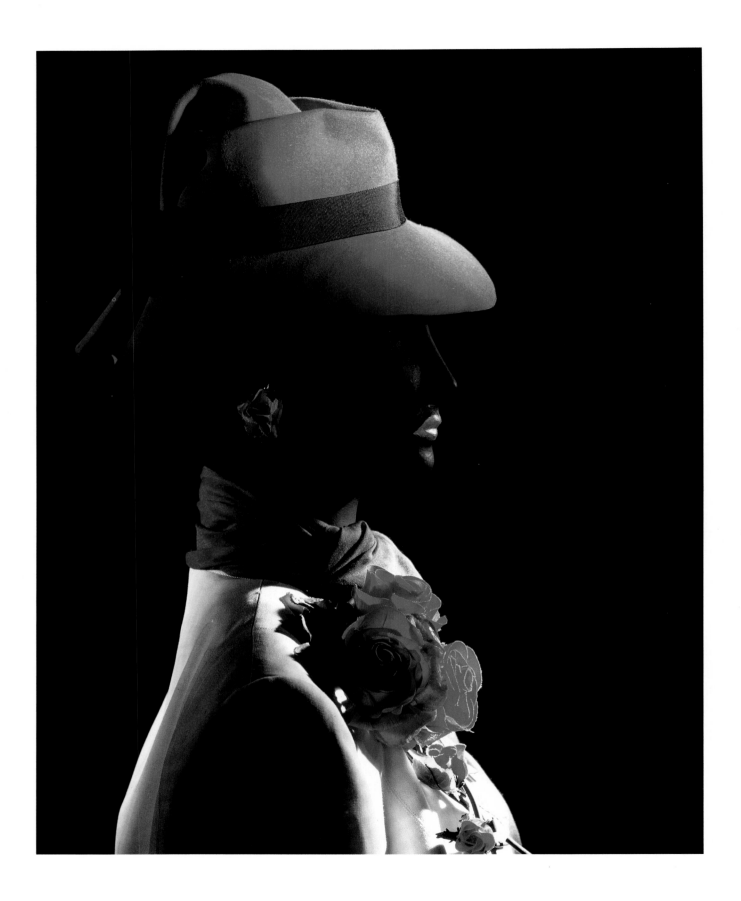

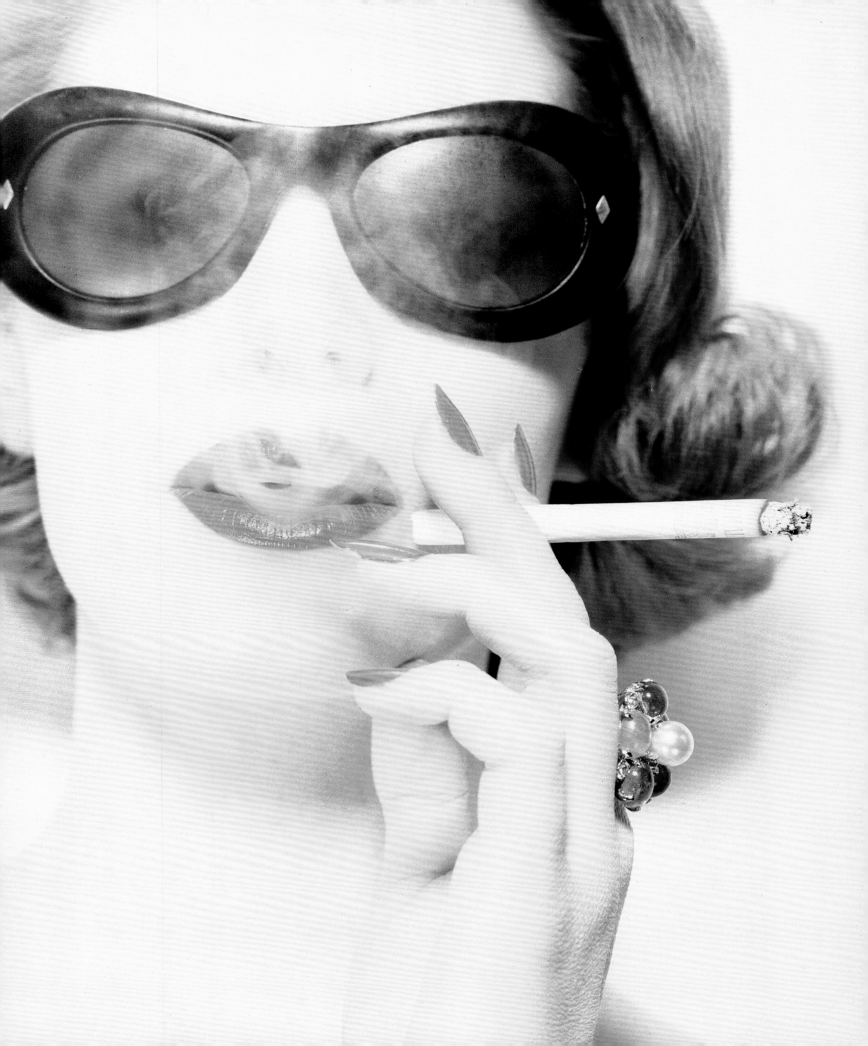

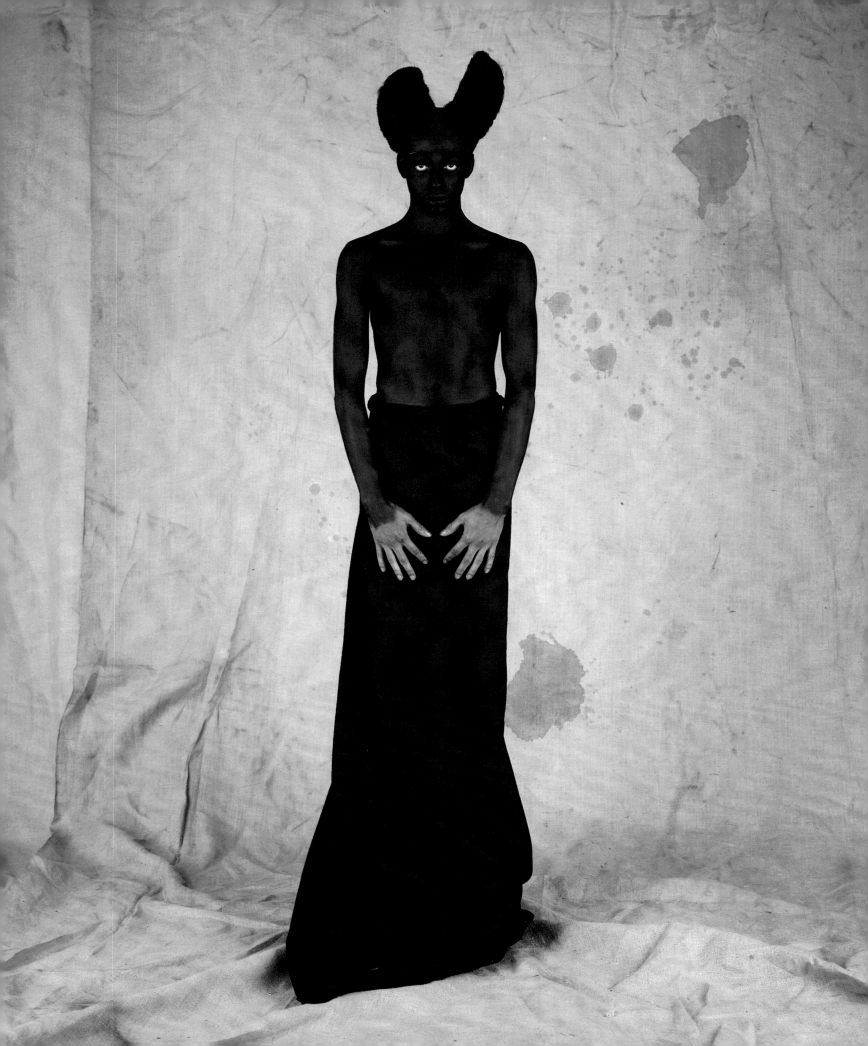

FASHION ART

by Anne Hollander

The beauty of dress comes alive in art. Ever since the breathtaking achievements of the ancient Greeks, dressed perfection has been embodied in images, visions of enhanced reality that teach the eye how to see clothes, and teach clothes how to look. Images show how artists tailor the figure to suit the fashion, so that it wears its clothes to advantage. The eye is taught to see living clothed figures in the light of the image and to believe what it sees. The force of the authoritative fiction can create the truth of appearances.

Living bodies can only shift a little to match artists' vision of them—people can get fat or thin and alter their posture; but fashion itself can change extremely, spurred by the brilliant images offered in the world of art, and it can mold ordinary bodies to suit its own laws. Clothes in the ordinary world always try to measure up to the fleeting elegance that artists imagine and make real; modern artists of the fashion camera are heirs to an artistic tradition that has continually established and reestablished the true view of clothes.

For centuries, courtly artists attempted to render elegant clothed figures as if they were eternal icons, displayed in as timeless a harmony as possible, even if the fashions were bizarre. The stunning effect of Bronzino portraits comes from the way the cumbersome clothing is made to seem easy and inevitable on his princely sitters, however heavy

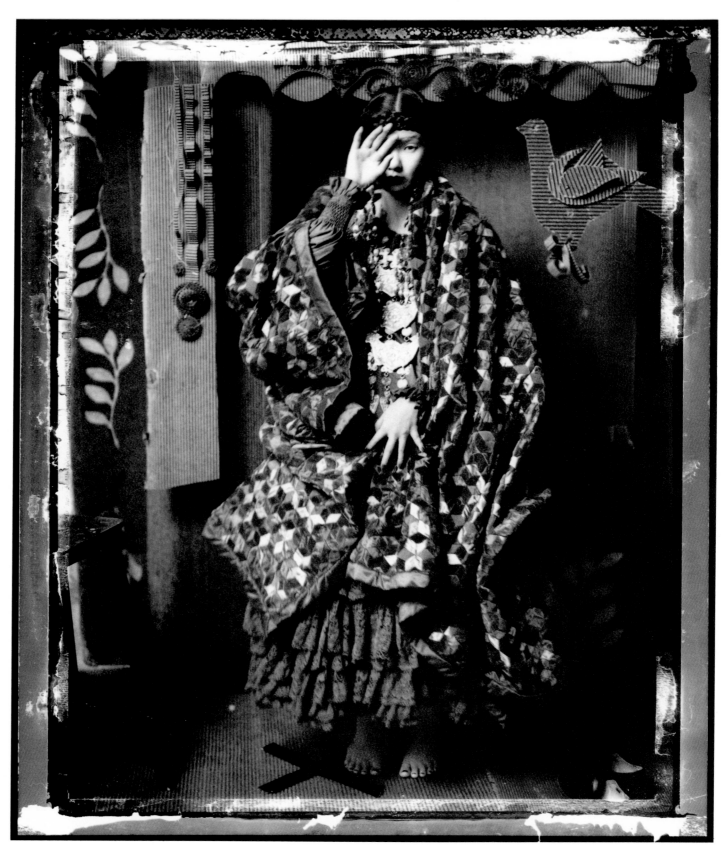

SARAH MOON, *Dior,* Paris, 1990

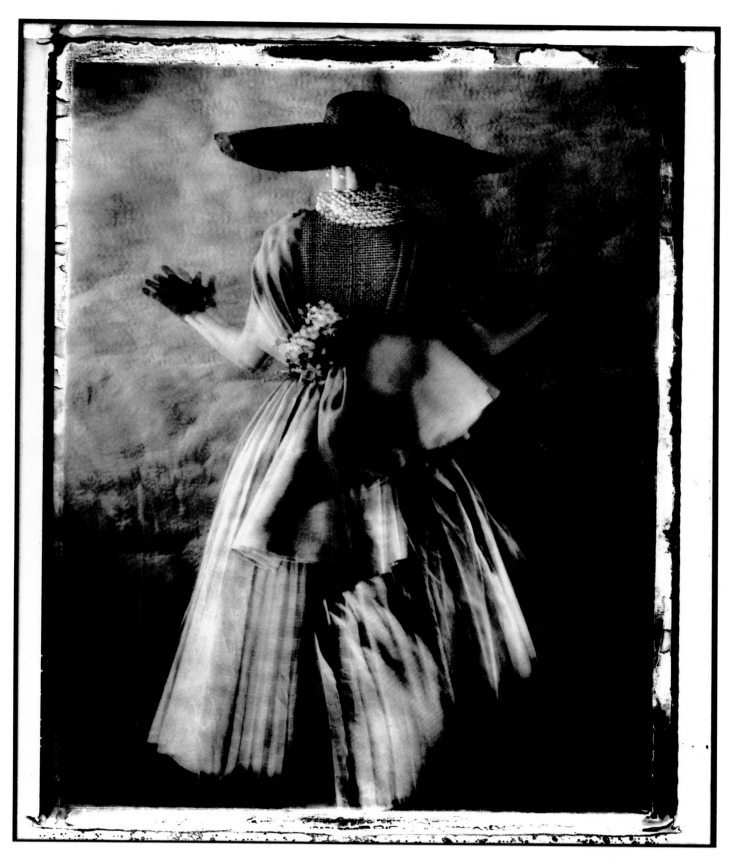

SARAH MOON, *Callaghan*, Paris, 1989

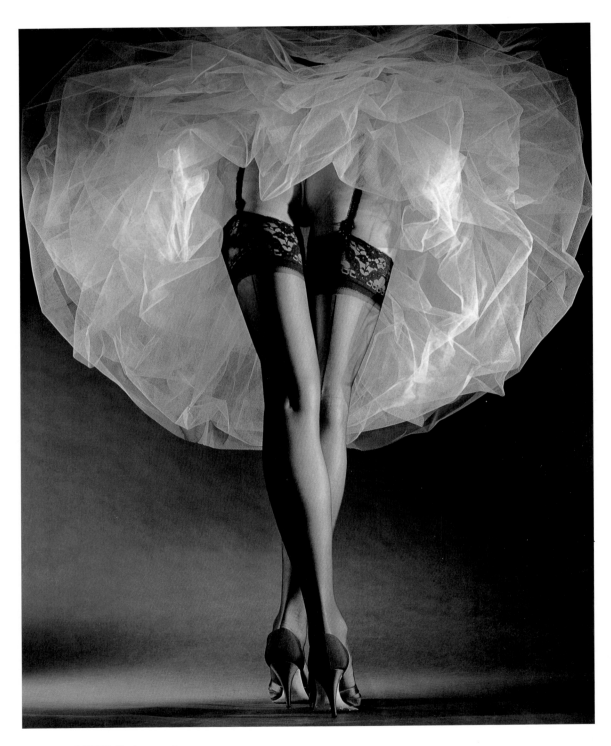

HORST P. HORST, Paris, 1978

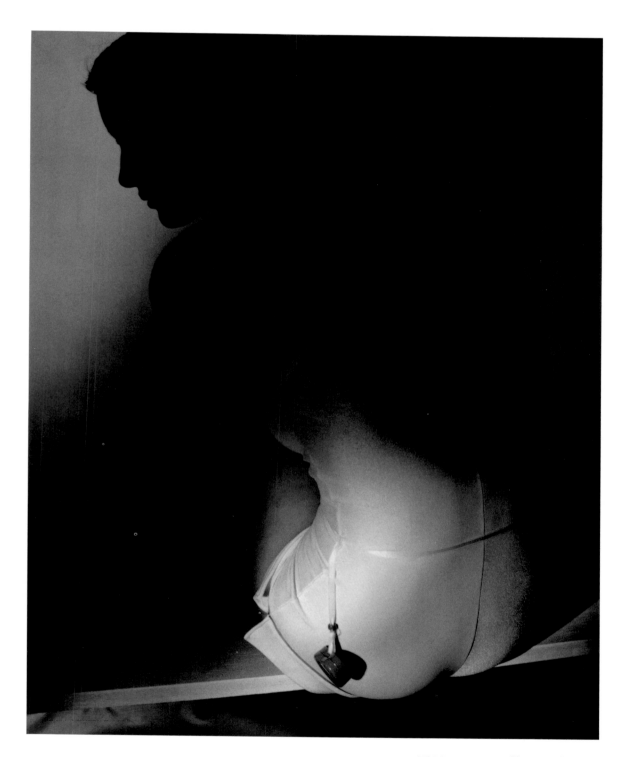

HORST P. HORST, New York, 1987

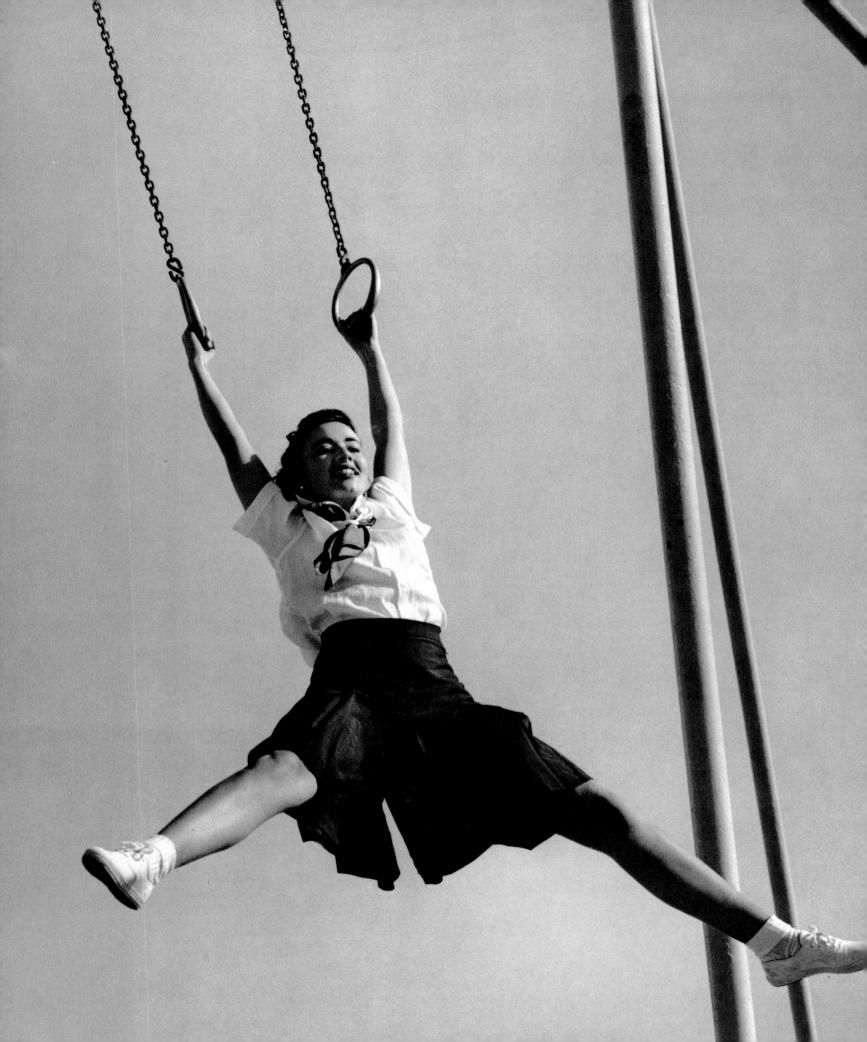

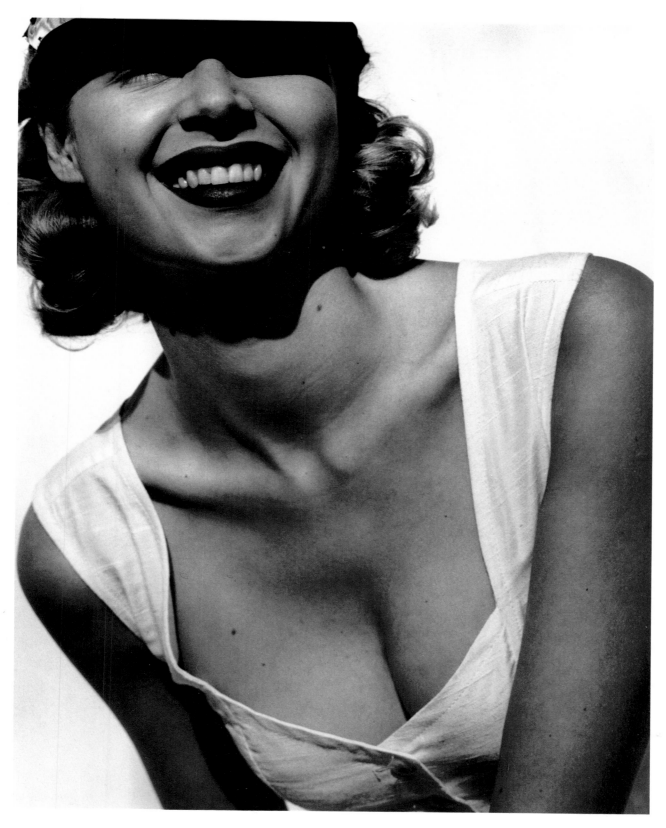

KOTO BOLOFO, *Lucy Carr,* Los Angeles, 1988

TO BOLOFO, *Rebekah Powell,* Los Angeles, 1988

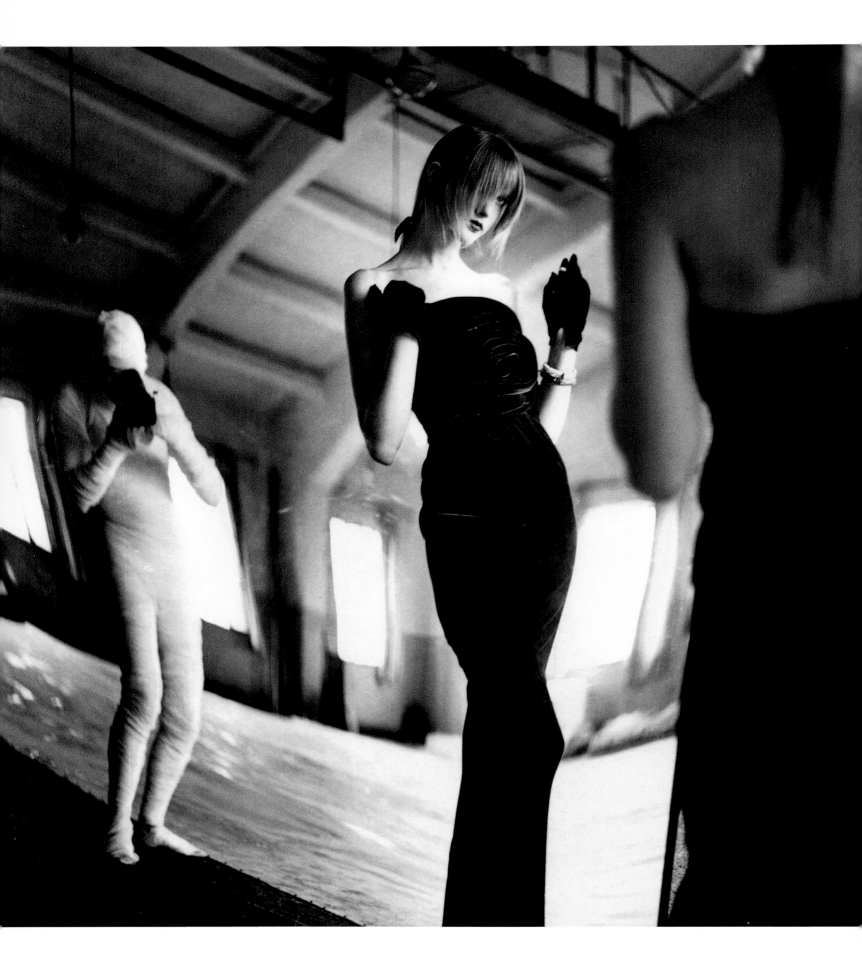

and taxing it really may have been, and hard to keep in proper trim. Although clothes were actually made by tailors, fashion in the sixteenth century was inspired and moved along by such artists as Titian and Bronzino, who could turn all absurdities and grotesqueries into graceful adornments, and even produce a longing for more of them.

In the superior world of the painter, noble personages in all sorts of awkward gear were created and presented in a state of ideal dignity and refinement; and so a standard was set for perfect appearance that might be followed by the living originals, who could feel beautified by their trappings instead of trapped. Consequently, still bigger lace ruffs and even thicker silk skirts might continue in vogue, even into the next generation, because Rubens and Van Dyck and their colleagues were at work rendering them glorious to see, wonderfully becoming, and apparently effortless to wear.

In the days of ducal courts, empires, and absolute monarchies, the aim of such images was the suggestion of a certain false permanence. The desired effect was of continuity with all past and future greatness, so that fashionable figures in art tended toward substance and stasis, and painterly realism had a sumptuous quality, laden with all the riches of tradition just as the actual clothes were laden with padding, starch, and metallic embroideries. Later styles of painting followed later ideals of elegant living, with their different ways of seeing the beauty of fashion; and fashion changed to suit.

Rococo notions demanded a sense of wit and delicacy in dress, even though the shape and construction of clothes did not change very much; so painters freshened up the palette of elegance and made all clothing seem light as air. Fashion required frothy accessories and mobile postures, all ideally offered in the compelling imagery of Boucher and Watteau, where billowing flesh and fabric seem made of the same lovely stuff, a cloud of erotic allusion spiced with faint irony. The burden of greatness was lifted from chic; people could relax and lean back, or sit on the grass and flirt.

In the 1770s, the inauguration of fashion plates caused a significant new accord between art and clothes. Elegant paintings were no longer the only vehicles for the image of dressed perfection. For the first time, printed pictures of ideal figures sporting modish clothes with supreme flair were published in magazines wholly devoted to the mode. The fashionable world, moreover, had outgrown the confines of court life; it was living in cities, and mixing with interesting strangers. The new fashion art suggested the impersonal flow of urban visual life, and helped replace the fixed stars created by courtly painters of the past. Fashionable dress now had to capture the idle, scanning gaze of the general public, to seek appreciation even on the public street. Anyone could play; and fashion plates—outrageous, wondrous, captivating—showed the way to do it.

Fashion plates sustained a high level of taste and an affinity with the best art of the eighteenth century; but they declined a great deal during the next one. Nineteenth-century fashion plates developed a separate illustrative style that showed no impulse to keep pace with the evolution of serious art. As a result, fashionable dress itself began to seem more and more like vain folly, steadily losing moral and aesthetic prestige as its components became more elaborate and its image less serious. Fashion was also more exclusively associated with women.

As fashion-plate imagery became more frivolous, suggesting insipidity and moral nullity as it purveyed the effects of puckered taffeta and draped satin, the very details of fashion seemed more spiritually burdensome, more at odds with earnest pursuits and dispositions. Manifold flounces and braid, feathers and veiling, trains and crinolines all took on the ambiguous and limiting flavor of feminine narcissism; and an elegantly clad woman became an unaccountable apparition, delicious to see but obscurely threatening, disconnected from the reasonable arrangements of life.

During all this time, as the nineteenth century progressed, photography was developing in huge creative bursts; but it nevertheless remained retrograde in dealing with the image of female elegance. Until the very end of the century, fashion had no interesting new food for the ravenous camera eye, and dress showed no desire to be created anew by the shaping spirit of the lens. Its own debased illustrative medium held the image of fashion firmly in its genteel paw and stifled the possibility of an imaginative camera life for fashion. Portrait photographs of fashionable personages tended to imitate the effects of old masters instead of exploring explicitly photographic ways to enhance fine clothes.

But painters did better. The glittering visions of the Impressionists added new possibilities to the aura of elegance, new magic to the surfaces of silk dresses and powdered faces, which fashion illustration could never suggest; and they offered a new integration of fashion with the general texture of life, so that the beauty of rich clothes and the beauty of the natural world need not seem at war. This was a prophetic move, one the camera undertook much later.

Modern design and modern art wholly changed the look of fashion for a few short years after the turn of the century. Fashion illustration took a leap forward, inventing an avant-garde style for the image of the clothed figure that linked it to all other objects designed in the new spirit of reduction and abstraction. The increasing prestige of modern architecture and industrial design raised the concept of design itself much higher on the aesthetic scale. Fashion design could once more come into line with fundamental creative endeavor, for the first time in centuries.

Fashionable dress was quickly reduced in scope and increased in clarity; women's clothing borrowed the essentially abstract shapes of men's tailoring and began to match the spatial character of male clothing instead of spreading out in waves of fantasy. The graphic art in which fashion was purveyed again bore a relation to the newest developments in modern painting and print making: the body in its dress became a clear-edged, streamlined object made of cubes and cylinders or of flat geometric patterns arranged with dazzling finesse. Fashion art also displayed connec-

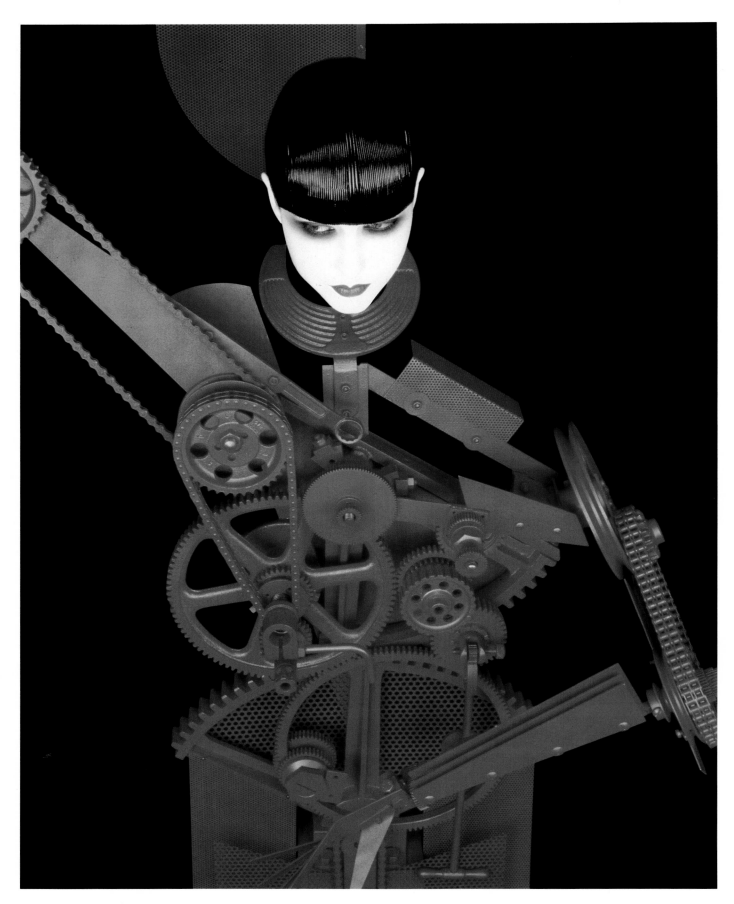

SERGE LUTENS, *Mecanique Rouge,* Paris, 1989

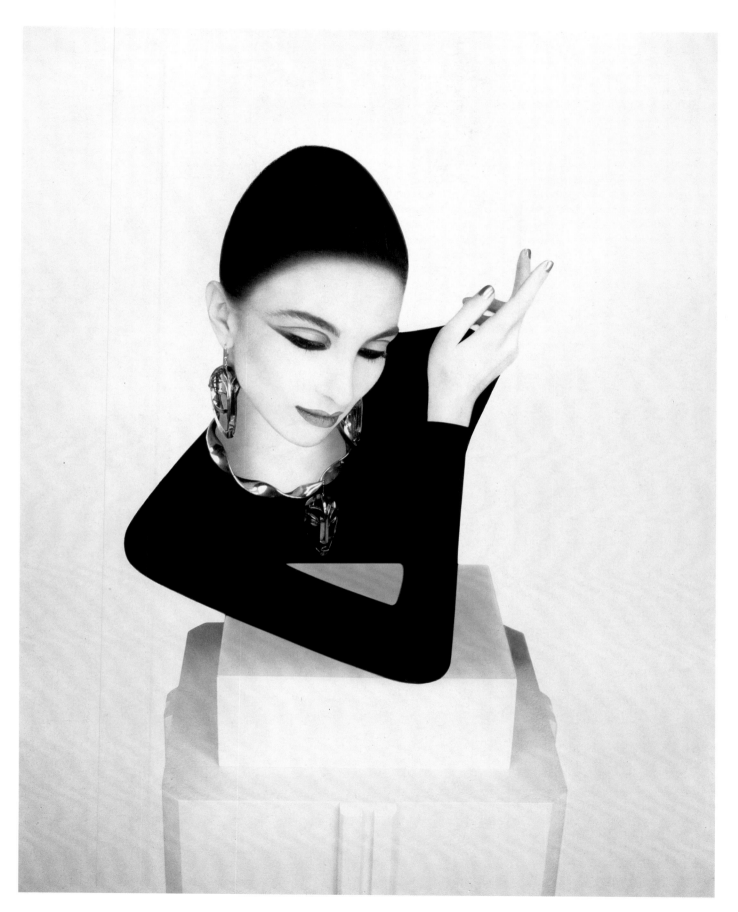

SERGE LUTENS, *Suspens Colors*, Paris, 1986

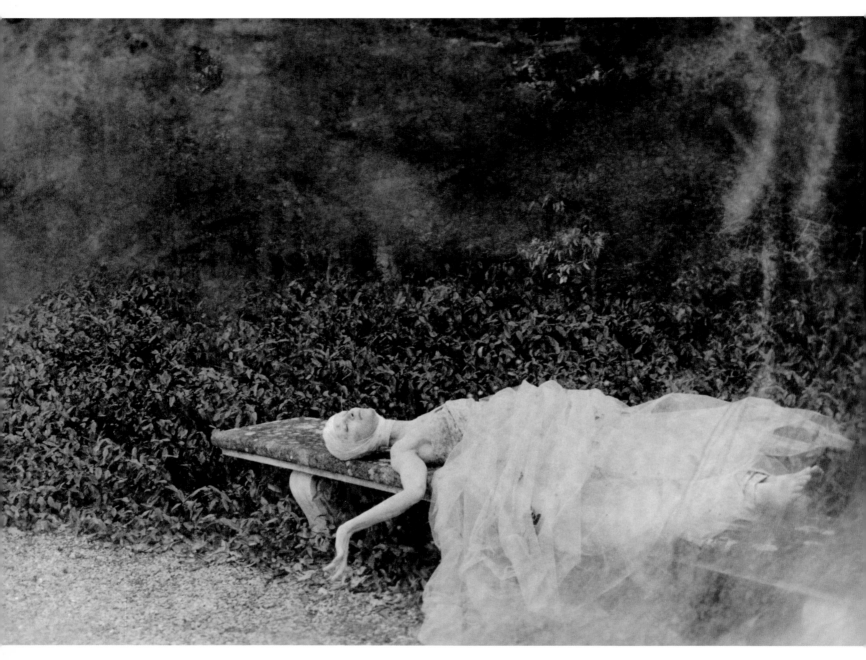

DEBORAH TURBEVILLE, Vaux-Le-Vicomte, Paris, 1985

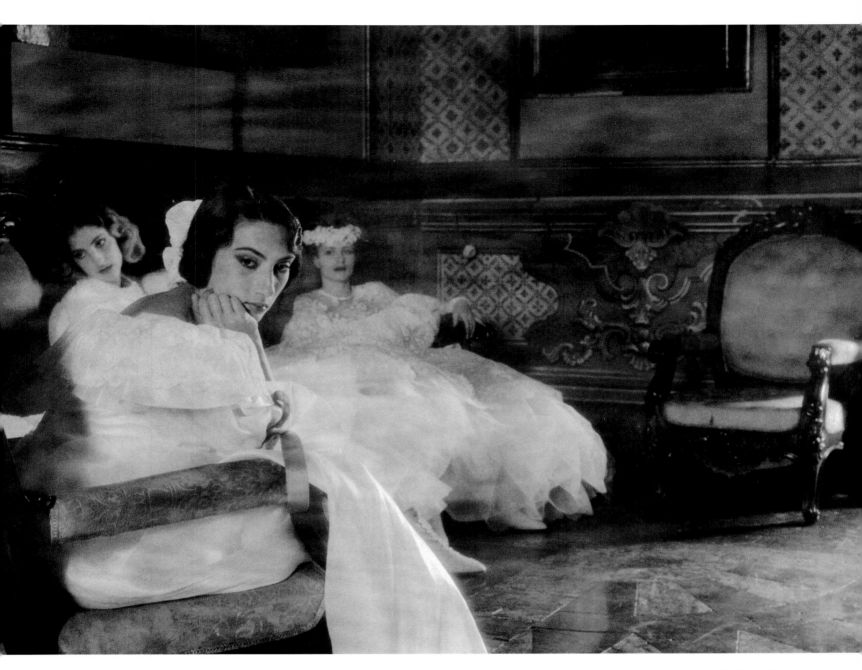

DEBORAH TURBEVILLE, Sicily, 1987

tions with the imaginative constructions of Braque and Léger, which lent further aesthetic luster to the whole idea of fashion.

During the first third of this century the camera had been continuously influencing the perception of the new architecture and design, of all man-made things, and of natural phenomena. The vigorous beauty of the modern world was being increasingly celebrated and virtually created by great photographers, whose vision eagerly included the clothed body along with deserts and bridges, cityscapes and rural desolation. Fashion photography, like the prints of the eighteenth century, began its life at the highest level of camera art, which manifested more aesthetic authority and creative power than any other graphic medium of the advancing twentieth century. And so fashion itself was redeemed, not only from the tacky illustrative graphics of the past but even from the impersonal and static world of modern design.

By the 1930s, in harmony with movies and photojournalism, fashion photography began to render the passing chic moment for its own sake, instead of fixing the mode in a timeless image indebted to the old history of painting and engraving or to the new course of the decorative media. This shift of emphasis in fashion imagery had a decisive effect on ideals of dress and irreversibly changed the look of modern clothing. Instead of being designed objects similar to chairs and cars, clothed figures in fashion art began to look like characters in small, unfinished dramas, caught in fantasy moments of acute tension and resonance that had no future and no past. Fashion itself, the very clothes themselves, gradually came to fulfill an ideal not just of free movement through the action of living but of quick replaceability. Mass-produced moments were to be swiftly lived through clad in a shifting sequence of mass-produced garments, all ensembles soon giving way to complete new ones, just as they did in the evocative pictures that similarly came and went.

In sharp contrast to past centuries, it became a modern assumption that clothes were not to be remodeled or even radically repaired, only replaced. Although fashion changed constantly in the past, garments still represented the sustained continuity of living. They embodied the phrasing of human life, the tough and flexible endurance of human society itself. When the mode shifted, extant clothes could be picked apart and the precious fabric refashioned so that something new grew out of the destruction of the old. Even when society was actually breaking up and institutions were crumbling, dress with its quasi-organic staying power through fashionable change, with its vital link to its own roots in known materials and handmade structure, spoke to its wearers of survival and stability. Fashion built and rebuilt on its own past.

But the modern camera began to suggest the absolute contingency of anything elegant, even something in itself stiff, thick, and still. Since the thirties, fashion photographs have continued to emphasize the dependence of desirable looks on completely ephemeral visual satisfaction, the harmony of the immediate moment only, which exists totally and changes totally. Transition to the next moment occurs by no visible process. Meanwhile the clothes that make people fit into such images are now often made out of inexplicable fabrics and by unseen means, in industrial processes that can also be swiftly adjusted to make whole new sets of garments in great numbers on short notice, each meant to live for a few perfect moments and then be replaced by the next.

Under the influence of the increasingly suggestive fashion camera, garments ideally look not only quickly disposable but dependent for their current beauty and value on swift changes of psychological ambience. With the camera for its chief medium, fashion has come to seem more and more like a sequence of costumes illustrating a narrative of inward events. The photographic message has been clear that modern men and women may keep visually transforming through clothing with no loss of true personal integrity or consistency, preserving their emotional equilibrium by dressing all the parts they play in the continuing drama of their inner life. The postmodern woman has further learned that disparate, incongruous wardrobe items may not only cohabit in one closet, as if on backstage costume racks, but may now be combined to suit the present-day conflict and ambivalence in most private inward theater. In the new world of freewheeling, overlapping, unrooted camera images, old denim and fresh spangles may be worn not just in quick succession but together.

Practical life is not directly addressed by the fashion camera, any more than it was addressed by Bronzino and Boucher. Women are in fact better able to fit everyday actualities into their closets without direct reference to dream images; those, rather, are for the health of the soul and the nourishment of the inner eye. Women actually build up useful collections of garments in a very clinical spirit, negotiating the marketplace with wary prudence; but the flame of pleasure and fantasy nevertheless glows behind their eyes, lending imaginative force to the enterprise, making it a creative act.

It is the potent imagery of fashion art that provides the glow and generates the true art of dress, feeding the imagination and pushing the visual possibilities of clothing into new emotional territory. Designers need it and work under its influence, relying on the camera to realize what they propose, to ratify its virtues and expound its value, just as the tailors of the Renaissance needed Titian. Today's fashion is almost entirely perceived and judged through photographs disseminated in the media. Most of the vast audience for fashion sees the work of designers only through the camera's eye, and responds not directly to fabric and cut but to fabric and cut explained, translated, and ultimately transfigured by varieties of photographic magic. Actual clothes can only follow in the camera's wake, doing their mundane work of enabling the flow of physical life and sustaining the social world. The deep aesthetic pleasure they can give, the sparks of visual delight they can strike, are always largely in debt to the ideal fictions the lens has created, the vivid images that give fashion its true life. □

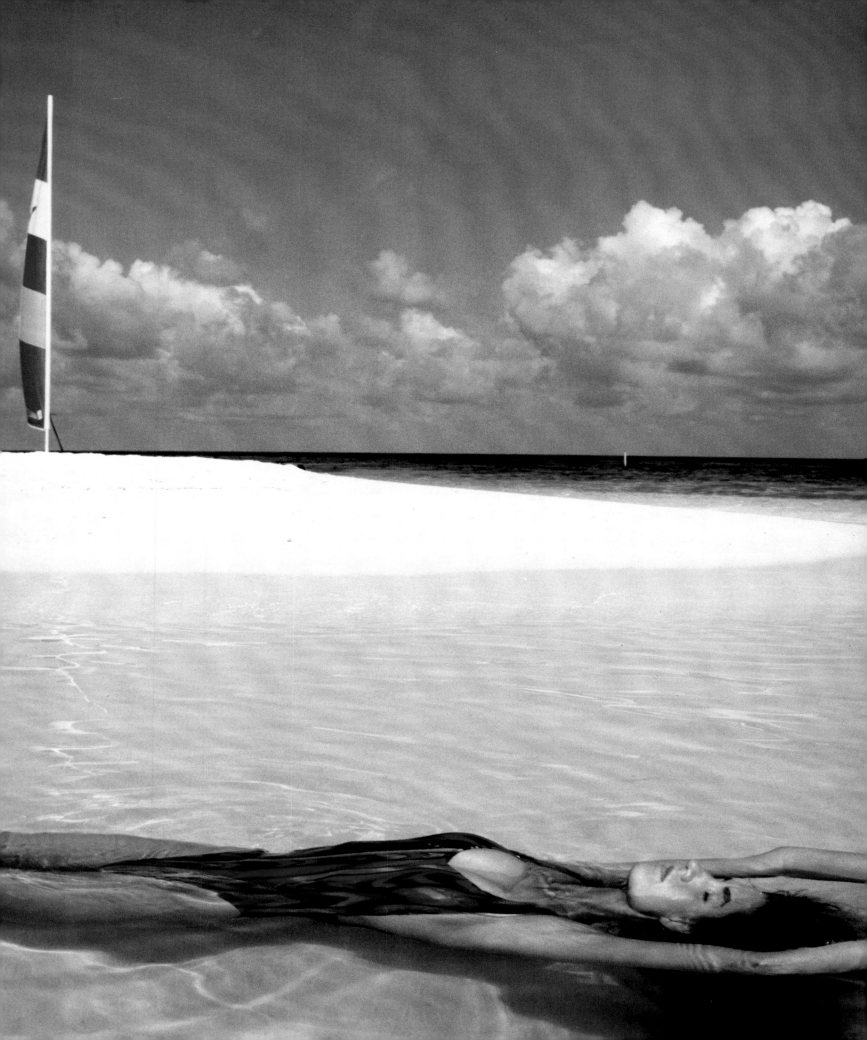

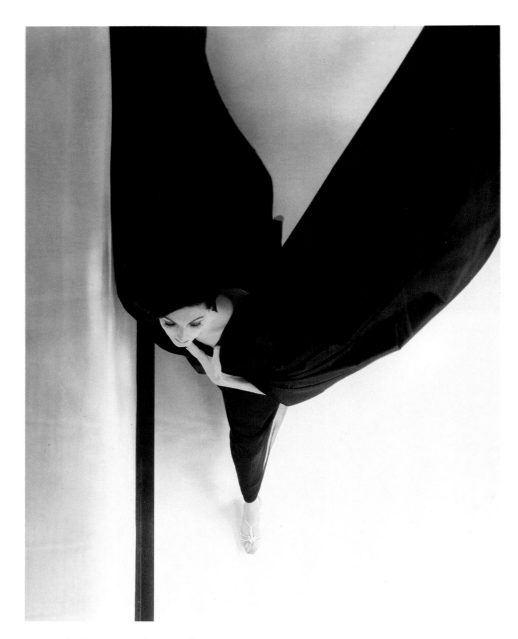

HIRO, *Black evening, dress in flight,* New York, 1963

HIRO, *Akiko in Rudi Gernreich sheath,* India, 196

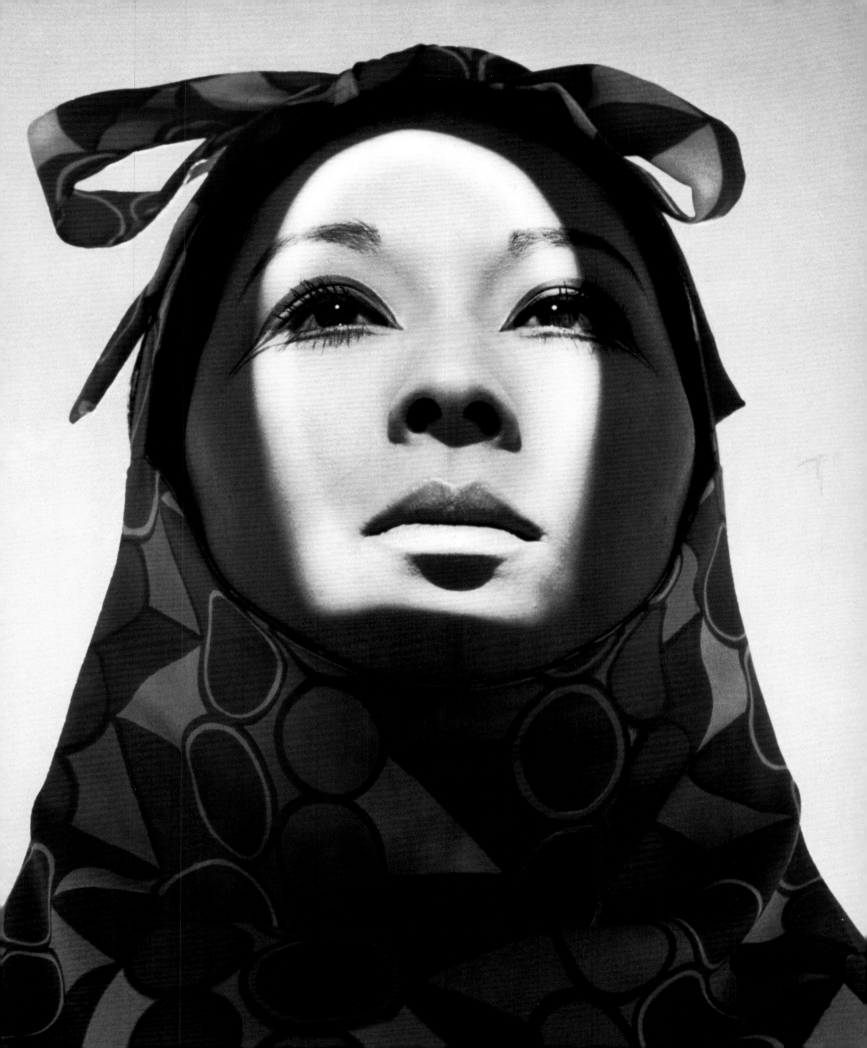

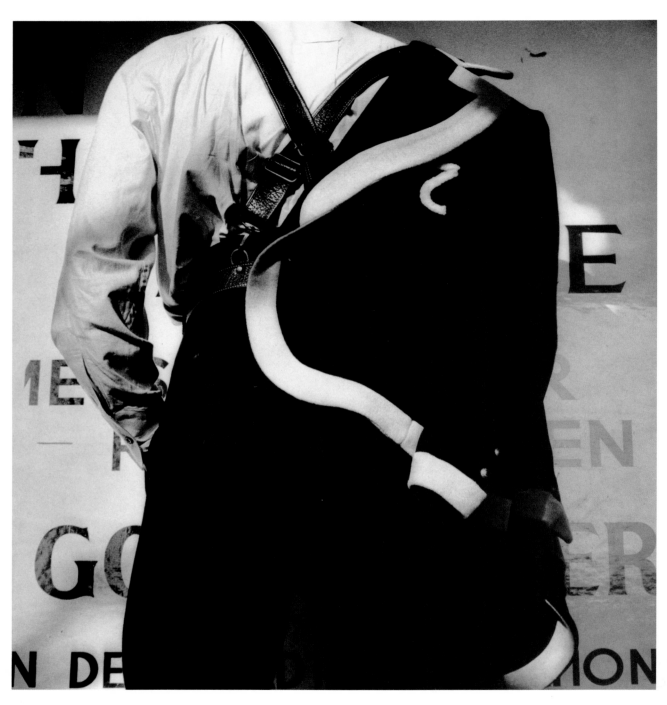

CHERYL KORALIK, Vienna, 1986; **opposite:** Vienna, 1986

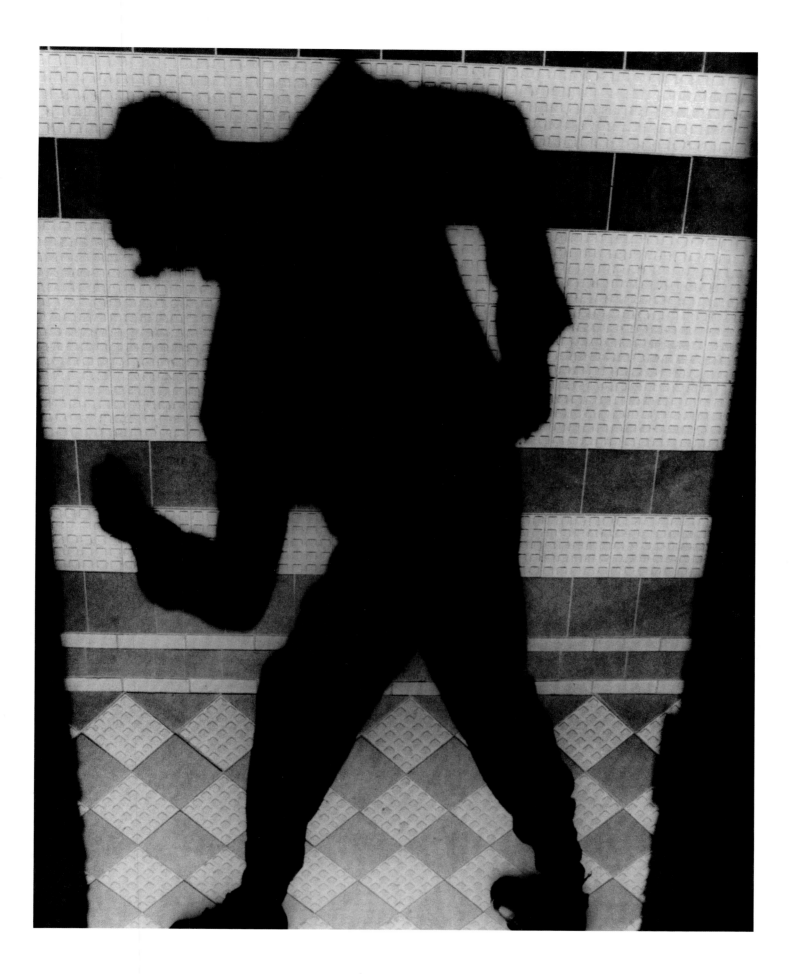

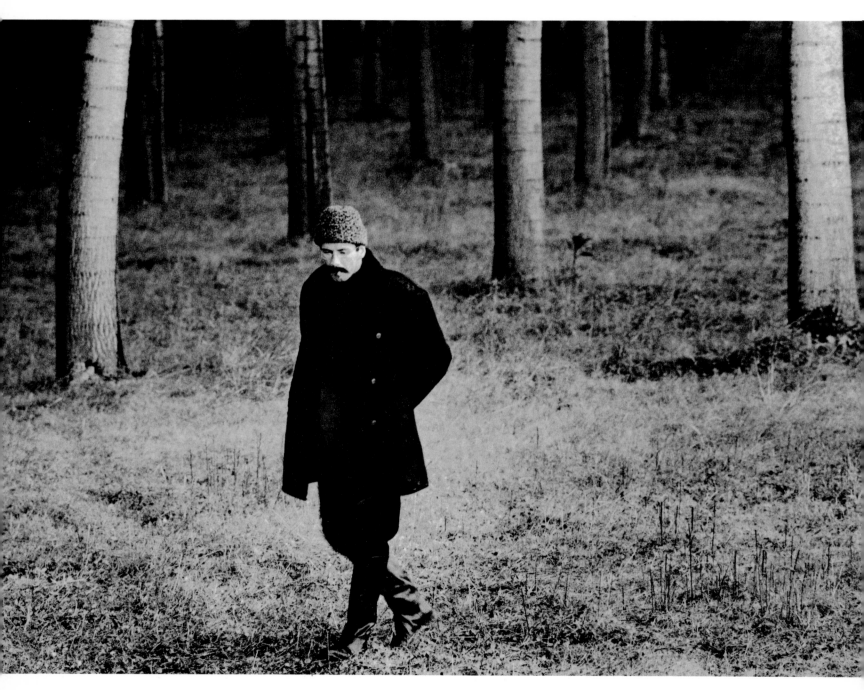

PETER ZANDER, *The Russians*, Milan, 198

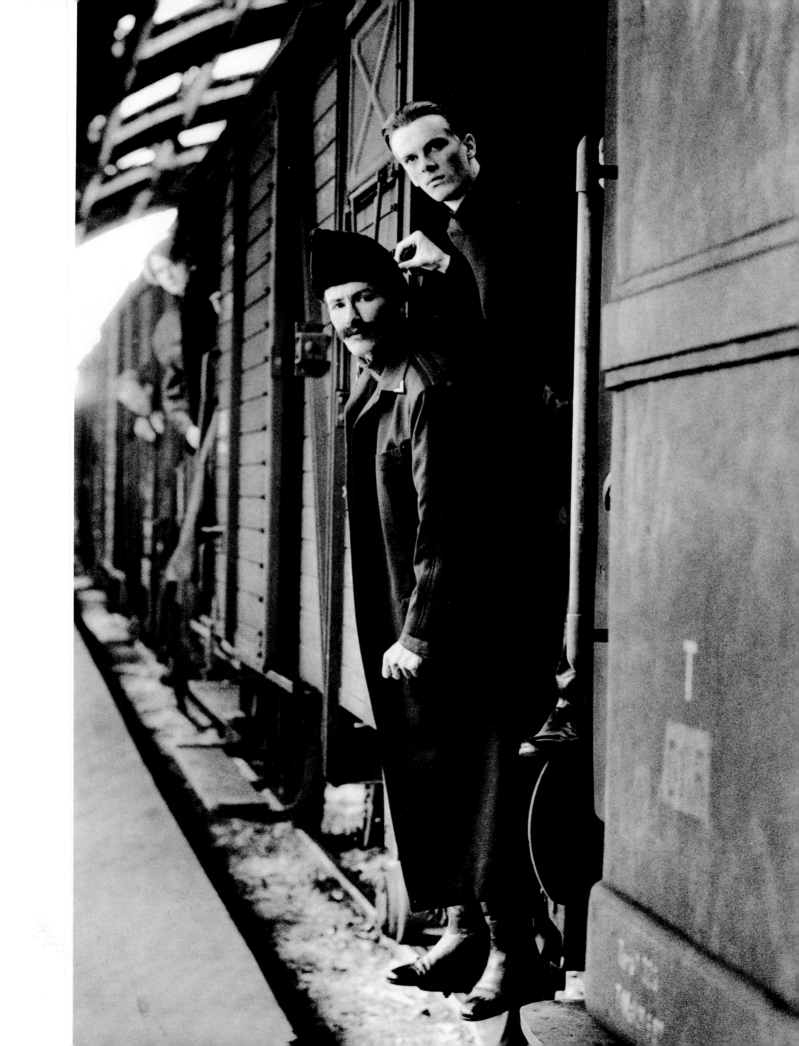

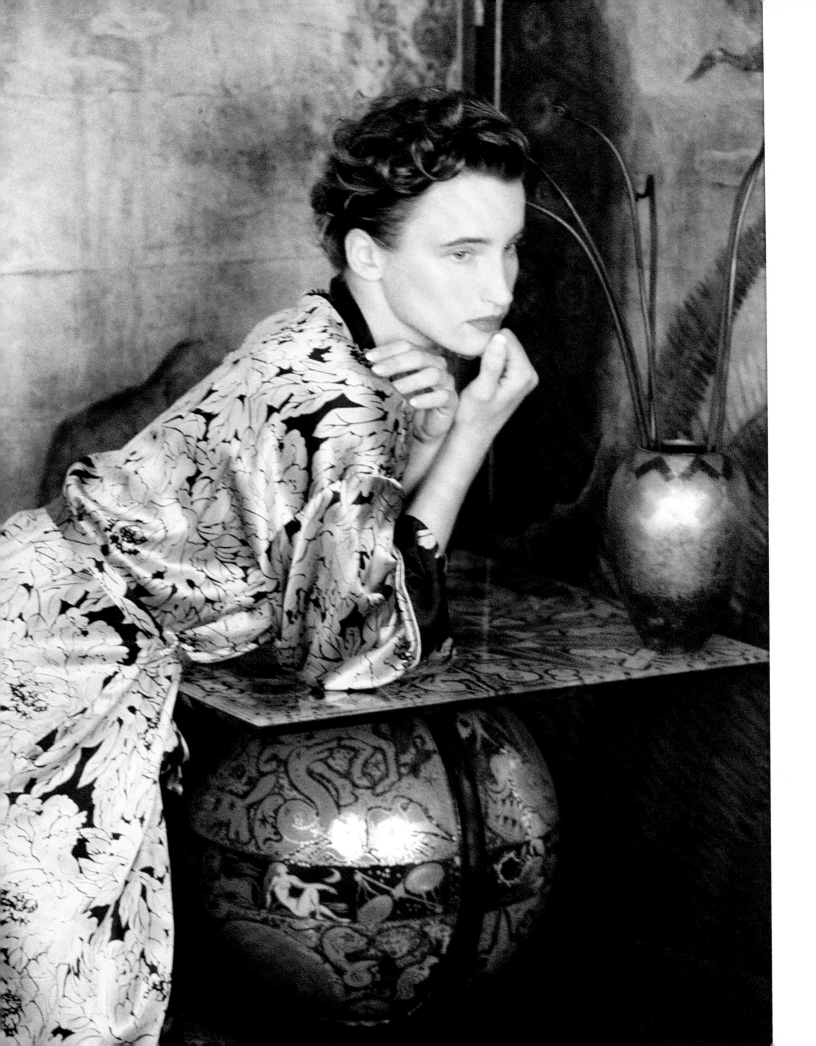

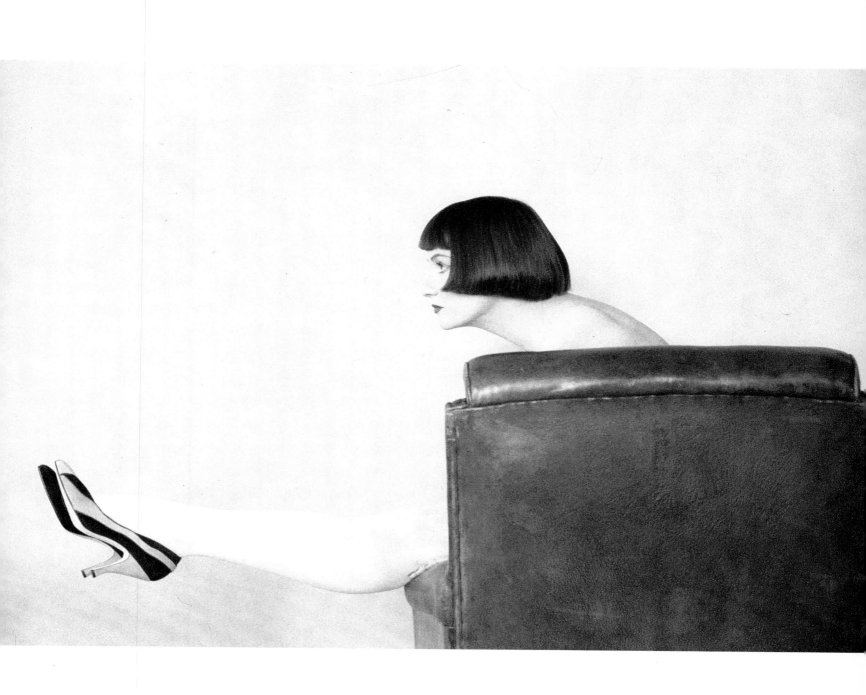

AN PAGLIUSO, New York, 1986; above: New York, 1986

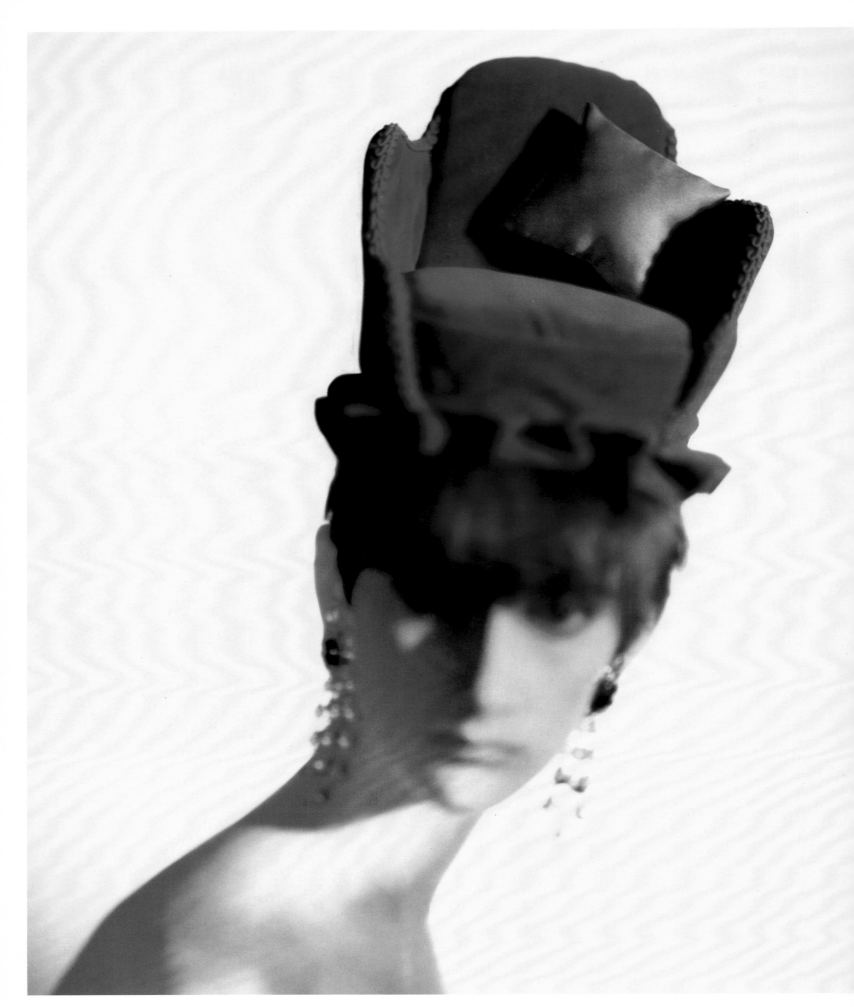

PAOLO ROVERSI, London, 1985

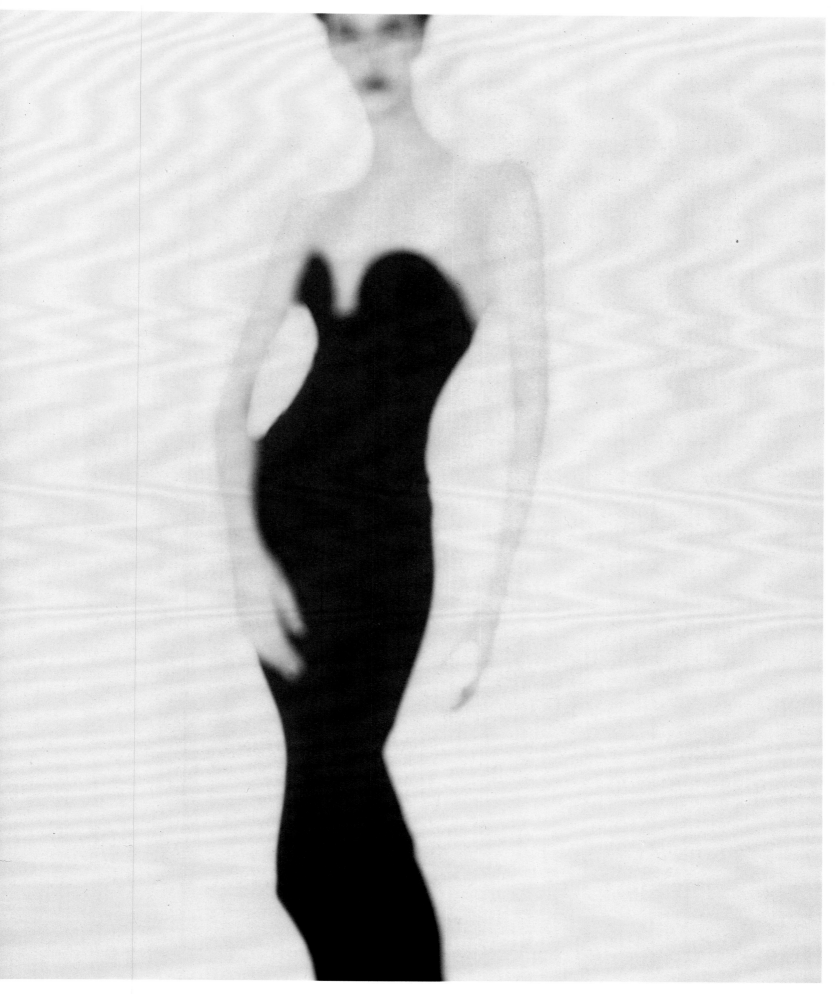

PAOLO ROVERSI, Paris, 1987

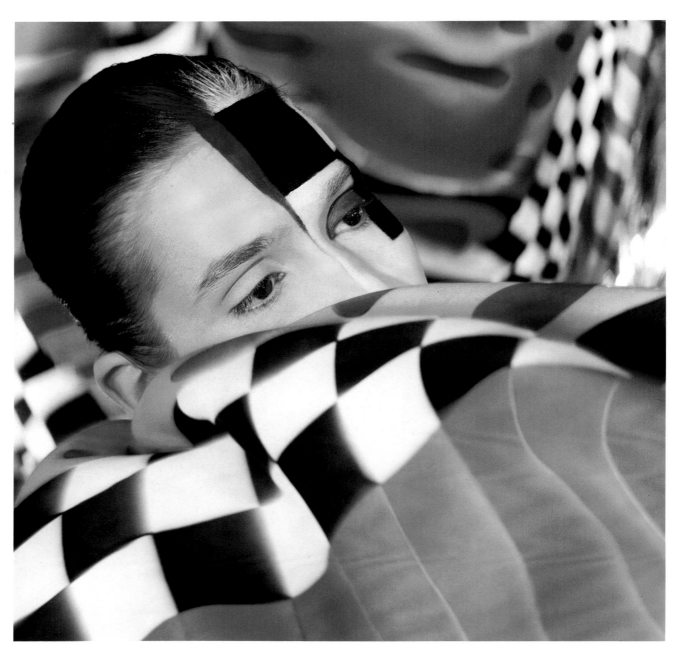

GEORGE HOLZ, *Face with Checkers*, New York, 1987

GEORGE HOLZ, *Face with Shadows*, Milan, 19

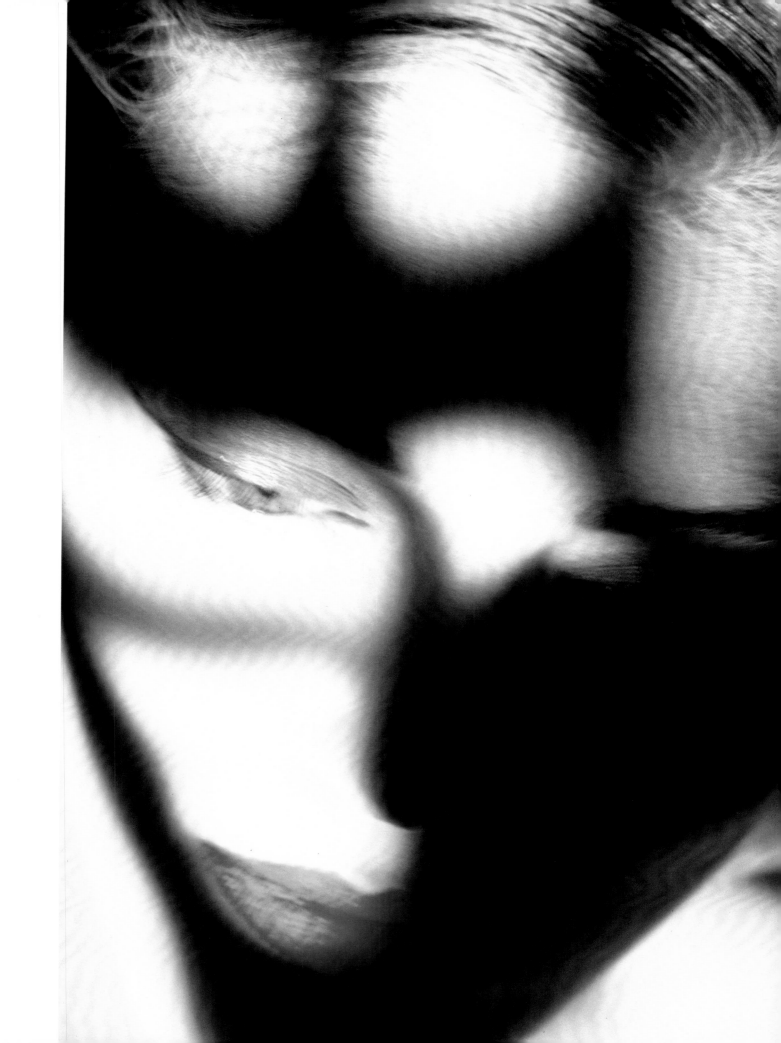

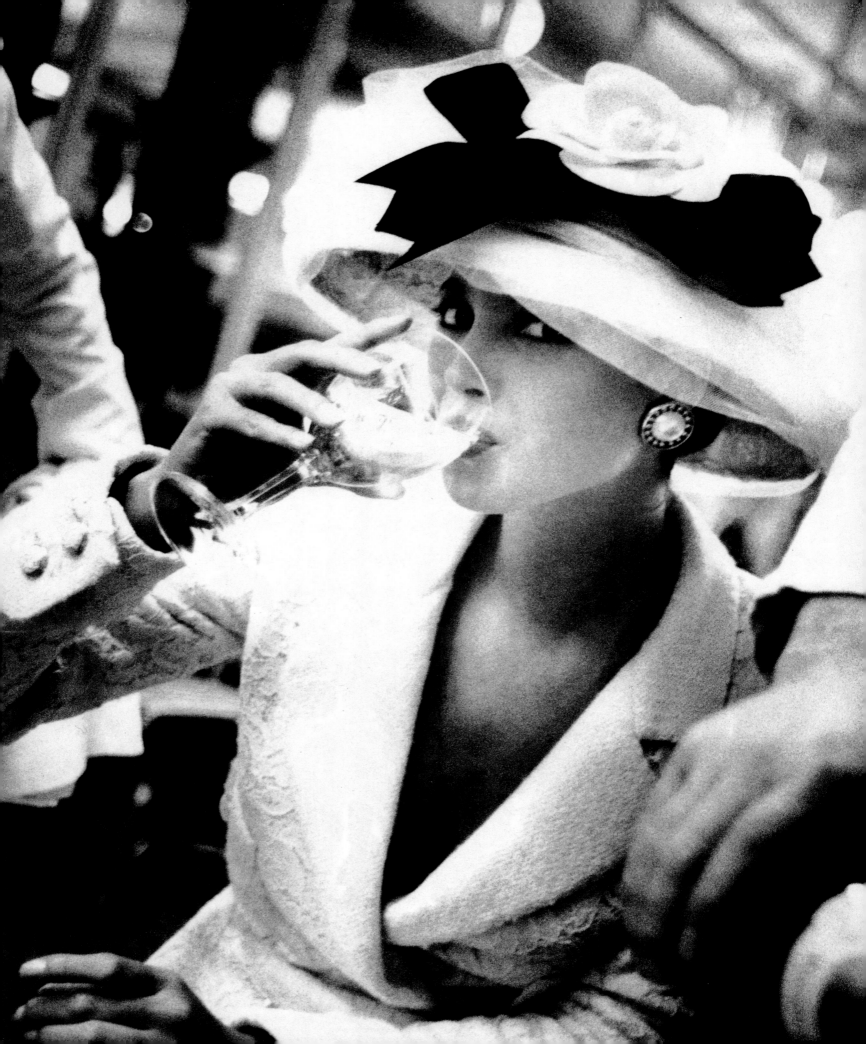

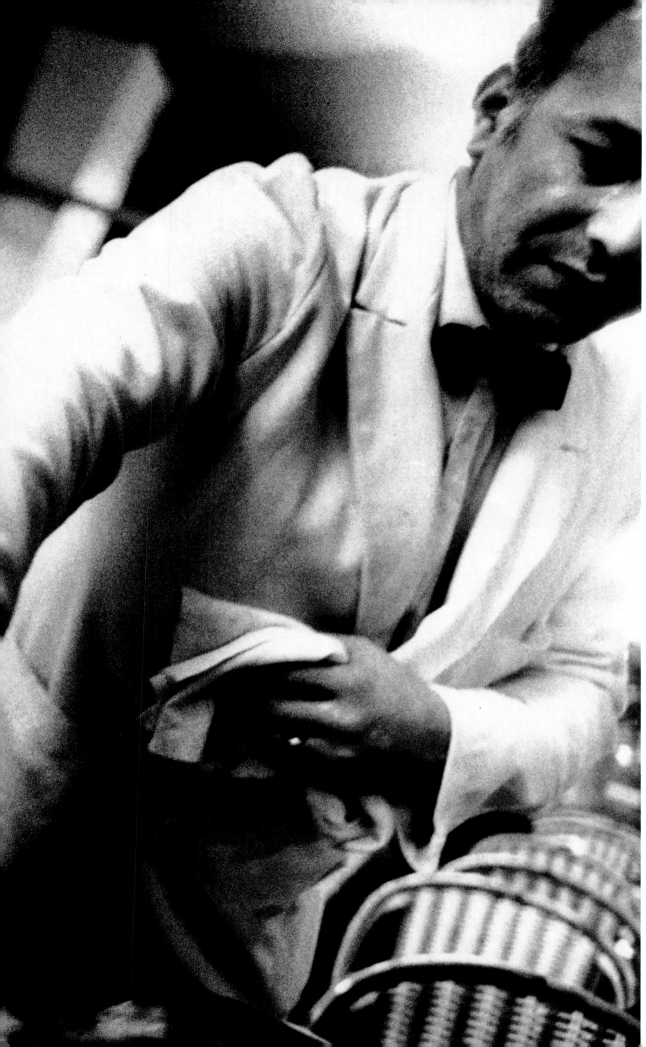

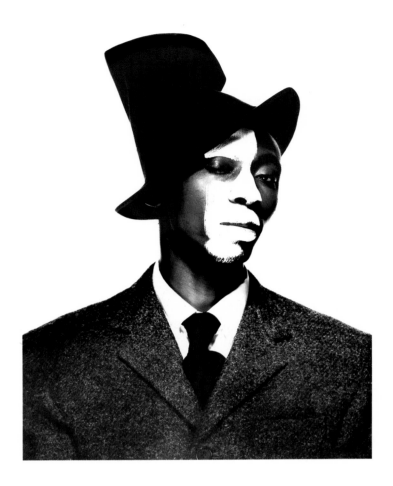

PINK THOUGHTS

by Glenn O'Brien

Fashion photography is pornography for connoisseurs. When the other boys were outside playing baseball, I was out there playing baseball. When the other boys were outside playing football, I was out there playing football. But when the other boys were inside panting over *Playboy*, I was inside panting over *Vogue*. I guess quantitative secondary sexual characteristics were not my bag. It was beauty that made me hot.

Not just the graven image of beauty. I was interested in the real thing and pursued it. But still the image was always there, promising more than what was evident in daily life—not the impossible, but the heroically imaginable. The most beautiful women in the world. Not au naturel but au artificiel. They might be naked, or nearly so, but they were made up, styled, and accessorized to the hilt. This beauty wasn't a simple matter of natural biological attraction. This beauty wasn't a matter of nature. It was art improving on the best nature had to offer. It was art in the service of evolution (or vice versa).

Pornography is often defined as that which appeals to prurient interests, but prurient interests are entirely natural, and most prurience could be seen as being in the service of the survival of the fittest. Fashion photography is entirely prurient in intention. It serves to create an itch, in some cases an itch that

NICK KNIGHT, Paris, 1986; overleaf: Paris, 1987

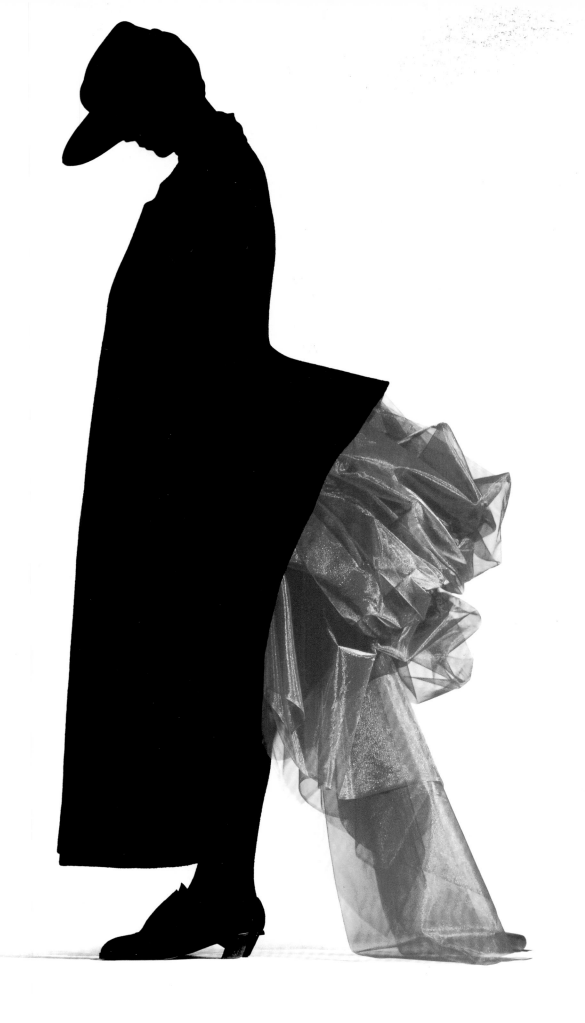

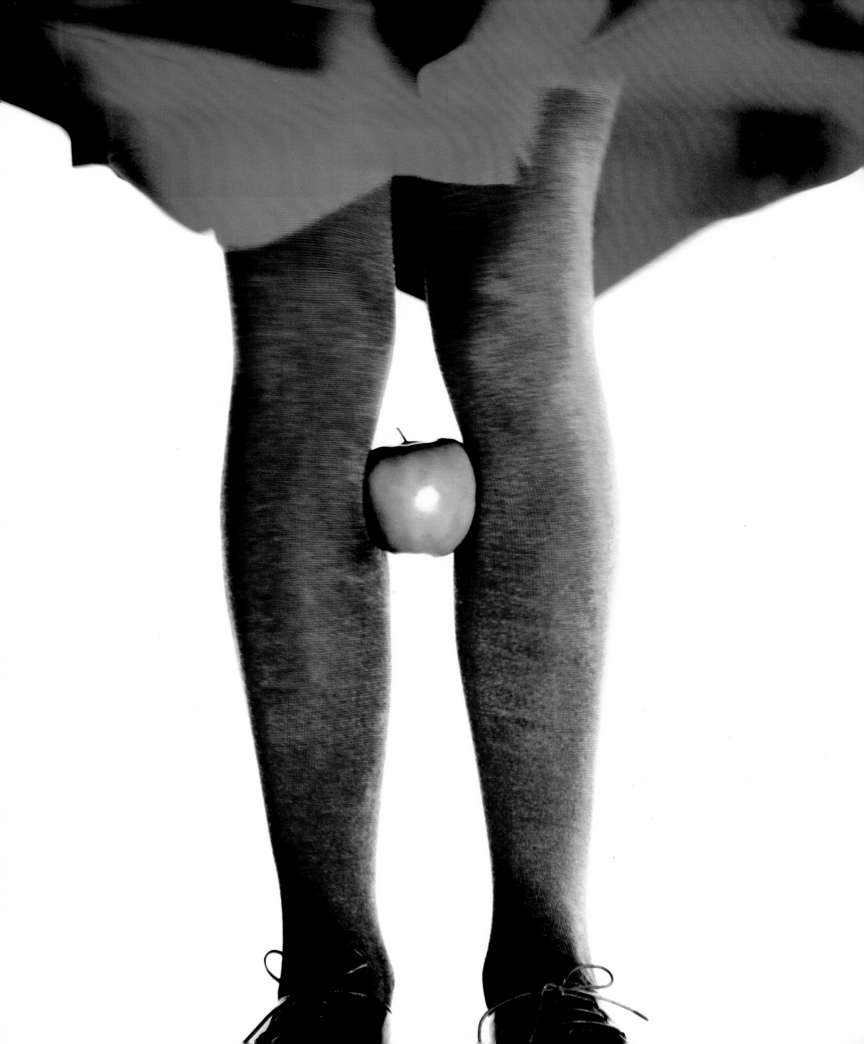

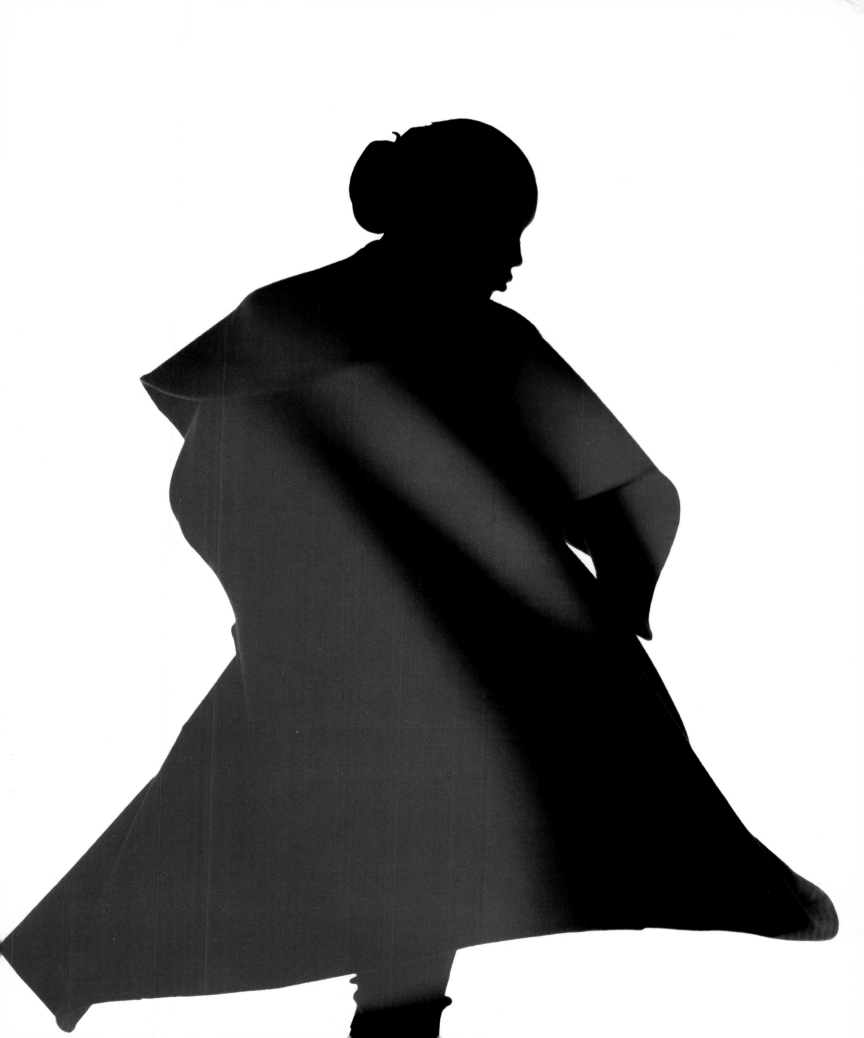

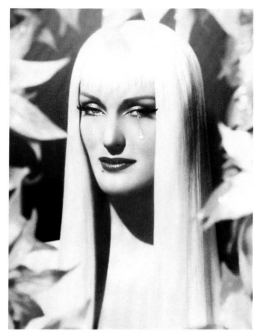

can be scratched only through fashion consumption.

Fashion photography (like cheesecake photography) is a two-edged sword. It creates a target for evolution. A mechanism for the process of divinity. Photographic evidence of the possibility of Olympus. It creates visions that its audiences embody—through clothing, cosmetics, hairstyling, surgery, and post–natural selection. It creates objective standards of desirability by which men's (and women's) sexual behavior is governed. Men don't settle for less, women want more.

But sexually stimulating photography does much more than create an aesthetic program for lust and reproduction theory. It also creates decoys for sperm, each image-generated climax is one less potential fetus for heaven to worry about. Each playmate is a prophylactic muse. Cindy Crawford surpasses Helen of Troy, being a face (and a body) that launched a billion sperm. Models moby the dicks of the mass of men.

Modern musehood is in direct proportion to quantity of image reproduction. Advertisers know that big models sell product. That's why there are so few top models and so many beautiful women waiting tables. It's not that Linda and Christy and Paulina are that much more beautiful than all the other girls. It's not that they possess, say, one-third of the collective female beauty in the world. It's just that they possess one-third of the good gigs. And that's because they have the power that comes from recognition. They have reinforced images that carry the echo of all the images that have been published before. They have real, perceptible auras of success and supersexuality. They also have stories, legends. We know them. I saw two black girls about twelve years old in a magazine shop. One pointed to a cover and said, "That's Cindy Crawford. She's the most beautiful girl in the world."

In the age of reproduction, models are the muses. It is the big model who inspires the mass of women who inspire the mass of men. How many men have slept with Christie Brinkley or Cheryl Tiegs in a way? Not just in fantasy, or in a nocturnal succubus visitation, but in a kind of actual, psychic transference. There is something of the model in her female audience. She gives her look to the masses, so the masses own portions of her soul. Photography might steal the soul, but reproduction amplifies it.

Several of the very top models in New York live in the Police Building. Does that have any resonance? Is beauty a kind of police force? Is there an official

This beauty isn't a matter of nature, it is art improving on the best nature has to offer. It is art in the service of evolution

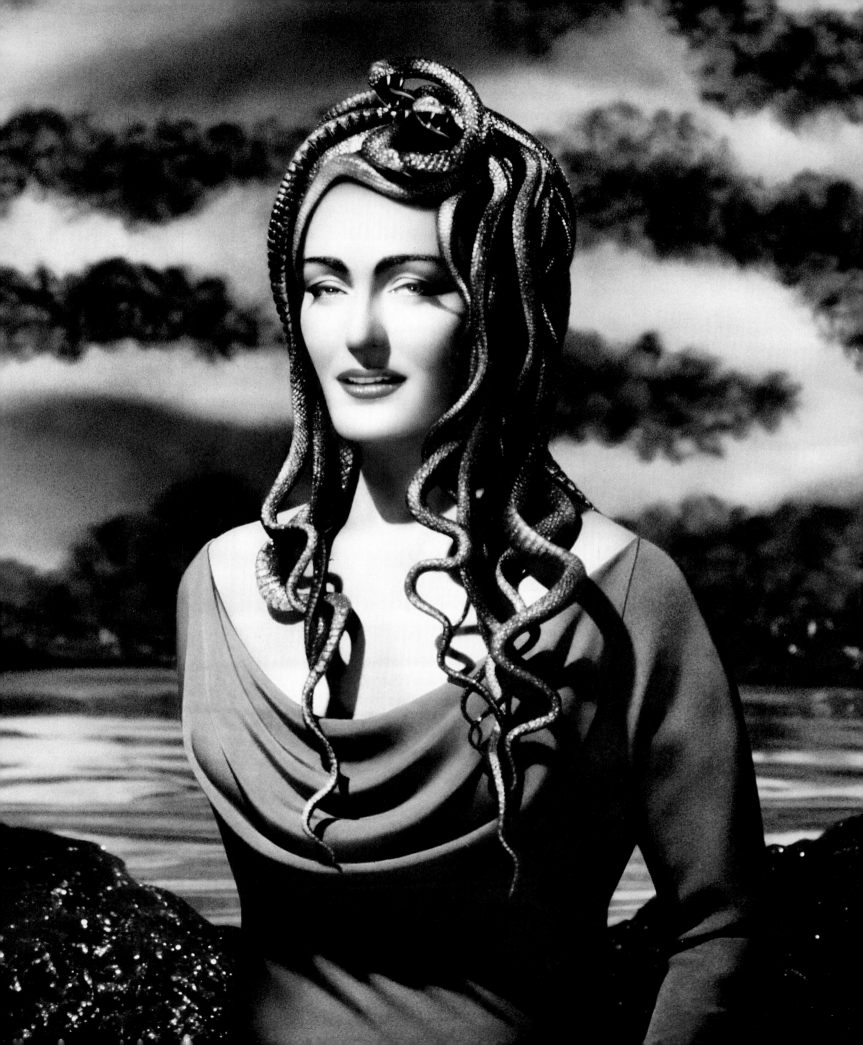

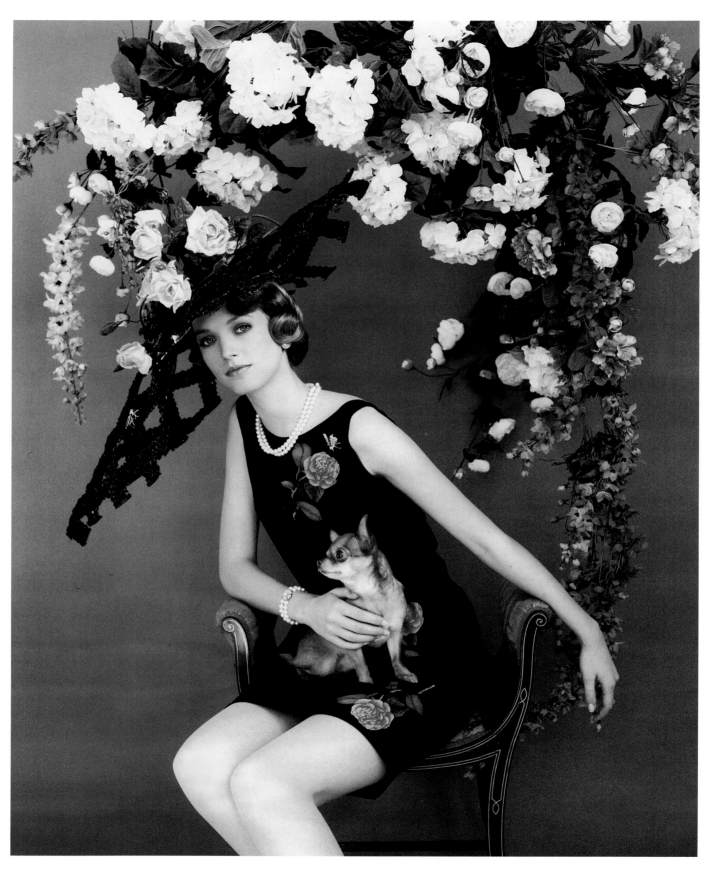

MARIO TESTINO, Madrid, 1990

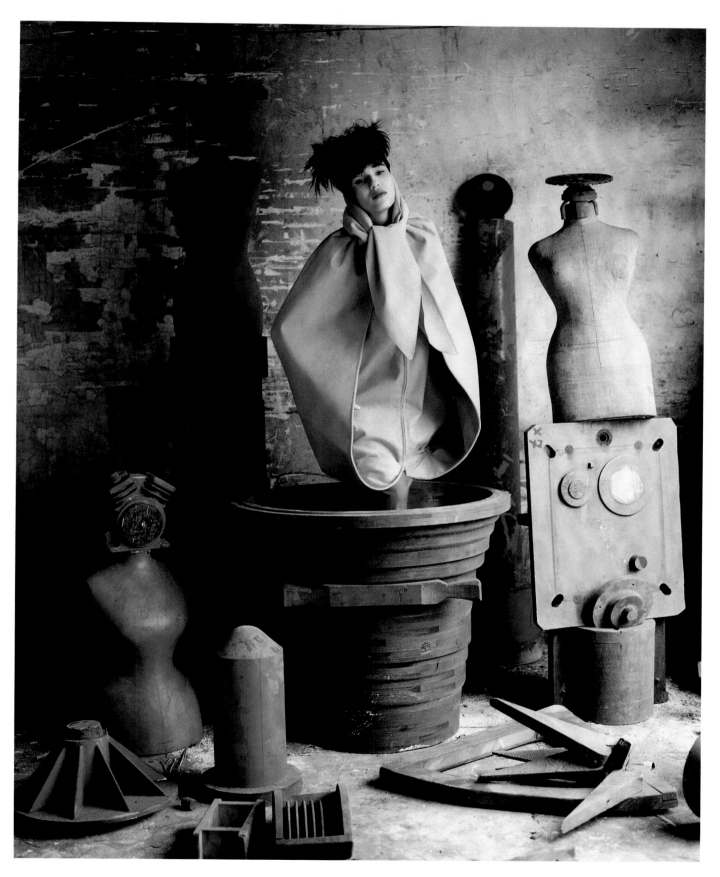

MARIO TESTINO, London, 1990

Fashion photography, with its trite poses, unbelievable situations, and transparent intentions, is an awesome and transcendent power

beauty code? Is there such a thing as designer genes?

Poses are the asanas and mudras of an esoteric yoga. Fashion magazine poses may often seem corny. The way she stands with legs posed just so. Maybe she was taught that way at the Wilfred Academy. Or maybe she learned it from studying fashion magazines. Or maybe by now it's coded in her DNA.

These poses, like the pictures of yoga, draw electromagnetic power from the collective consciousness reserves. They help the body achieve a favorable polarity.

Occasionally a great model will come along who invents a style of posing—say a Twiggy or a Veruschka or a Marilyn Monroe or a Betty Page—and that style will be adopted into the repertoire that constitutes the discipline. And that's the genesis of voguing, the trysexual dance ritual of seeing the world as a runway.

According to theosophists, glamour is one manifestation of maya, or illusion, and what we see is what we don't get. The ritual pose can be seen as an archetypal manifestation of glamour/maya, or it can be seen as a ritualized recognition of illusion that transcends it, a sort of yoga that is more than skin-deep. Think of it as Voga.

The prototype existential hero of the sixties was the fashion photographer played by David Hemmings in Antonioni's *Blow-Up*, whose camera is a penis substitute. And maybe vice versa. In shooting Veruschka he takes her to a climax that is achieved simply by posing. This photographer was a surly sort of seeker, an unconscious magician driven by quest for an answer when he didn't even know the question.

Blow-Up was just a movie. But it reflected and focused on a certain truth, and then amplified and projected that image until it became a reality. Today fashion photographers are not simple thralls of the rag trade. They do "their own work." They have shows in art galleries and museums. They are artists. Well, some are. You know who they are.

But the ability to be an artist without being able to draw or to formulate impenetrable webs of concept isn't the only thing that lures people into the profession. For one thing, fashion photographers are also in a great position to get to know, date, and possibly marry the most notoriously beautiful women of their times.

Heterosexual fashion photographers, like the hairdresser played by Warren Beatty in *Shampoo*, are in the perfect position to score the most desirable babes. Not only do they encounter them in their work, they transform the women in their work. They make them even more beautiful and desirable.

Who is the master and who is the slave in such a relationship?

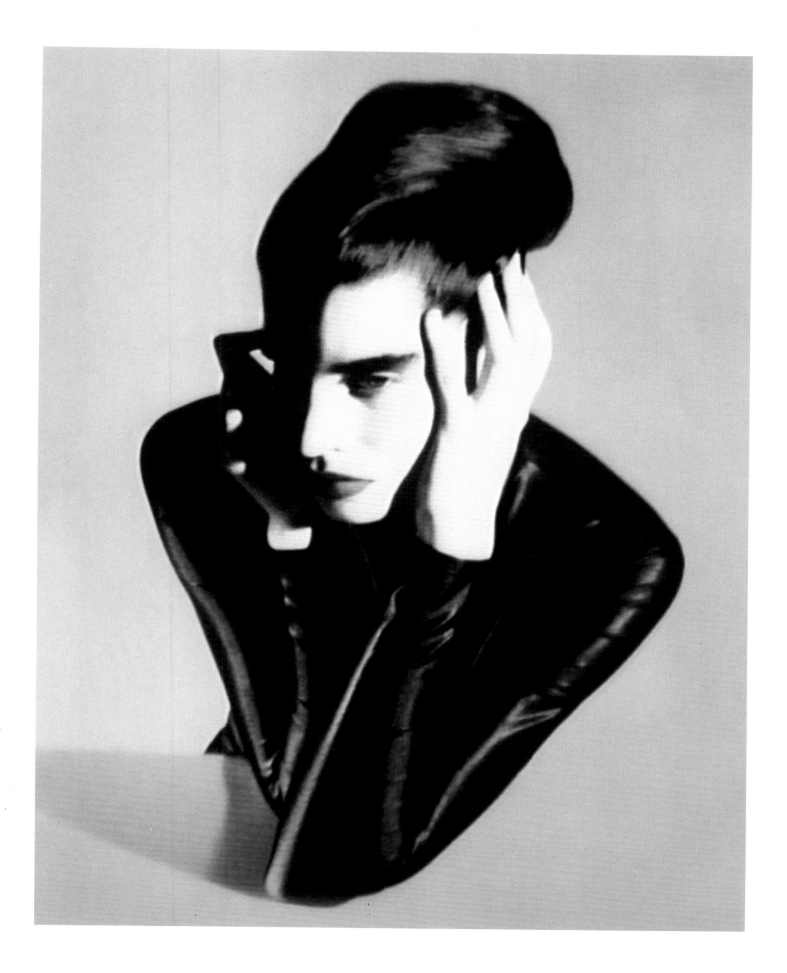

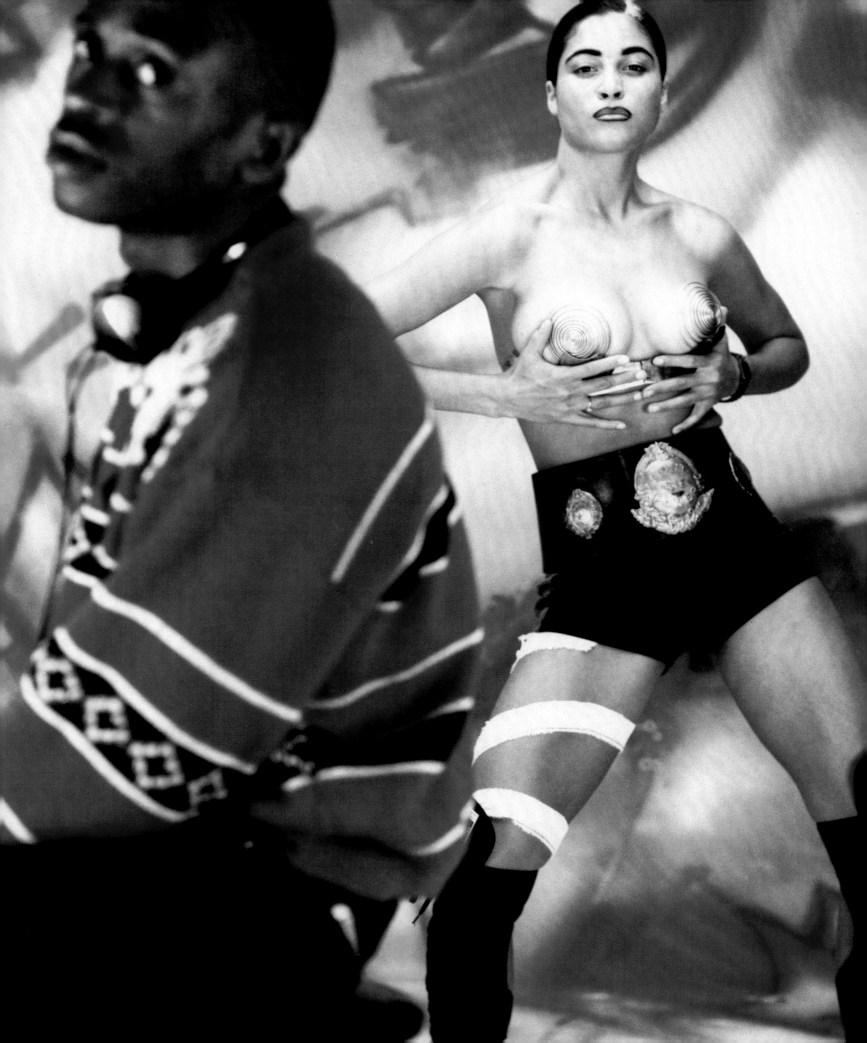

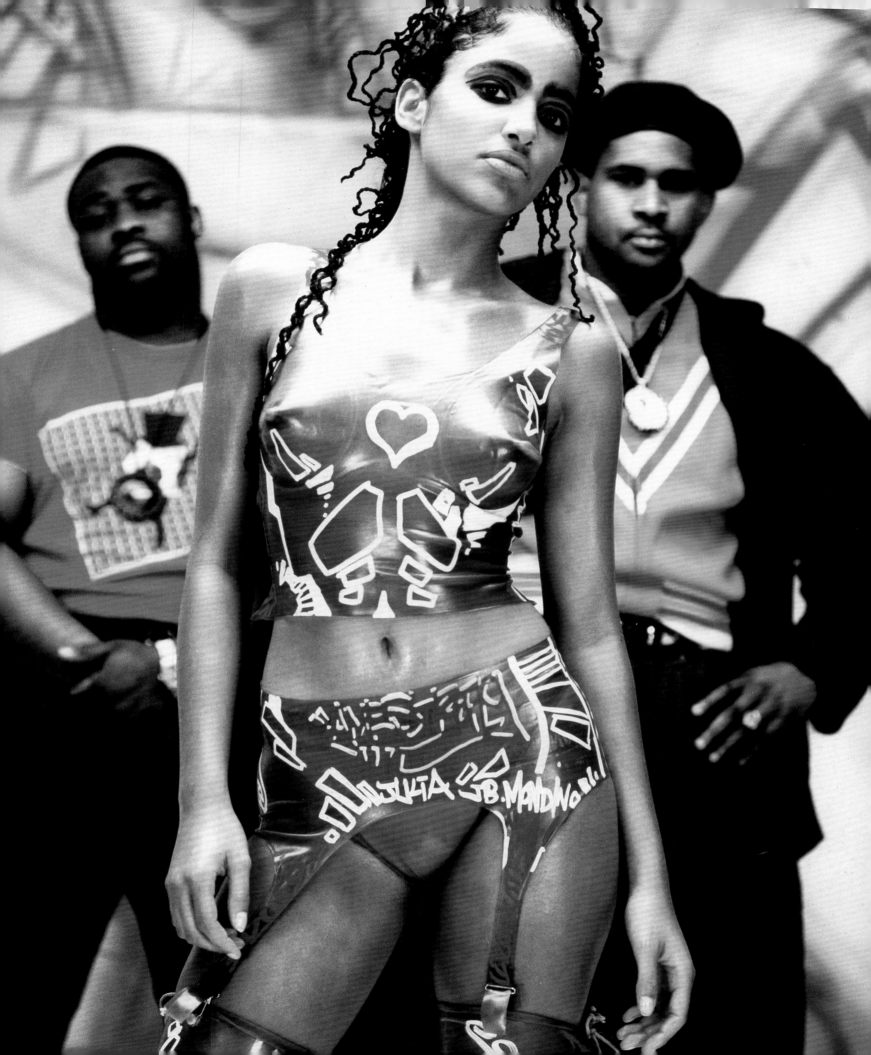

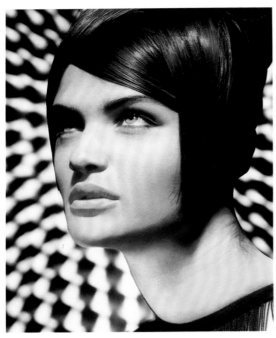

Is he a transforming Svengali, a couture Henry Higgins? Or is she sometimes an insect queen whose mate is entirely disposable? Is he a tool, an image attendant, or at best a photo-Boswell to her physical genius?

There are certainly examples of brilliance in all these categories. Is consorting with the living muses of one's time life as art? And what if a living person is the medium an artist works in? Not just pigment and emulsion but flesh and blood.

According to *Bullfinch's Mythology,* "Pygmalion saw so much to blame in women that he came at last to abhor the sex, and resolved to live unmarried. He was a sculptor and had made with wonderful skill a statue of ivory, so beautiful that no living woman can e anywhere near it." That was before photography.

A considerable number of distinguished fashion photographers are homosexual. And among them, perhaps, are cases in which the term *invert* can be applied with a certain accuracy, where the photographer creates a model who looks as he himself might look, a photographic negative of himself, his anima illustrated. He is a sort of Pygmalion. Not only correcting the faults of woman, but correcting his own, creating a hybrid creature of himself and his subject.

Is fashion photography narcissistic?

It does reflect the popular idea of narcissism, self-absorption, to a certain extent. But this is usually found in fashion photography that looks old, dated, or tacky. Great fashion photography represents classical narcissism.

In the Greek myth, Narcissus was not into himself. Not consciously. He mistook his own reflection for another. He died pining away for the untouchable beauty. But Narcissus was not a model or a photographer. He was a simple country lad. He didn't have a closetful of clothes, wigs, makeup, or the best hairdressers, stylists, and photographers with which to discover that his reflection was himself in fact, no matter how artfully disguised.

Modern classical fashion photography is intensive study of a face, an image, in all its possible alterations. And rather than mistaking herself for another, the great model realizes herself through her costume changes and through the creation of her portrait by many photographers, each with his own vision of her. By altering every incidental attribute constantly, one isolates the essence and makes it more visible. The other, the reflection, is free to lead various lives, while the essence, the original, prospers from the process.

Who can say that these photographs of beautiful women don't mysteriously affect the harvest, the weather, and global politics?

STEPHANE SEDNAOUI, *Helena,* Paris, 1989; opposite: *Devron,* Paris, 1989

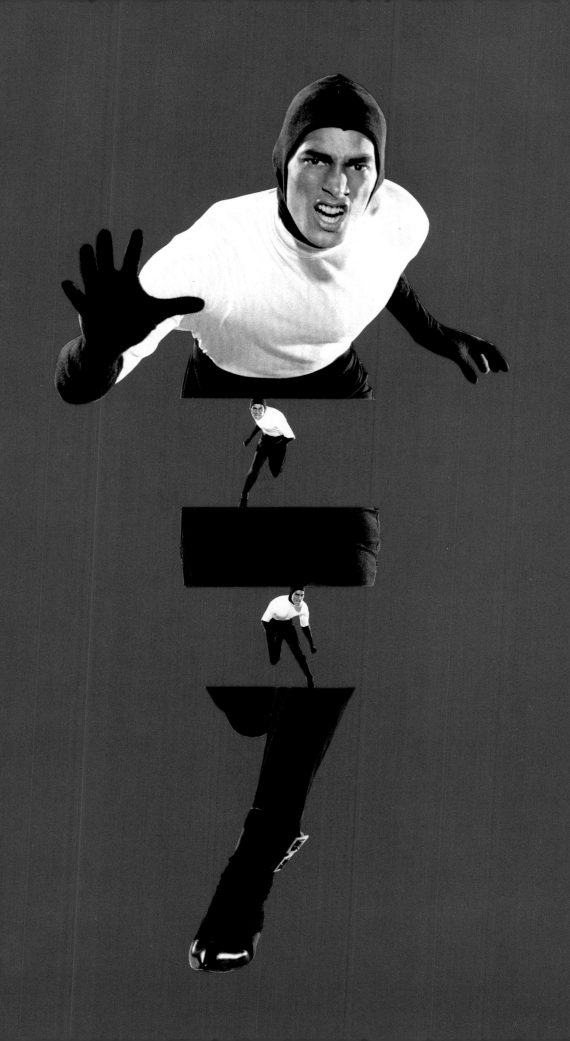

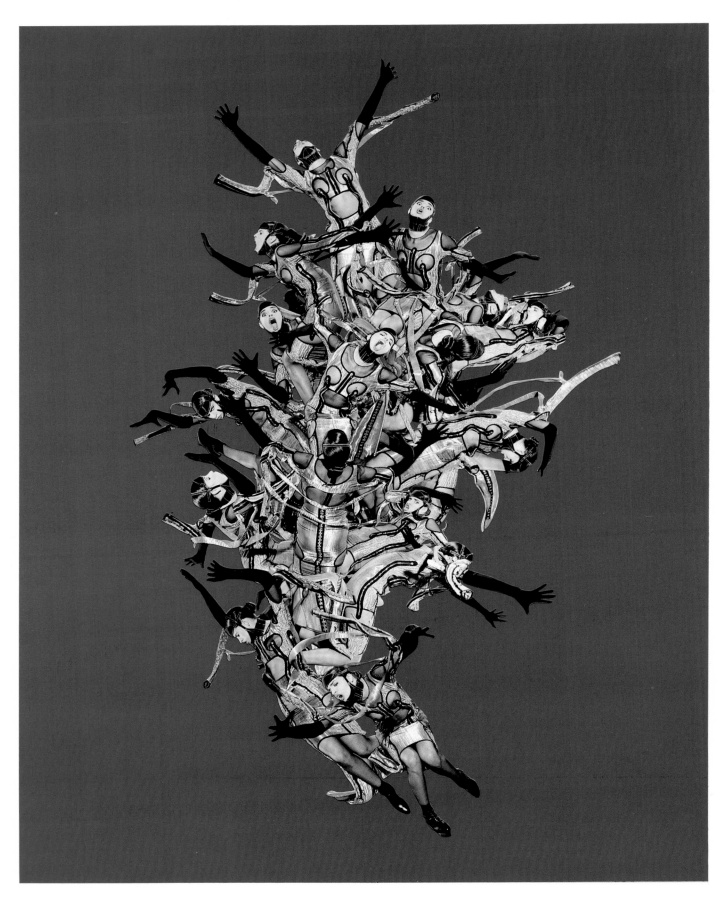

STEPHANE SEDNAOUI, *Claudia,* Paris, 1989

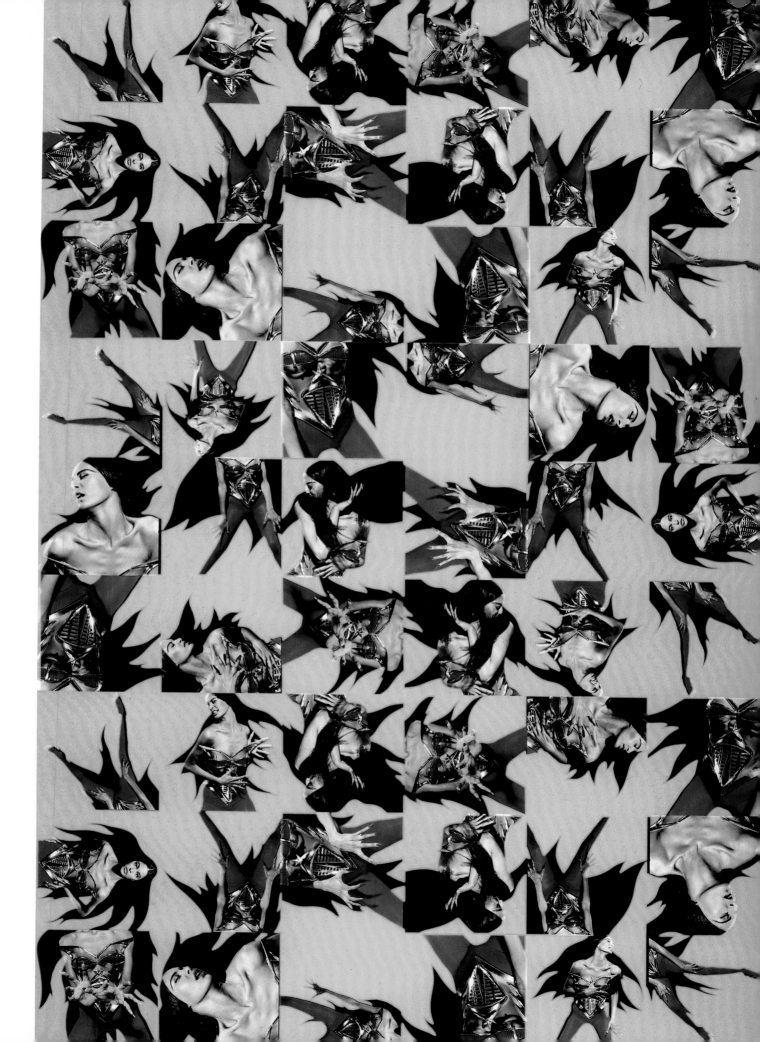

There is a world without men. A world without toil. That's the world in *Vogue*. That's the *Harper's Bazaar* world. It's a world hard as crystal and perfect as ice. No climaxes, just a constant level of ecstasy. Why come if you are there? It is a world of no sweat. A world of self-referentiality.

Women stand daydreaming in groups, wearing brassieres and panties. Is this lesbian imagery—conscious or unconscious? Or is it a world of pure self? Women sit naked on a beach radiating an orgone flush of sexual energy. And they are all alone. And they don't mind. They are Buddha nymphs, self-contained batteries of sexual juice, whose sexual short circuit creates a perfect world—solipsistic, parthenogenic, and immune.

It is interesting that both fashion photography, which is supposed to appeal to women, and T&A pornography, which is supposed to appeal to heterosexual men, are void of men. Both represent an erotically self-sufficient woman. Men are turned off by seeing men in their pornography. And if there are males as props in fashion photography, they are usually drone androgynies.

What is this coldness combined with electricity, this vacancy of action, this desert of desire that is the world depicted in fashion photography? It is a perfect world, a woman's world. There is no violence. There is no disorder. One always senses the world of men existing just outside the frame. This is a woman's world. But it wouldn't mean nothing. Nothing. Without a man or a boy to spy on it.

Fashion photography has about as much to do with art as it does with religion. In fact, it could be mistaken for a religion. It is all about worship. But I think it's just a part of a religion. The religion is beauty, and fashion photography is a pagan trip on the beauty tip.

Fashion photography might often seem stupid and shallow, but who can say that these photographs of beautiful women don't mysteriously affect the harvest, the weather, and global politics?

These photos cannot be studied conventionally. It's an esoteric art widely imitated by life. Peter Bogdanovich saw Cybill Shepherd on the cover of *Bride* magazine, then made her a movie star and married her. It is also an art that nature imitates, creating broad-based trends in the DNA transactions of the race.

Fashion photography, with its trite poses, unbelievable situations, and transparent intentions, is an awesome and transcendent power. It is beyond right and wrong. It is almost a force of nature.

As a fashion guru once said, "Think pink!" □

Fashion photography has about as much to do with art as it does with religion. In fact, it could be mistaken for a religion

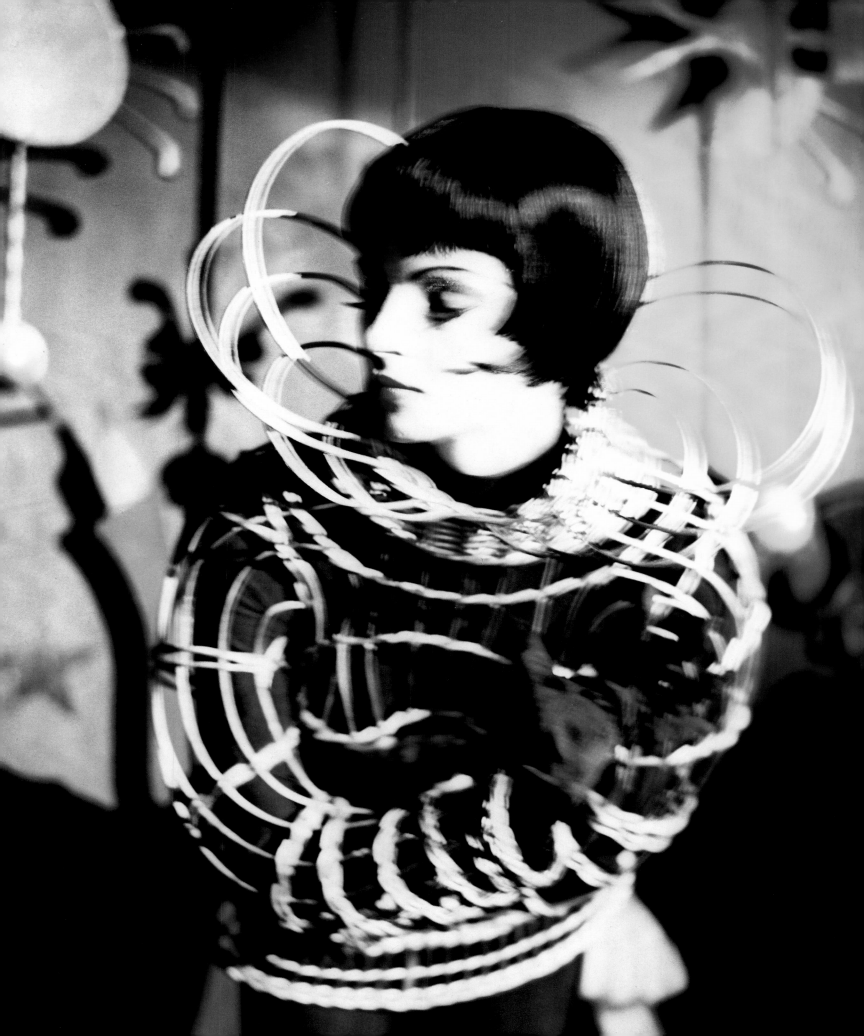

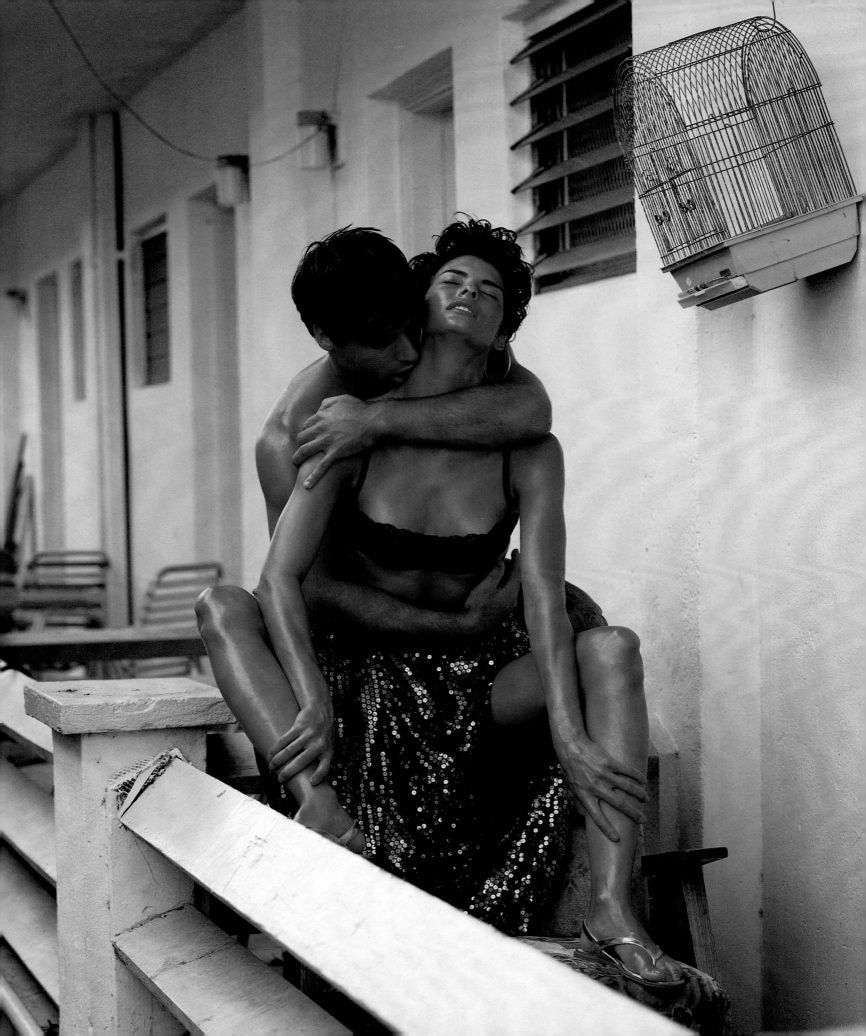

EROTIC ALLURE

by Valerie Steele

Voyeurism and exhibitionism are intrinsic to fashion photography, as they are to fashion itself. The entire relationship between body and clothes is fraught with eroticism — both perverse and playful. But although sex is an abiding theme in fashion photography, certain types of sartorial eroticism arouse more controversy than others.

Nudity entered fashion photography in the 1960s, the decade of the miniskirt and the birth control pill. The conventions of high art sanctified the "tasteful" display of female physical beauty, while the ethics of the day promoted sexual liberation. What made this nudity especially erotic was the implied contrast between the naked body and fashion's fig leaf. Despite complaints from readers of fashion magazines, nudity became so common that it lost most of its shock value—which may have contributed to an escalation of shock tactics in the following decade.

The real controversy began in the 1970s, as fashion photography became much more sexually explicit. The photographs of Helmut Newton and Guy Bourdin, in particular, aroused the ire of both conservatives and feminists because of their ambiguous sexual imagery, sometimes conjoined with more or less graphic portrayals of violence.

In 1975, Hilton Kramer wrote a piece for *The New York Times* in which he argued that much contemporary fashion photography had become a subcategory of pornography. While admitting that sex was a ubiquitous theme in fashion photography, Kramer regretted that its manifestations had become "clamorous and unsavory." In Newton's photographs, especially, "the interest in fashion is indistinguishable from an interest in murder, pornography and terror."

Violence certainly played a part in the new style of fashion photography, but it was actually less characteristic of Newton's work than it was of the more elegant but deeply perverse photography of Guy Bourdin. In Newton's photographs, the language of erotic desire has often focused on sexual aggression. With a few exceptions, however, most notably a fashion sequence for *Oui* that used the theme of murder, his fantasies focused less on physical violence, let alone death, and more on the relationship between sex and power.

It is really Guy Bourdin who has stressed the connection between Eros and Thanatos. As early as the 1960s, Bourdin posed an elegant fashion model in front of bloody carcasses hanging in a butcher shop. Most notorious, however, was his 1975 shoe advertisement for Charles Jourdan, in which the shoes are shown lying on the street in the aftermath of a fatal car crash. Whereas Newton's women are Amazons, the women in Bourdin's photographs are passive and defenseless, their provocative vulnerability seeming to invite assault.

Everyone knows that *sex sells*. If it sells shaving cream ("Take it off, take it *all* off"), sex ought to be even more effective at selling fashion, which is about bodies as much as it is about clothes. Despite a pronounced strain of puritanism in American society, sexuality is a basic feature of commercial advertising, including fashion photography.

But most fashion photographs published in America illustrate only a very narrow spectrum of sexual themes and stereotypes, such as the romantic adventures of the elegant lady and the fun-loving girl. Yet for better or worse, the revised dramatis personae of fashion photography—the sexual personae—include new types, such as the dominatrix, the fetishist, the prostitute, the lesbian, the exhibitionist, the female transvestite, and the nude—male, female, and androgynous. The juxtaposition of such figures often implies an erotic dialogue.

Straightforward promises of heterosexual genital intercourse are replaced by ambiguous invitations to polymorphous perversity. Because sexual disorientation makes for great theater, there is a predisposition in favor of the more theatrical types of sexual behavior, such as the dramas of dominance and submission or the gender confusion implied in cross-dressing.

One of Newton's photographs, for example, shows a woman in a semi-sheer black bathing suit who thrusts her pelvis forward and whips open her satin robe to reveal . . . that she has no penis. Since the act of flashing is associated with male exhibitionists, both her phallic aggression and her "castration" are shocking. Meanwhile, the "victim" of

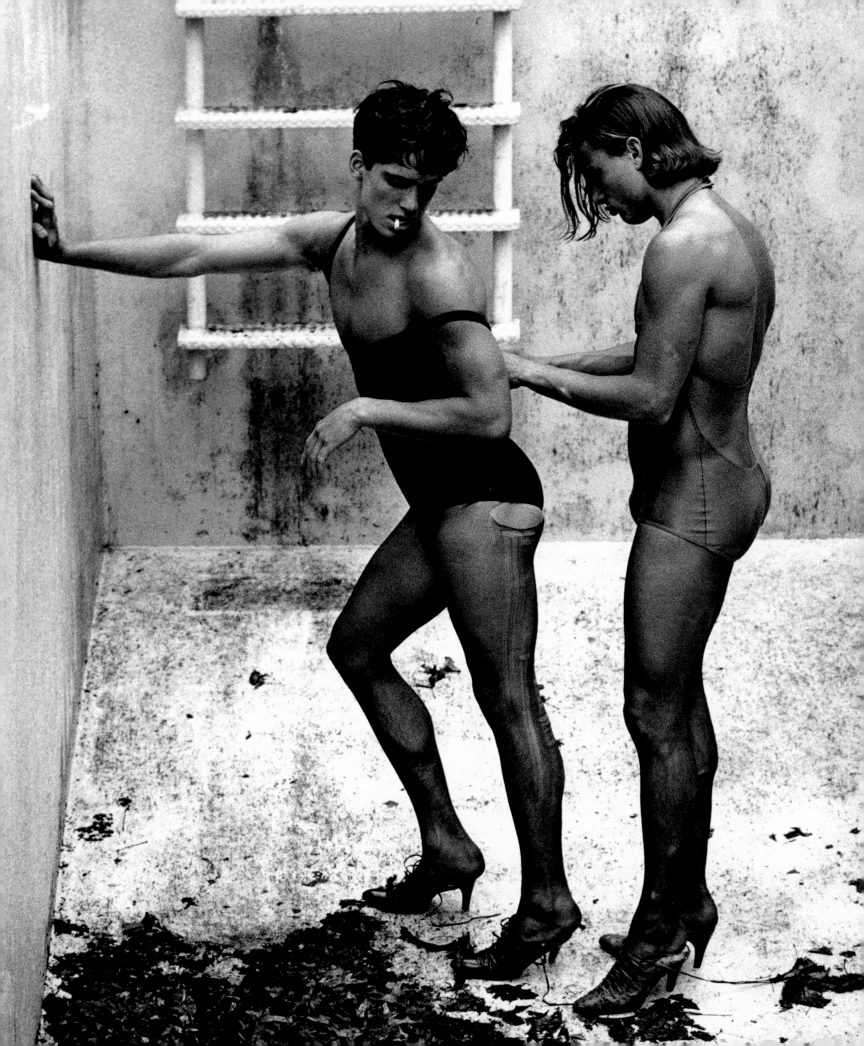

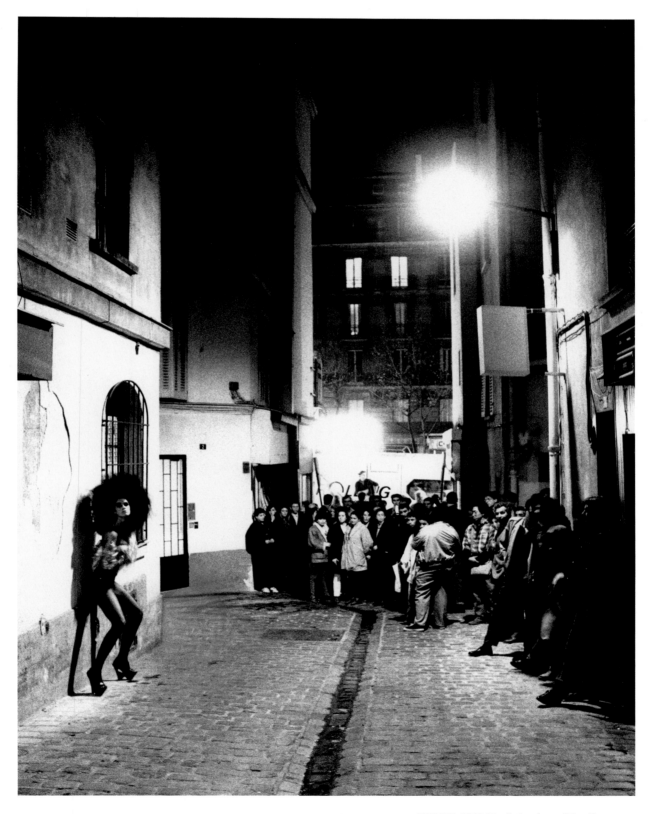

STEVEN MEISEL, *Friends at Pigalle*, 1990

STEVEN MEISEL, *Getting Ready*, 1987

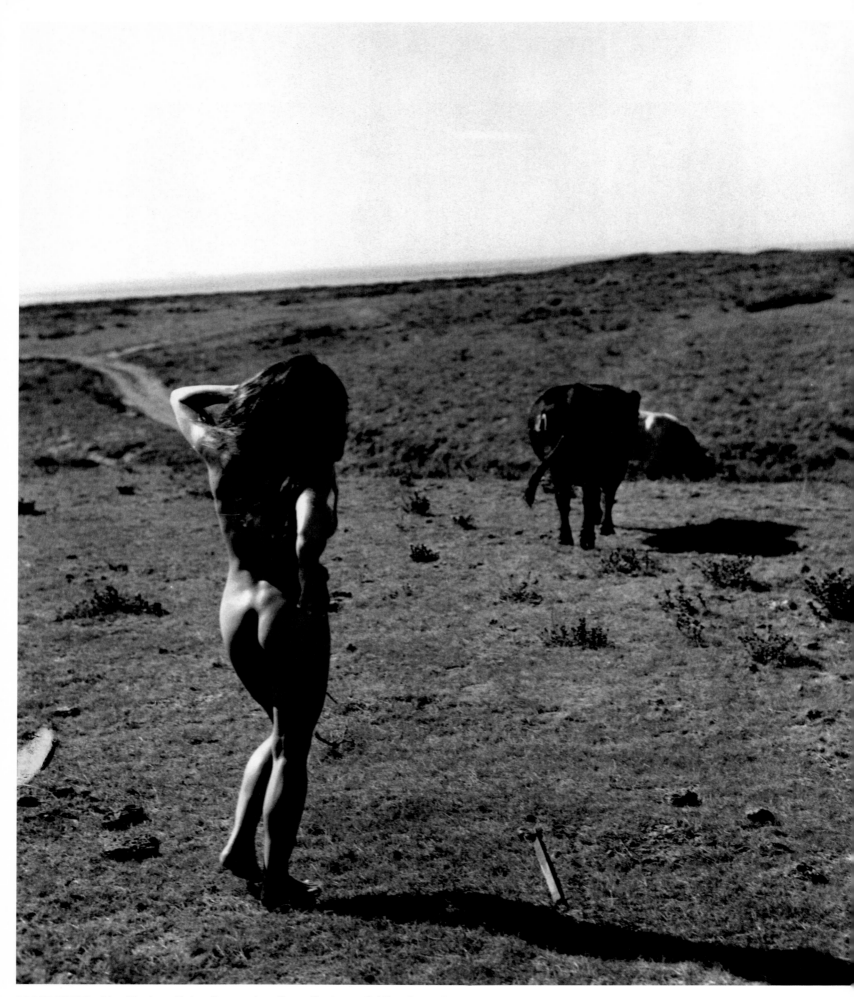

BRUCE WEBER, *Lisa Marie at Point Conception,* Santa Barbara, California, 1989

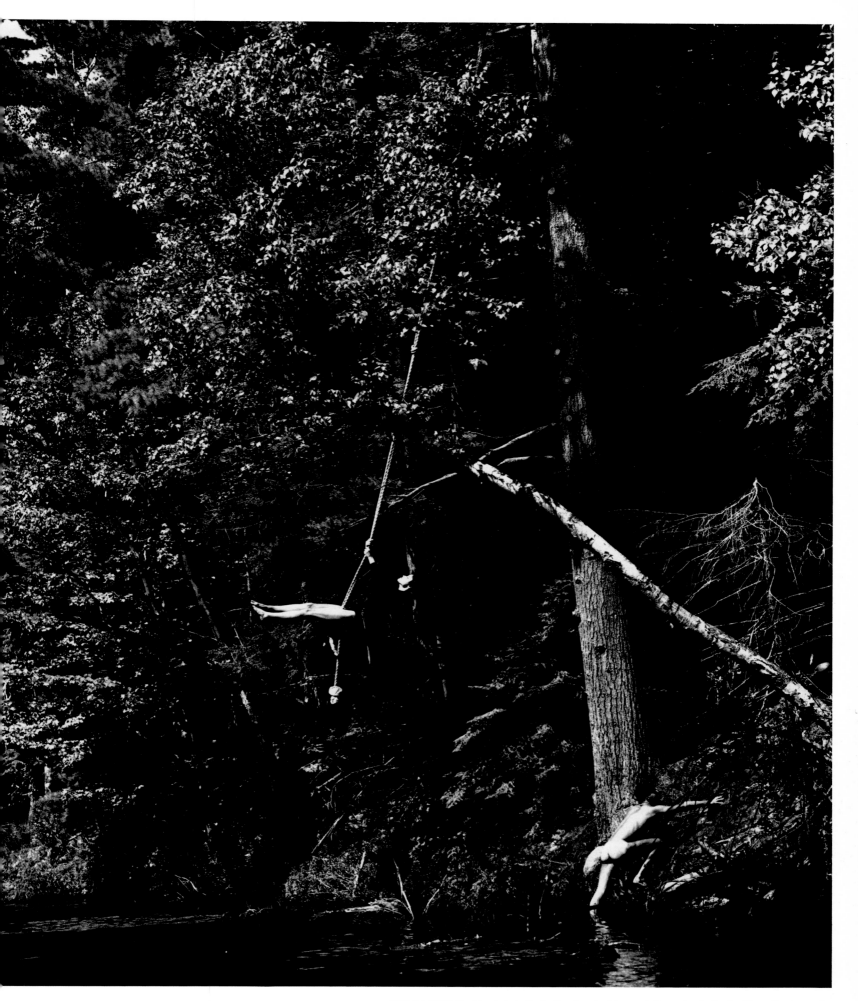

BRUCE WEBER, *Mariel & Rob*, St. Regis River, Adirondack Park, New York, 1989

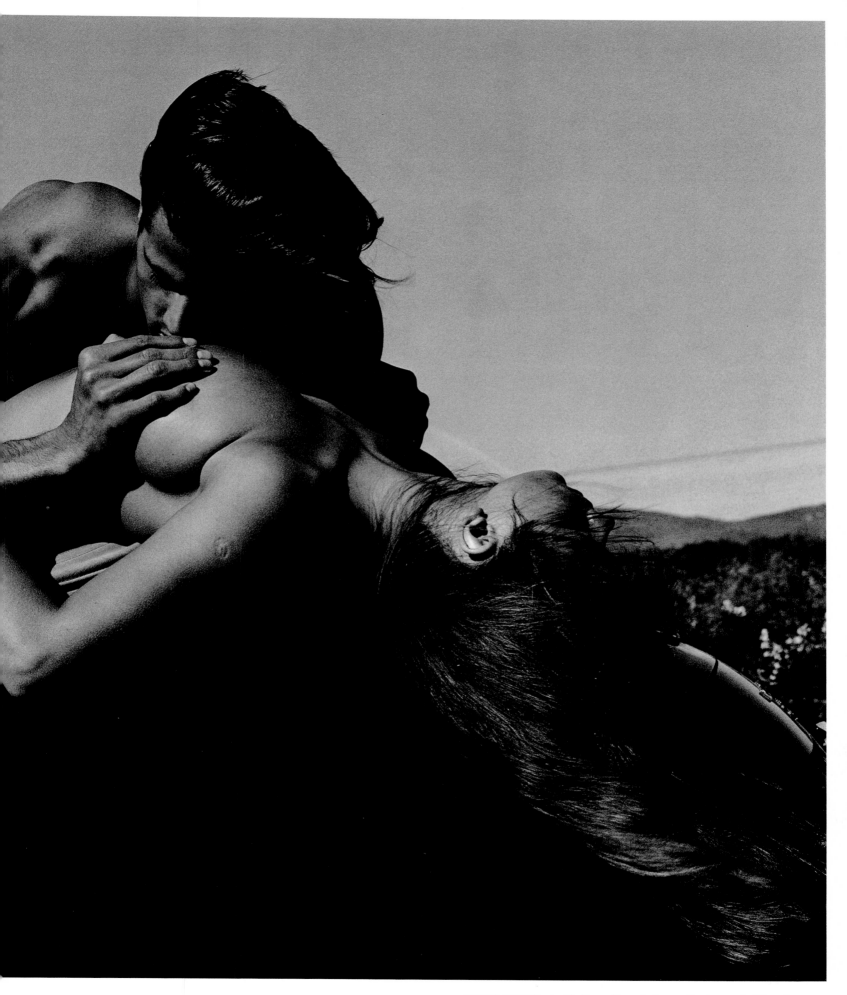

BRUCE WEBER, *At Holister Ranch*, Santa Barbara, California, 1987

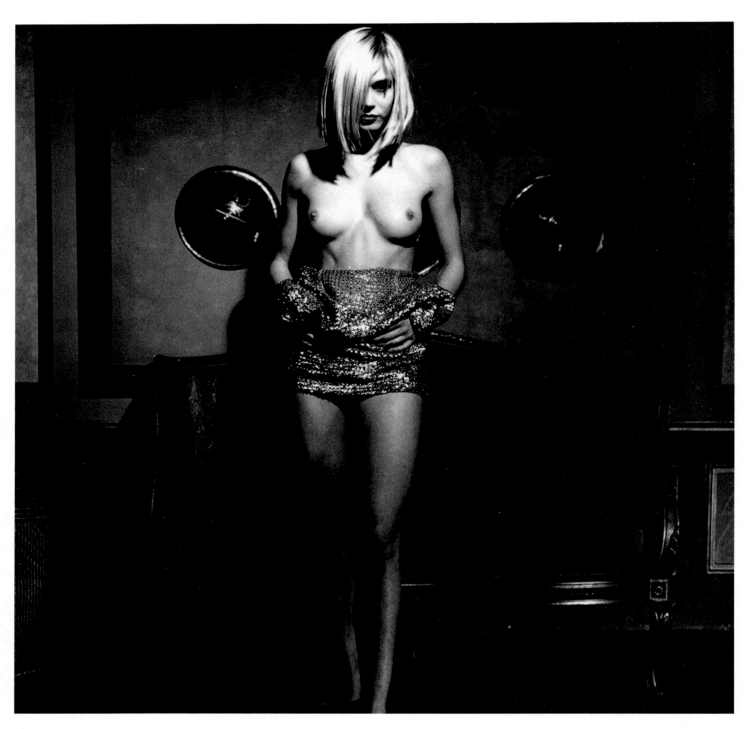

BETTINA RHEIMS, *Suzanna Descendant Sa Robe,* Paris, 1988

BETTINA RHEIMS, *Rachel Williams II,* Paris, 19

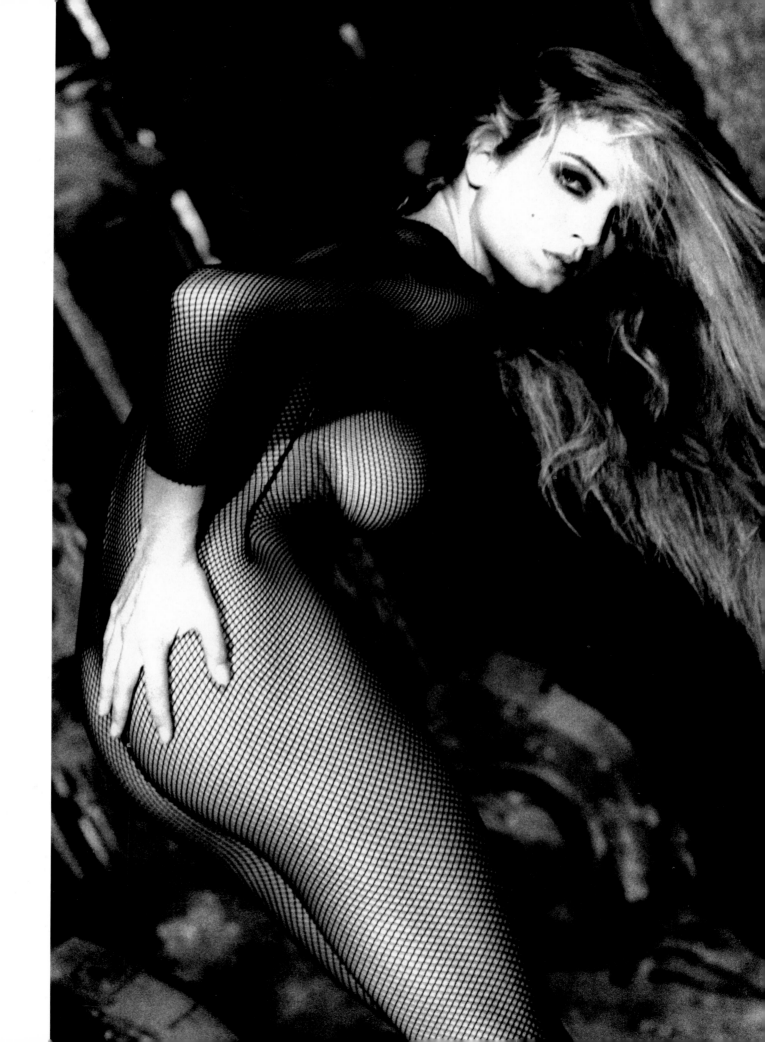

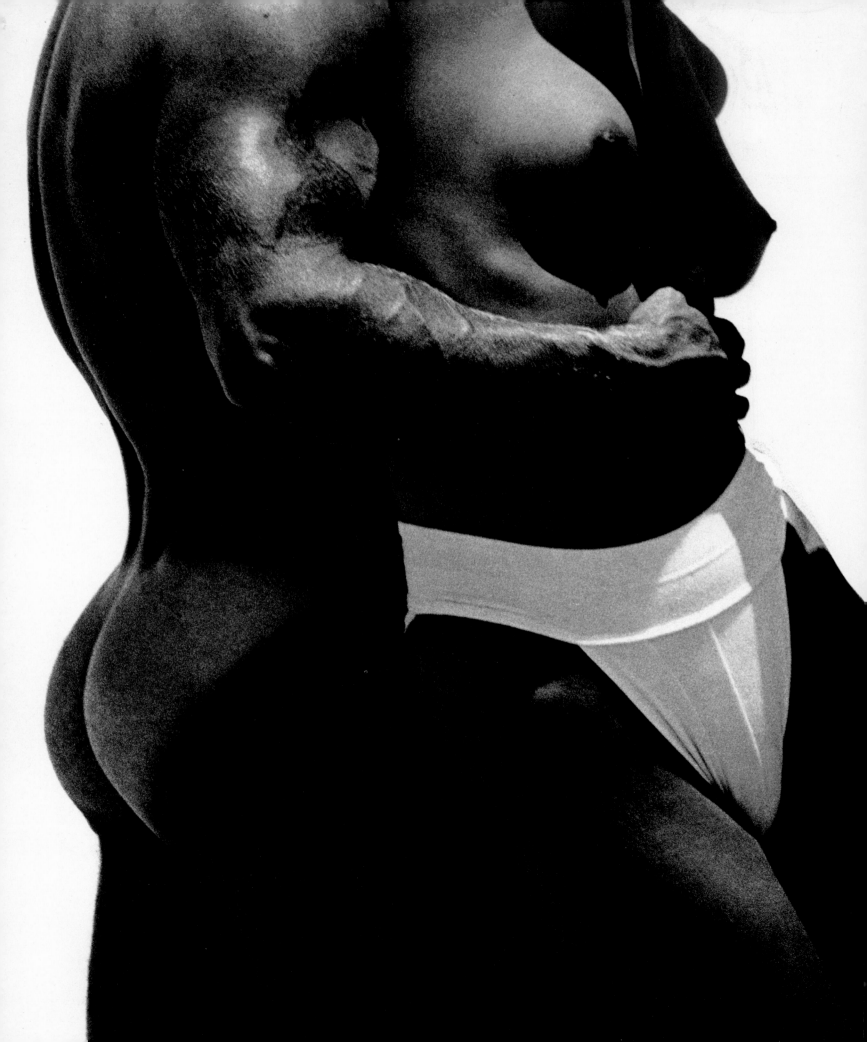

HERB RITTS, *Wrapped Torso*, Los Angeles, 1989

ERB RITTS, *Untitled Detail*, Paradise Cove, 1987

this sexual assault, an elegant woman, the archetype of a 1950s-style fashion mannequin, stares coldly away. Sitting nearby, a pudgy male photographer (a stand-in for Newton himself) watches the scene with some bemusement.

The image of the dominant "phallic woman" is ubiquitous in Newton's work; it is the master image that occurs in various surrogate subforms, such as the rich bitch. For not only does Newton express a very European sense of sex without love (or regret), he is also extremely interested in the sexual dynamics of status incongruities: a wealthy woman draped in fur and jewelry grasps her chauffeur in her arms, kissing him passionately. Not only does she have public sex with a social inferior, she literally steps down into a stairwell to do so.

Prostitution, lesbianism, and transvestism are all evoked in another photograph, in which two women stand in a deserted Paris street. One is naked except for high-heeled shoes and a hat with a veil. The other has very short hair and wears a man-tailored tuxedo by Yves Saint Laurent. Although this photograph appeared in a women's fashion magazine, the female image is seen through the lens of male sexual fantasy. On a psychological level, Newton's pseudo-transvestism is designed for masculine titillation.

Indeed, sexologists insist that only men can be sexual perverts. Strictly speaking, female transvestism does not exist. Women wear men's clothes for practical reasons and because pants symbolize power and authority. By contrast, male transvestites wear women's clothing because they find it sexually exciting; these men have a *fetishistic* relationship to female apparel.

The German sexologist Krafft-Ebing defined erotic fetishism: "The association of lust with the idea of certain portions of the female person, or with certain articles of female attire." To some degree many men are quasi-fetishists, but in pathological cases the fetish itself (long red hair, corsets, or high-heeled leather boots) becomes the object of sexual desire, and "instead of coitus, strange manipulations of the fetish" become the sexual aim.

This type of dark eroticism has gone over much better in Europe than in the United States, where only the tamest and the most wholesome of Newton's and Bourdin's photographs have been published. Even so, Newton's "The Story of Oh-h-h" caused a scandal when it appeared in American *Vogue* in 1975. The title, of course, referred to the notorious French pornographic novel *The Story of O.*, in which the masochistic heroine is a fashion photographer.

In the sequence from kissing to penetration, American fashion photography stayed strictly on first base. But in the 1970s it did take on some of the artistic conventions associated with hard-core pornography, which are quite different from the conventions of soft-core erotica and may be exploited for very different effects.

Women's underwear, for example, is widely perceived as being among the most erotic forms of clothing because of its intimate associations with the naked, sexual body (a person wearing only underwear is simultaneously dressed and undressed) and its connotations of undress as a prelude to sexual intimacy. But, as we have seen, there are many different kinds of sex and different styles of eroticism.

"Our image is elegant, romantic, and sexy," explained an executive at Victoria's Secret, a successful American lingerie manufacturer. "We believe in subtlety. We are not selling items for women who stand in doorways with a come-and-get-me pose." Like most lingerie photographs, those in the Victoria's Secret catalogs focus on a single female figure, either waiting coyly in her virginal bedroom or embracing a sole male "lover."

Bourdin's lingerie photographs, on the other hand, show multiple female figures. Several women sit in a row on a sofa as though waiting to be chosen by a client. One woman lies on a bed while others stand nearby, reflected in wall mirrors, giving the impression of an army of women. The construction of the pictures encourages us to scan each image, moving, for example, from what appears to be one bedroom to another.

Unless we envision a perverse girls' dormitory, the setting is surely that of a brothel. The clothing itself is sexualized: several women stand next to the bed, on which lies a pajama bottom, strategically spread open like the legs of a prostitute.

Soft-core images are lit softly and naturalistically. They typically feature conventionally attractive young women in a limited range of stereotypically romantic poses. By contrast, both the subject matter and the style of hard-core images are deliberately *strange* (as Kathy Myers and Rosetta Brooks have pointed out in articles on the subject). Hard-core girls look like prostitutes or lesbians; they may even be dressed as boys. Furthermore, hard-core pornography (like police photography) often uses hard flash and other techniques that call attention to the presence of the photographer.

The consumer of soft-core images can pretend that he just happens to be looking at a nearly naked person. With hard-core images, however, the explosion of the flashbulb destroys the pretense that the model is unaware of the viewer/voyeur. A third person comes between them: the photographer.

Yet a peculiar ambiguity arises from the creation of sexual images of women for other women to contemplate. Ordinary fashion photographs often use the male-oriented conventions of titillating soft-core pornography, ignoring the fact that the pictures are designed for female consumption; the ambiguity is glossed over.

But in the work of more avant-garde fashion photographers, latent images of lesbianism and narcissism are brought into focus. Thus, although the Bourdin/Newton type of photography has offended many viewers, some critics have defended it against charges of sexism on the grounds that it is actually "subversive" and sexually liberating.

From the fashion photographer's point of view, the "decadent" style gave new vitality to a familiar theme: How many ways can you show a dress, a bra, or a bathing suit? Consider Italian *Vogue*'s 1990 bathing suit issue: sun and sand having been done innumerable times (including

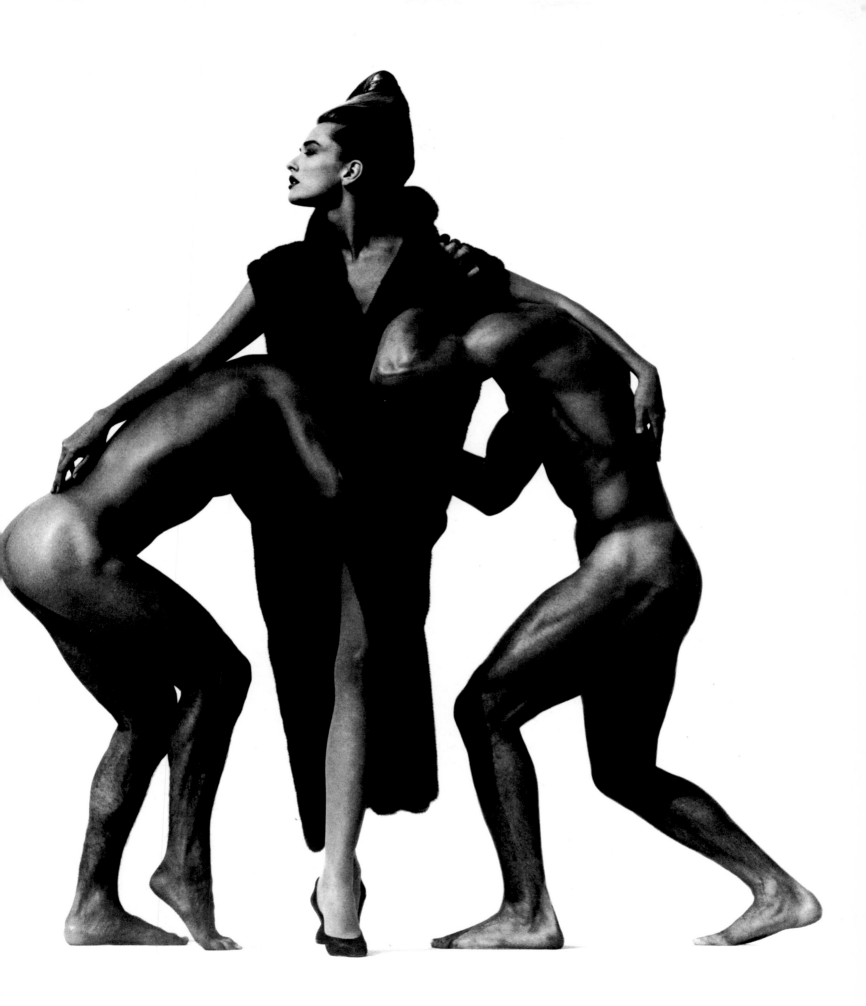

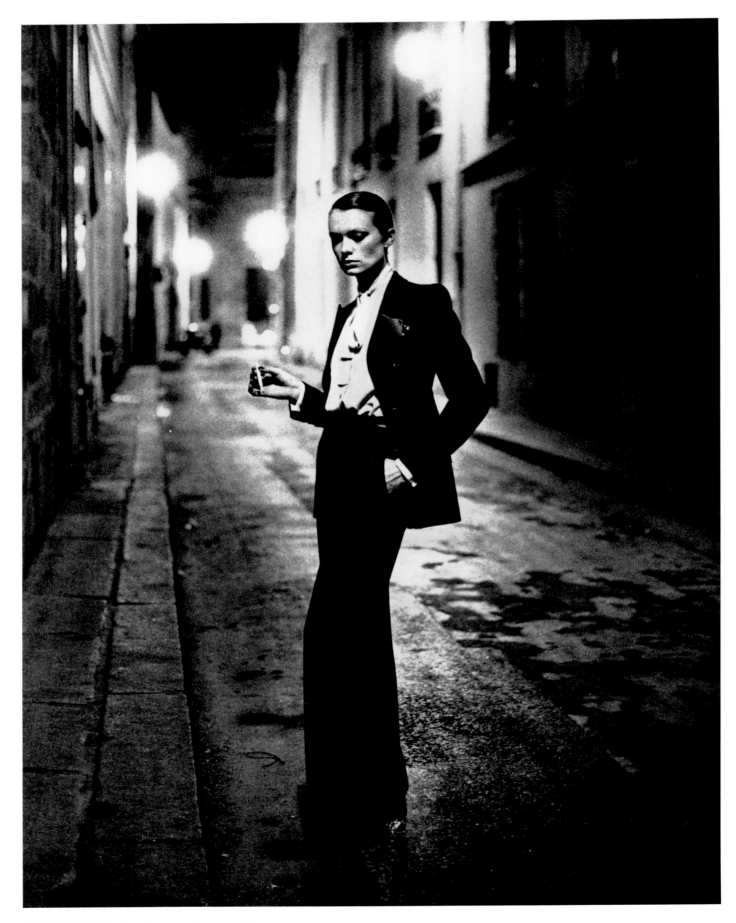

HELMUT NEWTON, *Rue Aubriot*, Paris, 1975

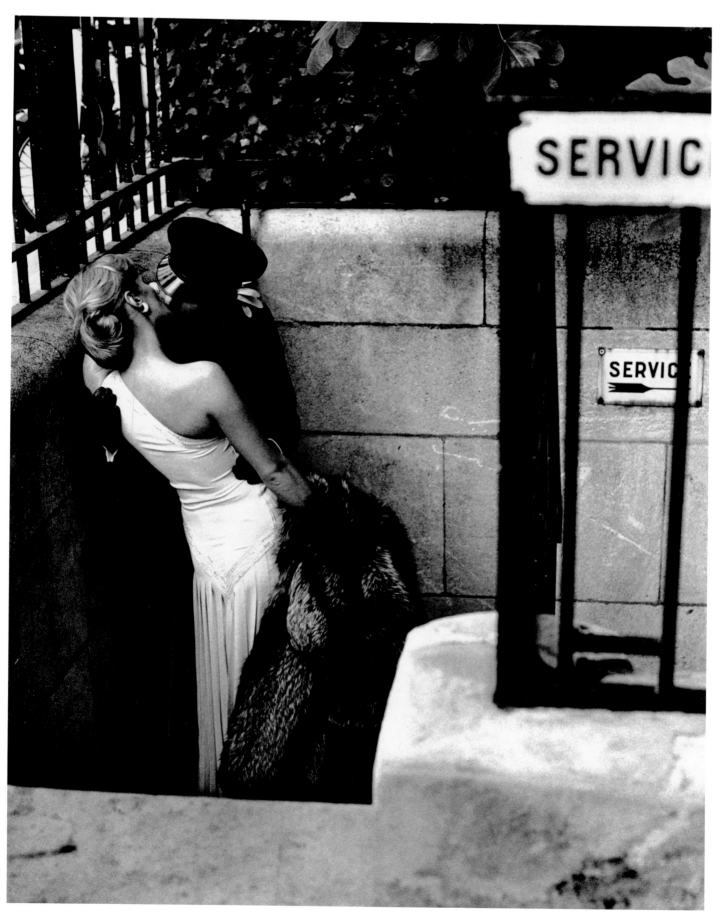

HELMUT NEWTON, *Gilles Dufour pour Marie Martine*, Paris, 1976

several times in that very issue), Steven Meisel chose to photograph the swimsuits in grainy black-and-white on a city street, accessorized with fishnet stockings and high heels and worn by a model who appeared to be a transsexual prostitute.

As the 1970s gave way to the 1980s, however, hard-core "fashion pornography" began to seem passé—at least in Europe. It did not disappear, but it was no longer considered adventurous. In America, on the other hand, the seventies experiment in relatively erotic fashion photography came to an end, and the exigencies of a mass market ensured that cheerful mediocrity would reign supreme—with a handful of exceptions, such as the work of Bruce Weber.

"You'd be surprised how around America people still think everything's pornographic," says Weber. "You know, even a bathing suit is pornographic." The reaction to his own photographs, however, reflected not only sexual puritanism, but also homophobia, since his athletic male figures were widely perceived as homoerotic.

Although fashion photography is basically photography of women, the image of the male sexual object has become a feature of recent work. Bruce Weber became nationally famous for his Calvin Klein advertisements, especially the ones showing statuesque men clad only in jockey shorts.

Nude men actually flourished in the fashion photography of the 1980s, although they were seldom treated with the loving attention that Weber lavished on them. Thus, in many fashion photographs, nude or nearly nude men were crudely juxtaposed with clothed women. This nicely reversed the conventions of traditional erotic imagery while avoiding offending feminist sensibilities.

Indeed, not only are the women clothed in power in many 1980s photographs, they are positively aggressive—biting, scratching, grabbing, tying up, or otherwise dominating passive male victims. This type of "playful" violence is apparently an acceptable manifestation of sexuality—as are the open mouths, smoldering expressions, and deep cleavage that characterize so many fashion images.

"I don't want to downplay how I feel about this," says Nick Knight. "I think fashion photography expresses quite crass views of sexuality. People treat sex as a crass joke. You know how if you go to a bar and someone chats you up really *badly*, talking about sex all the time—it's that sort of expression that you get on the models in a lot of fashion photographs. Why should the model always be talking about sex?"

Knight is probably best known for the catalogs he shoots for Japanese designer Yohji Yamamoto. Japanese avant-garde fashion is deliberately rather asexual, in contrast to the overt sexiness of most European fashion, and Knight has said that he strives for a more subtle and complex vision of sexual roles.

"I don't want to sound moralistic or negative," he insists. "People should do whatever they want. It's just that in terms of photography, we're talking in baby language. I don't want sexual stereotypes repeated in my photographs. The men in my photographs aren't overtly heterosexual or homosexual. There's so much sexual pigeonholing."

Most erotic images are deadly serious, but there is a minority view which holds that a sense of humor is sexy. Stephane Sednaoui, formerly a model for fashion's enfant terrible, Jean Paul Gaultier, makes fun (and funny) fashion photographs. Sednaoui's photographs are often heavily "doctored" with artificially heightened colors, and his cut-out style sometimes stretches the bounds of anatomy, as when he gives a model more than two arms or legs.

Javier Vallhonrat, another creative young photographer working today, has avoided the role-playing of 1970s-style fashion photography, focusing instead on the erotic possibilities inherent in photography itself. By raising his color values, for example, Vallhonrat has given his images a rich sensuality. The fact that many of his photographs are slightly out of focus also adds an alluring sense of mystery. Like clothing, they arouse sexual curiosity and the desire to see through to the source of erotic power.

Bettina Rheims and Ellen Von Unwerth are among the small but growing number of female fashion photographers. Catherine Deneuve has described Rheims's images of women as "very pure, but at the same time carnal." Breast exposure is a recurring motif: slips and brassieres are always falling down, or the women are peeling off their dresses. In this way, Rheims emphasizes the ambivalent symbolism of clothing, which always implicitly alludes to the body underneath.

A former fashion model, Unwerth knows how it feels to be on the other side of the camera, actually wearing the fashions portrayed. Whereas a male photographer often establishes a quasi-sexual relationship with his model/muse, with the camera functioning as a surrogate phallus, Unwerth began by taking "some pictures of my model friends." There is a joyfully hedonistic quality to her work, as one might expect from a woman who once described location work as "all fun and sex and rock'n'roll." Her empathic approach often focuses implicitly on the tactile eroticism of clothing, the way clothes feel as they hug or caress the skin.

It would probably be a mistake, however, to overemphasize the differences between male and female photographers. It used to be said that "men look, and women watch themselves being looked at." But the eye is an erogenous zone for both sexes; the voyeur and the exhibitionist are two sides of the same personality.

"I am a voyeur!" declares Helmut Newton. "If a photographer says he is not a voyeur, he is an idiot!" Not only the photographer but each of us who looks at a photograph is as much a voyeur as the crowds of people who stand *watching* in Meisel's bathing suit photograph. And each of us is a sexual exhibitionist, for no matter how modest or sexually repressed we might be, clothes provide us with what Freud called a loophole to display and enhance our physical charms.

Fashion photography owes its fundamental eroticism to the power of the visual imagination, which is a basic element of the human sex drive. In fact, photography is uniquely well suited to expressing the instinct for pleasure inherent in the libido for looking. □

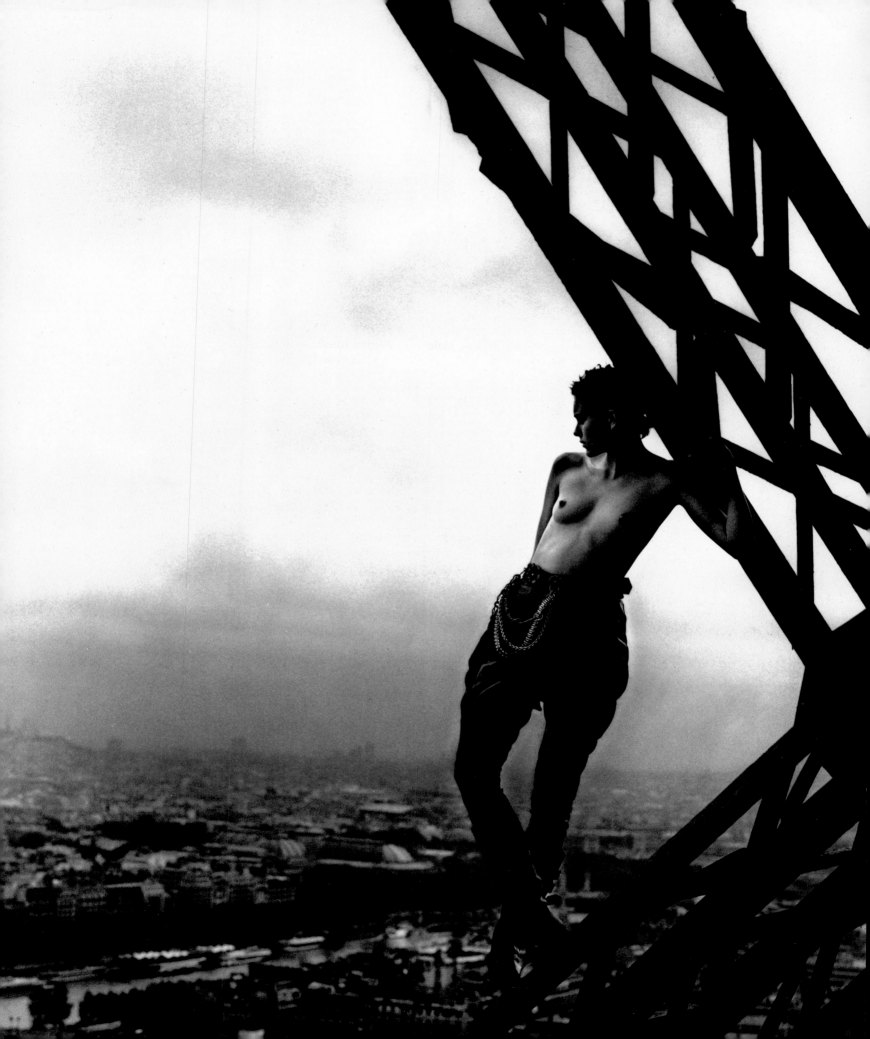

PETER LINDBERGH, Paris, 1984

PETER LINDBERGH, Deauville, France, 19

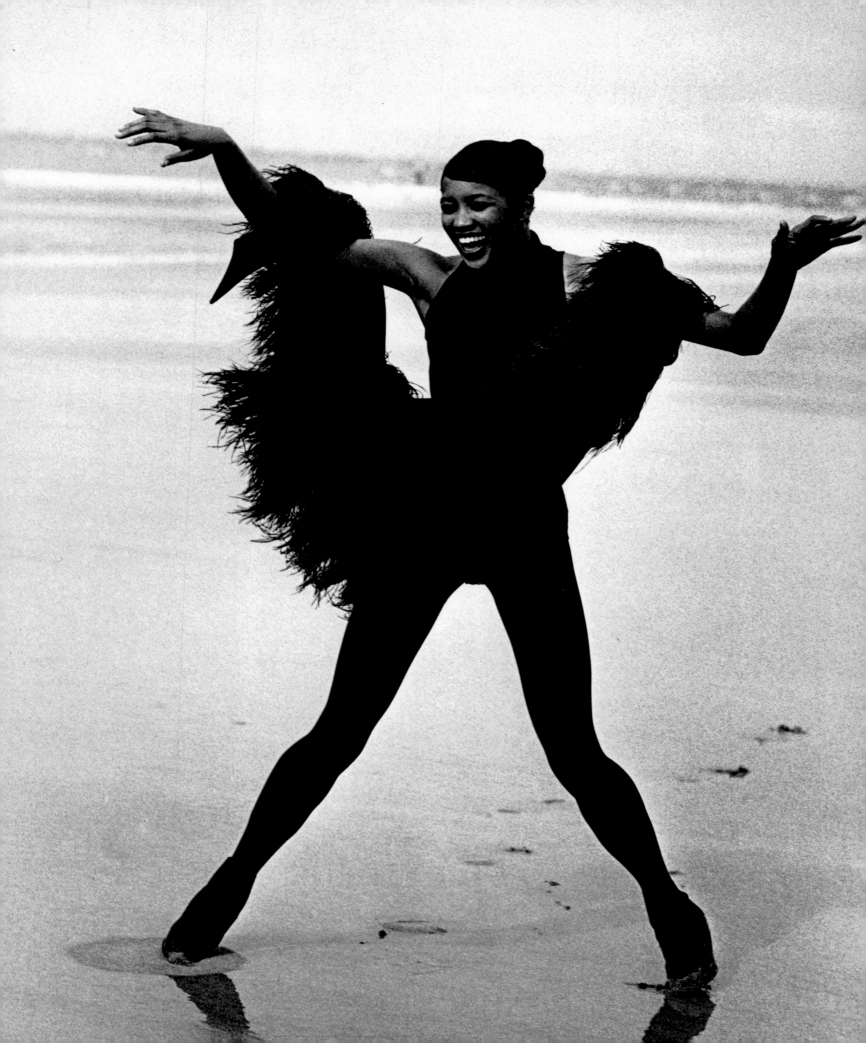

ELLEN VON UNWERTH, London, 1986

ELLEN VON UNWERTH, Paris, 19

A CONVERSATION WITH KARL LAGERFELD

by Andrew Wilkes

As the designer for Chanel for the last eight years and the creator of his own label, KL, Karl Lagerfeld has played a major role in the design community for the last three decades. His designs have helped revive Paris haute couture, specifically, the House of Chanel, where Lagerfeld has expressed both a reverence for Coco Chanel's brilliance and an irreverence for her clichés. Lagerfeld began taking his own photographs in 1987. These two relations to the fashion world place him in a unique position to comment on fashion photography.

Born in Hamburg, Germany, in 1938, Lagerfeld today resides in Paris, Rome, and Monte Carlo. Each of his homes is decorated in a particular style: in Paris,

eighteenth-century French; in Rome, neoclassic; and in Monte Carlo, Memphis.

At age sixteen, Lagerfeld entered and won a design contest for amateurs juried by, among others, Pierre Balmain and Pierre Cardin. He spent the next three and a half years working in Balmain's studio, where he began his career in fashion design. In 1958, at age twenty, he joined Patou and created two collections of haute couture each year. It was not long before his creative goals required that he move on to a new challenge; in 1963, he joined Chloe. It was at Chloe, during the years from 1963 to 1983, that he began to design daring and controversial collections that became "events." For these collections he imposed the Chloe style—elegant

lines running close to the body in supple, unconstructed fabrics. At Chloe, Lagerfeld mastered the forward-thinking style that combined the elegance of haute couture with the convenience of ready-to-wear. In 1966, Lagerfeld began designing fur collections for the Fendi sisters in Rome.

It was in 1983 that he took over as artistic director of Chanel, designing first its couture and later its ready-to-wear. In addition, Lagerfeld frequently creates original costumes for theater, cinema, opera, and ballet. Recent projects have included Berlioz's *Les Troyens* at La Scala and Offenbach's *Contes d'Hoffmann* in Florence; next he will tackle Puccini's *La rondine* for L'Opera de Monte Carlo. This interview was conducted in June 1990 in Mr. Lager-

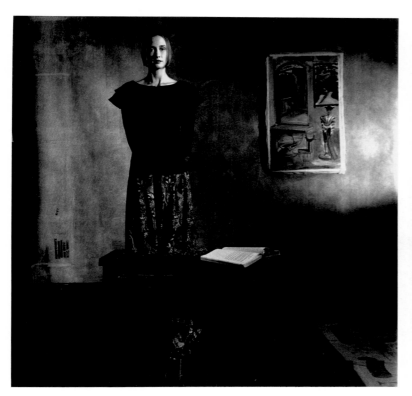 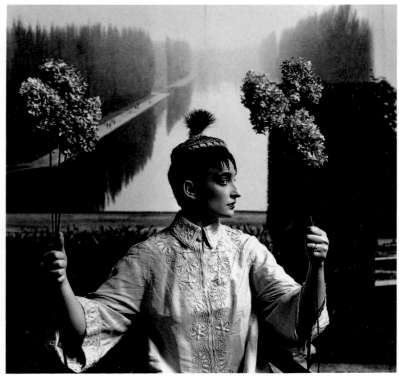

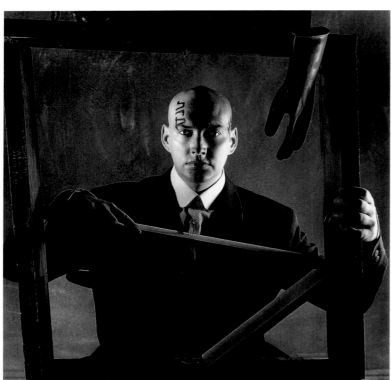 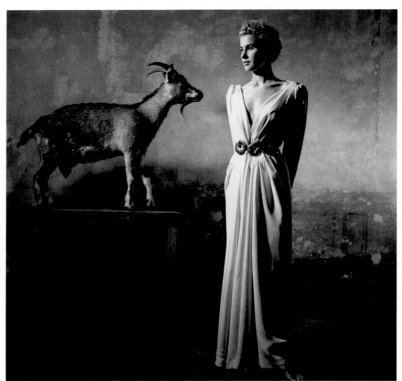

JOSEF ASTOR, clockwise from top left: *Girl on Table,* New York, 1989; *Girl with Branches,* New York, 1988; *Woman and Goat,* New York, 1989; *Man and Rubber Glove,* New York, 1989

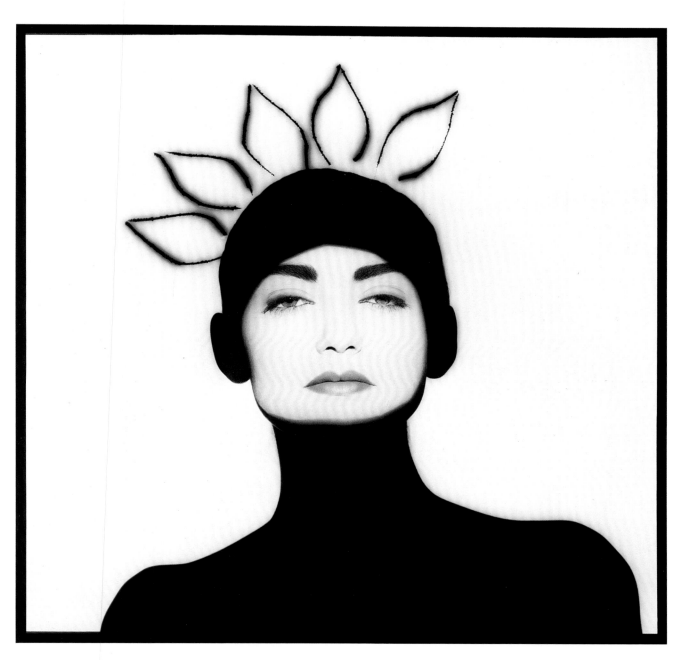

DEBORAH SAMUEL, *Sunflowers,* Toronto, 1987

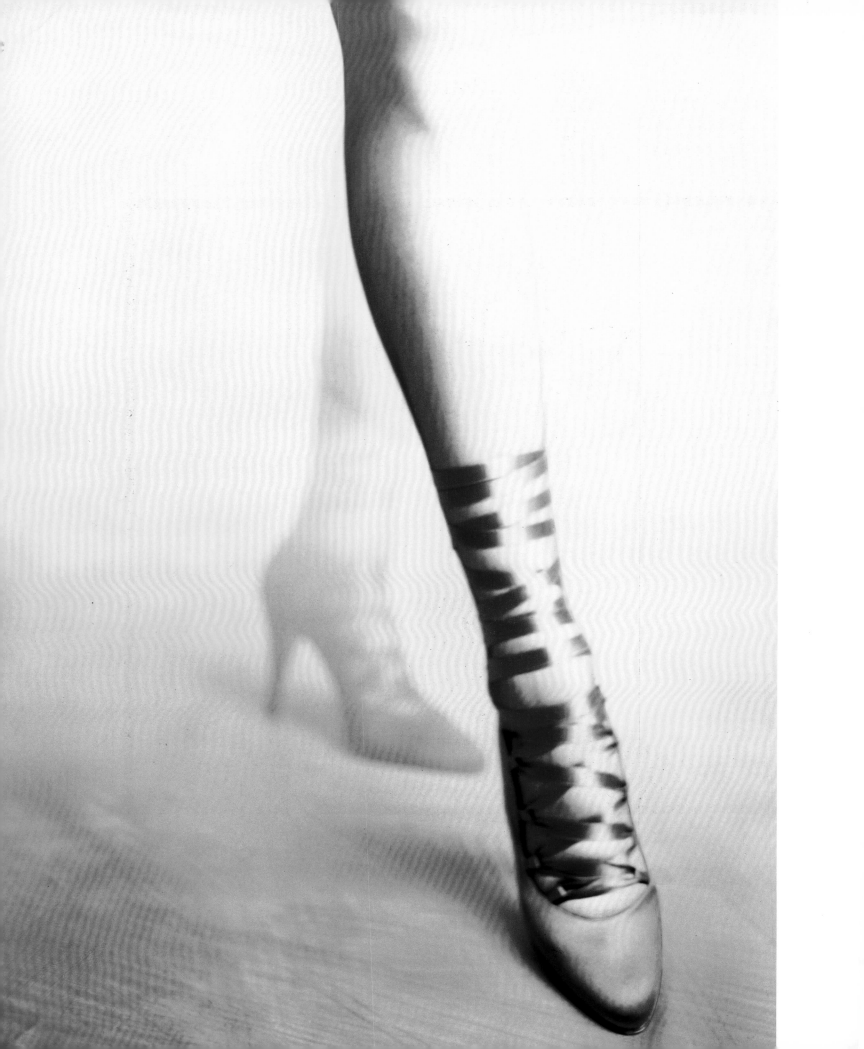

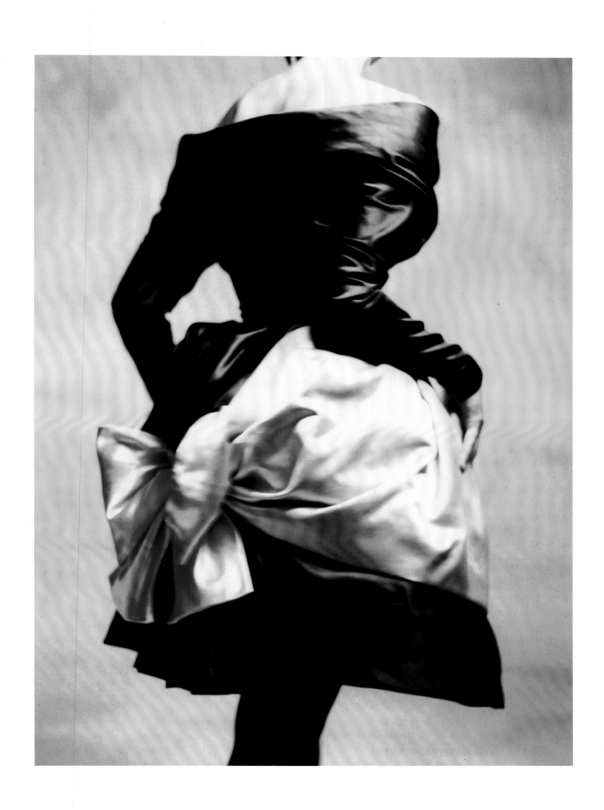

IER VALLHONRAT, Paris, 1987; **above:** Paris, 1987

Most of my photos begin as a sketch. I don't go in too much for surprises. Mostly I want exactly what I planned for

feld's Chanel office on the rue Cambon in Paris.

KARL LAGERFELD: How I got started in photos is, in a way, the key to my whole approach to fashion. I think the photographer can do anything. You are not the best photographer or a lousy and poor creature only because you do press kits. One of the reasons I started off was press kits—no famous photographer wanted to do them.

One season we had three different photographers do the press kits. All three times the work went to the garbage can, and I said, 'That's enough.' That's how I got started. Press kits are not fun, because they have to be black-and-white and handled in such a way that they can be used for daily papers. Press kits have to be made a week to ten days before the collection is finished. Very often I photograph unfinished dresses, so I have to know how to fake them, how to make them look finished. That was four and a half years ago, but I was already prepared for it.

I am of a graphic attitude. I sketch very well. I have drawn portraits all my life. When I was a child I wanted to be a portrait painter. Anna Piaggi, the Italian fashion editor, has published a book of many of these drawings that I have done. Sketching and laying things out is, for me, what I have always wanted.

ANDREW WILKES: Tell me about your photography.

KL: I do a lot of society portraits and portraits for royalty. These friends use the photographs for themselves—for their houses, for their friends. They order about a hundred prints. I do my portrait work with a 8 × 10 Sinar. I often employ very strange backdrops. I will show twenty portraits at my next exhibition. This is something very special. There is only one print from each negative and it belongs to the subject. At these exhibitions, nothing is for sale. On the other hand, for a charity exhibition at London's Hamilton Gallery, fifty-nine photos were for sale, and all of them sold the day of the opening.

AW: Do you collect photography?

KL: Yes. I collect late nineteenth and early twentieth century work. Steichen, Stieglitz, a little Baron de Meyer—I have a beautiful one. Also, Käsebier, Demachy, Paul Citroen, Kertesz, Coburn, Kuhn, Munkacsi

and early Lartigue. The Lartigues were given to me as gifts. In fact, much of my photo collection is made up of gifts, it is never-ending.

I love Paul Strand and Minor White. I also collect Helmut Newtons, tons of them. Very beautiful and huge ones. The last thing I received from him was a beautiful photo of David Lynch and Isabella Rossellini where Lynch had Isabella's hand in his hand—a marvelous photo.

Today I think I prefer to collect photography rather than to collect paintings. The new artists such as Peter Lindbergh, Bruce Weber, and Steven Meisel—they are my favorites for the moment.

AW: Do you see fashion photography becoming as valuable as fine photography?

KL: For me old fashion photos are pieces of art. Steichen, for example. What is as beautiful as a Steichen? It may have become a lower commercial product because there were too many prints available.

AW: Do you think photography is art? Can a photograph compare with a Monet or Hopper?

KL: For me, modern photographs touch me personally because they are from my time. Monet feels far away from me now. Early twentieth century photographers are as good as Monet and other painters in a certain way—but one should never compare. It's like [comparing] sculpture and painting—it's something else.

AW: What is a Lagerfeld shoot like? Do you prefer the control of a studio or the spontaneity of location work?

KL: I have very bad working habits. Sometimes I start at ten in the evening, and at

ten in the morning I am still working. I can be slow, well, not slow, but it takes a lot of time. I don't believe in those thirty-five-minute jobs. I have a big team. Often we are between fifteen and twenty people—makeup artists, stylists, models, lighting people. I work with nearly all the people I started working with from the beginning. You can't spend nights and days with people you don't like or don't know. I don't want to. I don't have to.

It's fun to be in a studio, and I think it's fun to be outdoors. In fact, I like very much to be outdoors, but there are some photos that require a backdrop. You know, these backdrops are paintings that a Parisian stage painter makes for me. A backdrop like this costs between $5,000 and $10,000. He was once very famous and had trouble because he made copies of real paintings. He's unbelievable.

AW: Do you like restrictions on your work when you shoot for Chanel or KL, and do you put restrictions on yourself?

KL: Yes. I am the photographer but also the client, and I am in the marvelous position of being at the center of my own life. For Chanel, Fendi, and KL, I can do what I want. Many photographers cannot decide even with big budgets what they want. My restrictions are my own restrictions. I know what goes into the garbage can and what doesn't. After all, we're in business, and the better things are, the more money I get to do other things with. So I can afford to play around more and experiment with less commercial projects.

AW: Alexander Liberman has commented on the delight of "accident" in photography. The "controlled or unplanned accident" is the area in photography that he feels permits discovery. What are your thoughts on this kind of excitement or spontaneity?

KL: Yes, I love the idea, but you can never say it will happen. Obviously you cannot prepare for it. I think it is even more interesting when you have, on your film, a strange occurrence that you haven't seen yourself. It can be an accident with light or whatever. Often, you get something you never thought of before. Most of my photos begin as a sketch, though. I don't go in too much for surprises. Mostly I want exactly what I planned for.

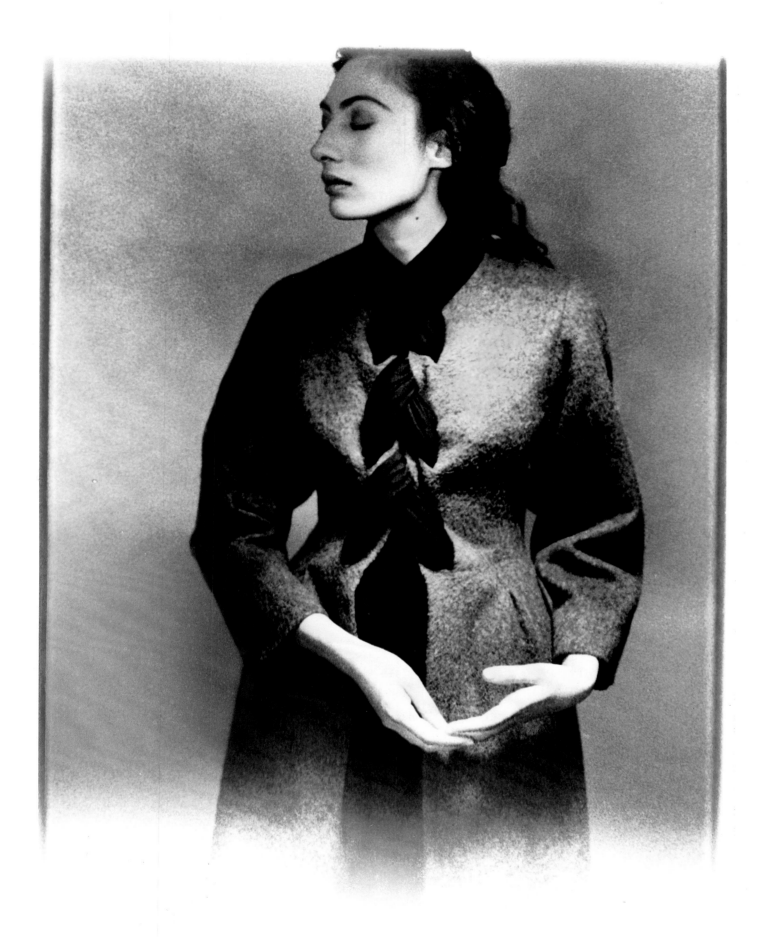

ENRIQUE BADULESCU, *Man with Sombrero*, London, 1989

AW: Do you conceptualize your fashion photography?

KL: Yes. I look at the product. I know what the photograph must look like to be right. I am my own client, and for Chanel, they like what I am doing. In fact, Chanel wants to show the dresses, but I am careful to be different, much more subtle, because I want the image to be different. For example, my work for Fendi is very different—it is based on German and Russian fairy tales or a mood like that found in De Chirico paintings.

AW: Fashion photography, as well as clothing design, borrows so directly from fine art and popular culture. Do you pay attention to pop music, videos, film, and street culture as sources for mood and inspiration?

KL: Everything gives me inspiration. I think Madonna is divine. I think she is it. I'm not sure I'm the right photographer for her; but I think she's great. All of these areas of popular culture helped to make up the 1980s. I don't believe in closed eyes. I am like an antenna on a building, I receive all those images.

AW: American fashion photography seems to deal with graphic depiction of clothing, while European more often deals with mood or fantasy. Do you know the source of this difference? Does "seeing" the clothes ever stop mattering?

KL: There is a very simple explanation. America is more market-oriented than Europe. European executives whose companies have interesting clothes and who commission great photographers do not have the budget to do big ad campaigns. If you only have one or two pages, you better create an atmosphere. On the other hand, if you have hundreds of pages, as with Chanel, then you can show the dresses. KL is less commercial in that way, but you can still see the dress. I do atmospheric work more with my personal photography.

AW: Let's talk about the commissioned/commercial photograph. Usually a fashion photograph has commercial boundaries. Many critics feel this is what separates commercial work from fine photography. What is your opinion, and what limitations do you find when photographing?

KL: You know, a commission is not something that makes the photo less attractive.

Many photographs collected today were commissioned for magazines. Whatever is good will survive; the rest has to go into the garbage can

The photographer who is very honest, even with a commission, will make a special effort. Work is work—and commissioned work is valid work. Sometimes with a commission you have to put walls up; this I think is very healthy. If everything is open, the choice is too unlimited.

Helmut Newton always says that he likes restrictions. Lots of Helmut's advertising jobs are as good as his personal work for exhibitions, books, or portraiture. But Newton sometimes doesn't care and he doesn't like fashion anymore.

And the drama in fashion is that if you don't like fashion anymore, it doesn't like you. One can even get out of touch with the fashion "feeling" because one may think one has more vision of the woman than of the clothes, but people's taste in women changes. It's my feeling that the professional who does not like fashion or thinks fashion is no longer interesting should get out of it. That doesn't mean he or she is not a good photographer, but rather no longer a good fashion photographer.

Often fashion photographers who become well known create a mold whereby they think they are too good for the job. They must remember that they will be remembered not for what they do later in a different genre, but for what they did at the height of their fame as fashion photographers.

AW: A special relationship often exists between a photographer and a designer. Who have you worked with on this level?

KL: Helmut Newton, Bruce Weber, Peter Lindbergh.

AW: Do you prefer black-and-white or color photography?

KL: I prefer black-and-white, but what I also like is to hand-paint photos.

AW: You do your own tinting?

KL: Yes, I do it mostly with my social portraits and with gifts to friends. I did a print for Princess Caroline of Monaco and it took ten hours. It takes such a long time I don't even own one myself.

AW: What cameras do you currently work with?

KL: For me, a camera is the toy of all grown-up men today. Everybody has a camera, it is one of the few toys grown-ups are allowed to have. I have an 8 × 10 Sinar, which is my newest one. But I have done nearly all my work with a Hasselblad. I love the Leica 6. I like the physical touch and noise. I think a camera is something very physical.

AW: Do you shoot a lot of film on a job?

KL: Very little. My assistants push me sometimes to do more. I have one vision of the thing, and not two. I'm not a photographer who shoots three hundred rolls of film.

AW: Is your printer in Paris?

KL: I have two printers for my color and one for black-and-white. I have my photographs printed on Canson Mi-Teintes sketching paper. A special printer does my color prints for exhibitions; sometimes the photos are two meters high.

AW: What role do you believe fashion photography will play in coming years?

KL: You know, I do not separate fashion photographs from fine photography. They're part of the same thing. Without a doubt there will be some great new photographers.

AW: Can commercial work be important after the moment of its initial impact? Will this work remain important and continue to have lasting value?

KL: If it's good, it can, and when people forget that it was originally advertising or editorial. Look, many photographs collected today were commissioned for magazines. Simply, whatever is good will survive; the rest has to go to the garbage can. Every good photographer can do bad photography because of a mood, because of bad climate, atmosphere, or the product. But the good photographs endure. □

MAX VADUKUL, *Cat on Hot Tin Roof*, Paris, 1989

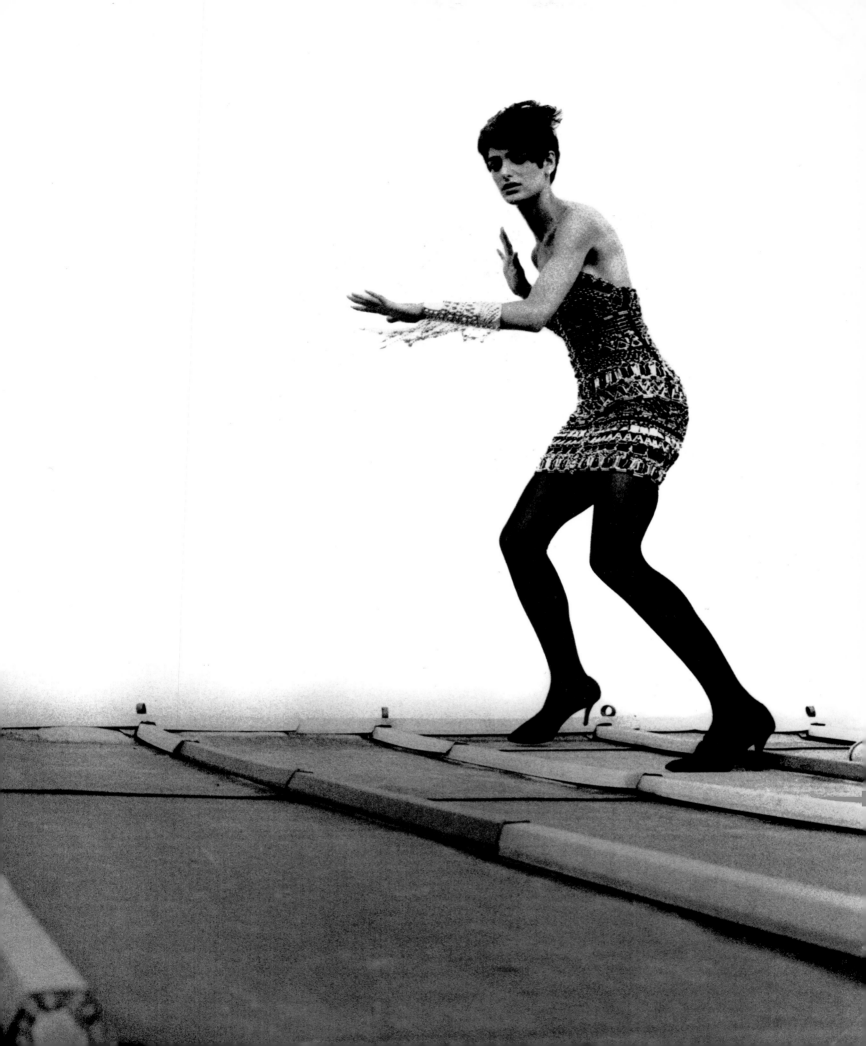

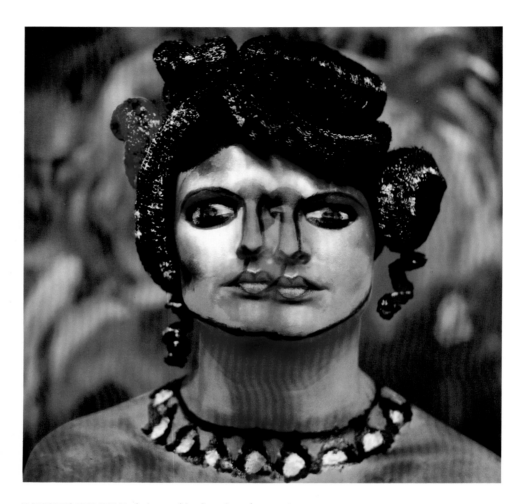

MATTHEW ROLSTON, *Ariane, Air,* Los Angeles, 1987

MATTHEW ROLSTON, *Aly, Long Neck,* Los Angeles, 198

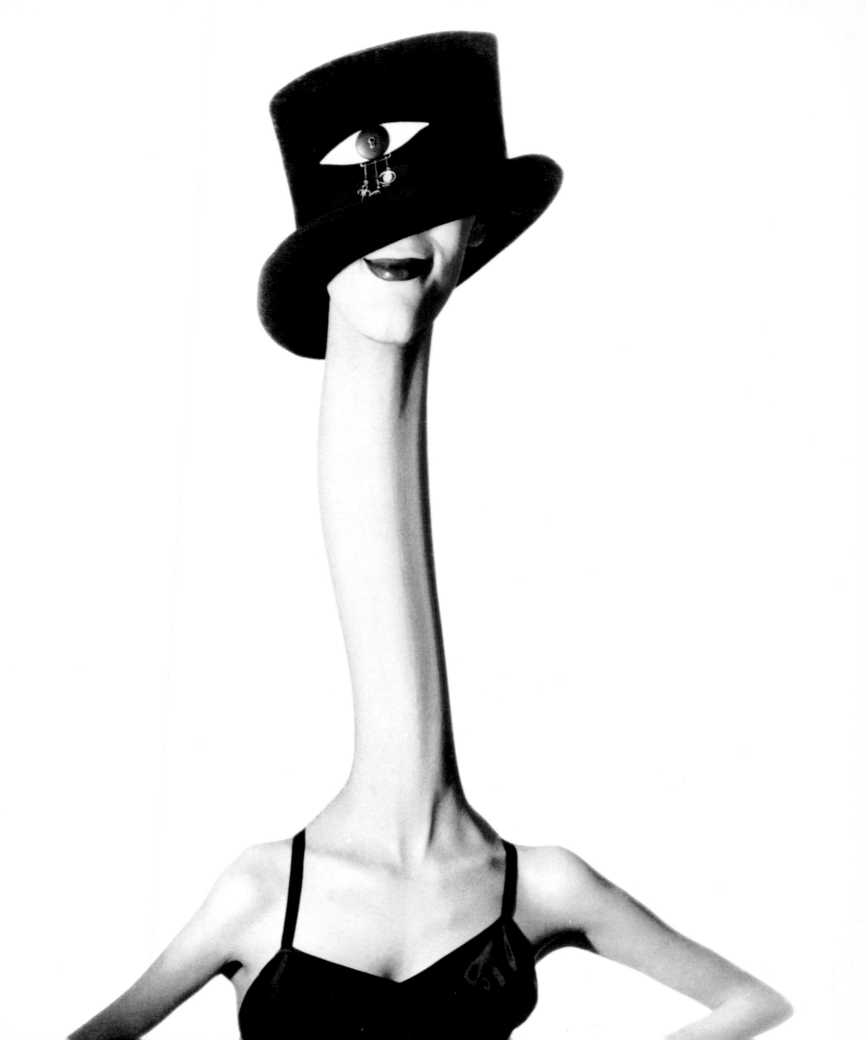

Music video is visually omnivorous, its appetite unlimited. It prowls the savannas of high and low culture, devouring images from the movies, television, modern art, burlesque shows, religion, and fashion magazines—and everything it consumes becomes part of its own distinctive look. That look, except in the most straightforward concert videos, is almost always dreamlike: a series of brief, enigmatic vignettes (moments of pleasure, peril, power, escape) bound together not by narrative rules but by the ineffable logic of desire. The first commercial art form to be *born* postmodern (having passed through no previous stages), music video occupies ground cleared by Surrealist painting, photography, and collage, as well as avant-garde theater and film. But in significant ways, the ancestor it most resembles is another genre of commercial art: fashion photography.

Commercial art, however breathtaking its quality, differs from so-called fine art—of the twentieth century, at any rate—in what it encourages the viewer to *want*. A fine-art photograph of a nude, for example, may depict a body possessing none of the qualities commonly deemed attractive. It may be too wrinkled, too fat. Conversely, the body may be lithe and sleek, yet presented in a way that prompts contemplation and wonder more than prurience. In either case, if the work is successful, a kind of desire is aroused whose

people and ideas

primary object is neither the photographic subject nor anything outside the frame. We want to look at the textures and shapes and tones of the photo repeatedly and at length—to possess them, if only in memory. Whether the picture incidentally wets our appetite for sex, money, or utopia, the focus of our desire is the art object itself.

In a fashion photograph or a music video, however, what is encouraged above all (though we may respond to the quality of the art as well) is our desire for the person on display—or else our desire to possess the subject's power, freedom, mystique, subjectivity. All the visual techniques of the media, sometimes including negative devices that tease the viewer, such as distortion or defacement, are bent toward enhancing the model's or performer's magnetism; whatever narrative line exists is often fractured or distorted beyond comprehension by the subject's

erotic force. Yet our encounter with this force is fleeting, frustrating. A fuller satisfaction, a deeper communion, is promised in the purchase of the musician's recording or the model's dress. Our desire is led from the subject to the extrinsic commodity.

It's hardly surprising, then, that music videos sell clothes as well as records. Manufacturers report that sales of such items as leather jackets and parachute pants swell and dip with what's being worn on MTV. Nor is it surprising that a few fashion photographers—Herb Ritts, Deborah Samuel, Jean-Baptiste Mondino, among others—have tried their hand at directing videos. These artists bring their fashion-bred techniques and obsessions to the new form. Ritts, for example, shot Madonna's "Cherish" on a California beach in his trademark black-and-white; the video features the surfers who populate much of his fashion work, dressed this time as mermen.

Music video, like fashion photography, traffics in what Roland Barthes, writing on fashion, called "the dream of identity" or "the dream of wholeness." The dream, simply put, is that if we can get our look together, our lives, magically, will come together too. In the stories told by fashion photographs and music videos, the plot stems not from a character's psychology, historical situation, economic position, nor from any mysterious force of destiny—but from his or her *appearance*. These are dream stories, with a dream's ellipses and wild shifts. Yet they cannot afford to be as shapeless, as ambiguous as real dreams: a commercial art form's message requires closure. In the absence of conventional narrative, the structure of a video or a suite of fashion photos tends to be the kind traditionally found in music. A set of themes is pronounced; the themes interweave in a series of repetitions and variations; there is at least one climax and

DEBORAH SAMUEL, video still from *Alannah Myles, Love Is*, 1990

then a final, ringing cadence or a fade.

Although the videos communicate aurally as well as visually, the link between what's seen and heard is often tenuous indeed. The action onscreen may have little to do with the lyrics, and even the catchiest musical "hooks" are less memorable when they're competing with televised images. What sticks with the viewer of MTV are visual hooks: faces, bodies, gestures, settings, costumes, cars. Meaning resides primarily in surfaces. The glamorous performer, like a fashion model, is at once signifier and signified—and thus whole, individual, invulnerable, at ease, significant, in a way ordinary mortals can only dream of being.

Looking at a music video or a fashion photograph, we enter a certain world. Its denizens are distant relatives of those inhabiting the cinema and nonmusic television: distant because they speak only in poetry, never prose. They are closer kin to the enigmatic beings who populate advertisements for perfume, cigarettes, and every other product that can be marketed as conferring style on the buyer. They never explain; they *embody*. But the people in the ads, however sexy, statusy, strong, spontaneous, and self-directing, are seldom more than a finger's length from the products whose avatars they are. The people in videos and fashion photos seem markedly freer and more powerful precisely because we can drift longer and far-

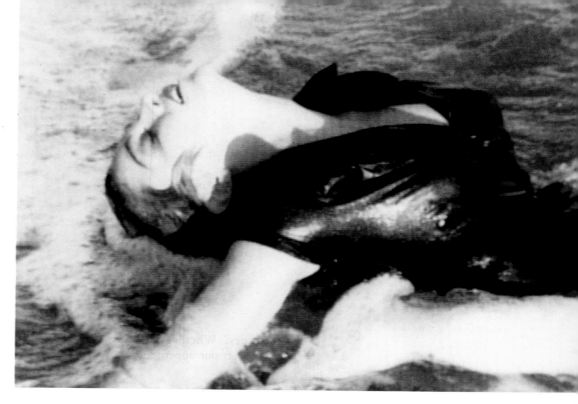

HERB RITTS, video still from *Madonna, Cherish,* 1989

lops on horseback across desert sands amid spectacular buttes and crags, following in the tracks of countless models. (Alternating cuts show her belting out the song against a white backdrop as the camera scans for sartorial details: her red high heels, seamed stockings, hemline, neckline, bangled arms.) U2 is filmed inside a formidable manor house, another age-old site for couture pictorials. Janet Jackson gazes from a gauze-curtained Parisian window

are safely suspended in the nighttime sky, prancing in the vastness. In another video, Madonna plays a pregnant teenager in a blue-collar town but also appears in recurring scenes (as the young woman's alter ego or future self) on a spotlit stage, swathed in an elegant Gaultier sheath. As in fashion photography, rude surroundings serve to highlight the hero's glamour. And either a posh or a downscale setting can provide an arena for a kind of magical social mobility.

In fashion photos, such mobility has typically been represented by the scene in which an impeccably groomed heroine stoops to conquer—seducing her chauffeur or some yeoman, for example, in famous pictures by Newton and Parkinson. In music videos, as in most rock mythology beginning with Elvis, the one who defies class boundaries is most frequently a man, and his social movement is upward. A hirsute, barbarous-looking fellow, tattooed and sinewy, wins a woman who appears to be a countess (or a fashion model). Perhaps he's an aristocrat in the rough. In any case, his vitality overwhelms all barriers. He can go anywhere—he is free.

The mythic freedom of both video stars and models is expressed not only in plot developments but in purely visual terms. In videos and fashion layouts, costumes are changed constantly and capriciously. Movement is extravagant—models and

Music video, like fashion photography, traffics in what Roland Barthes, writing on fashion, called "the dream of identity" or "the dream of wholeness"

ther in our fantasies about them before bumping up against the hard facts of commerce.

These demigods live among us, but in a kind of parallel reality. They tend to be pictured in exotic lands, in elegant rooms, in settings where the air is full of natural or financial power. In "Love Is" (directed by Deborah Samuel), Alannah Myles gal-

and wanders by the Seine; the photographic style is misty, soft-edged, post-Turbeville.

Even when a video's setting is humble, some sign of the performer's power to escape, to transcend, is seldom missing. A group of rappers seems trapped in a dark alley full of alluring but, the lyrics caution, predatory women; a moment later the men

performers alike streak by in fast cars and speedboats, hop down from airplanes and trains. Running, jumping, and dancing take the place of walking. Since fashion photography has been, for the most part, *still* photography, it has had to present frozen slices of the model's motion. Music video carries on the tradition of slicing, using quick cuts of a performer in media res to heighten the sense of joyful restlessness, of preternatural energy.

All the common tricks developed in still photography to signify freedom and power, and to reproduce the topography of dreams, are recycled in music video. The odd angles, radical cropping, extreme or distorted perspectives; the hallucinatory color; the lighting that bleaches a face of all but its essentials or casts haunting shadows; the white backdrop that makes a subject a world unto herself; the closeup of a stylish body sprinting down a blurred, crowded street: all these devices were pioneered by fashion photographers. Such innovations first reached a mass audience in the pages of periodicals like *Vogue* and *Harper's Bazaar*, forming a visual vocabulary that later became a central pillar of the MTV aesthetic. As America's mainstream fashion magazines languish in a conservative phase, the expansion of this vocabulary in print has largely shifted to Europe. But in this country the experimentation continues apace on the cable television screen, twenty-four hours a day. □

UNWRAPPED REALITY *by Fred Ritchin*

For a photojournalist, fashion photographs often do not seem to be about much at all, other than summoning the muses. Beauty, sexuality, romance are conjured up. The clothing is given credit for the magic, when, as we know, it is the directing photographer who takes even a rag and elicits any minor deity desired.

In photojournalism one is often concerned with harder issues that resist equivalent fantasies. In the grayer world of journalism the daydream is invaded by the nightmare. There is a constant accounting—whose skin was ripped by which projectile, not whose skin was caressed by which silk. There is often a loss of visual dynamism, the sine qua non of fashion photography, in the search for the answers to the mundane questions of word journalism—who, what, where, when, why. The photographer attempts to get the right people, place, event in the frame, maximize the sense of the compelling moment, and wherever possible have contributing evidence surround the major figures to help explain them or the event. The photojournalist's being there is what is impor-

tant. He or she becomes the witness and the eyes of the reader.

The journalistic function is concerned more with gathering evidence than unleashing imagination. The photojournalist is thought to be straightforward, while the fashion photographer is more the choreographer of desire. Photojournalism—constrained by the gathering of facts—often uses a simple visual strategy in which the elements thought to be important are centered in the frame. These elements do not have to move but simply be captured. The form does not necessarily articulate the content, but encapsulates it.

This tradition comes in part from newspaper photography, which puts what is important in the center of the frame so that if necessary the sides can be cropped to fit the picture onto the page. It is like the pyramid structure of word journalism—place what is important at the top of the article so the information of lesser importance at the bottom can be lopped off if there is not enough space. The photojournalistic strategy often includes a caption, which dictates the meaning of the image,

SYLVIA PLACHY, Cypress Hills Cemetery, Brooklyn, New York, 1986

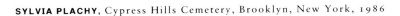

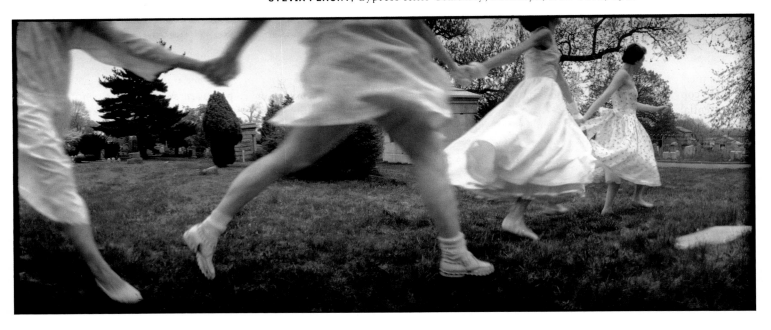

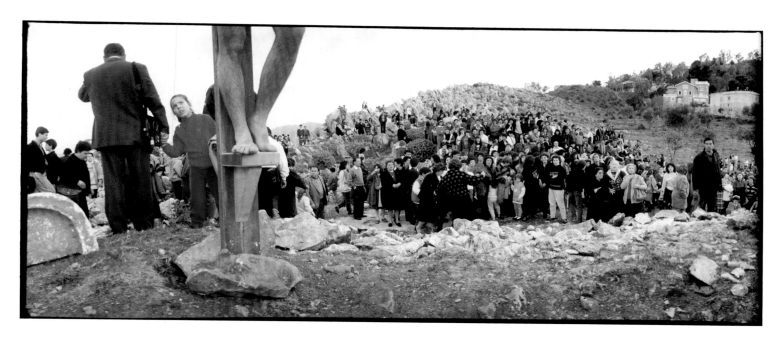

SYLVIA PLACHY, *Easter in Palermo*, Sicily, Italy, 1988

supplanting a visual dynamic. If one cannot describe in the caption what is going on in the photograph, then the problem is thought to lie with the image.

The allure that fashion photography creates and revels in is frequently that of ambiguity. The unexplainable and implicit is preferred to that which is more simply depicted. It raises the stakes, making simple existence so much more complex. There is a payoff—the reader is presumably allowed to enter into the mystery by wearing similar clothes.

Those responsible for editorial photography, aware of its heavy-handedness, cognizant that not every situation to be photographed provides the pyrotechnics of a war, have tried to some extent to follow the visual lead of fashion photography. But in their prudence they have often managed to copy its discarded husks more than its essential drama.

The journalistic depiction, particularly of powerful people, often aims for the head, the center of thought, the rest of the body being an accoutrement, the clothes structured to support the power of the person. Clothing in journalistic usage is often seen as armor, protecting people in their sameness. But something else happened in the borrowing from fashion's theatrical example—people began to hide by modeling themselves, enacting fantasies that they were only playacting.

But a change is occurring; there are

The beauty of fashion photography is that it is guilt free. You can work on a fantasy, on a might-have-been or a mood, and the model will repeat each gesture until you can perfect a moment. But still, it only works when it is spontaneous within a set-up and authentic within a lie.

In journalism you only get one chance. You succeed when you can intuit a moment that transcends the chaos. It is about facing what *is* instead of what should be, and the joy of journalistic photography is the visual discovery that is equivalent to your understanding. There is more risk than in fashion, where you pay for your pleasure. It is someone's real life or blood and feeling that is your raw material. You have to justify, if only to yourself, that even if you don't steal souls you always invade someone's privacy. SYLVIA PLACHY

those who are now less convinced that the journalistic photograph is a straightforward accounting of what happened, a simple gathering of evidence. Some question whether a journalistic photograph has a stranglehold on reality, asking whether it might not be more of an interpretation than a straight transcription. Reality is being thought of as somewhat more multifaceted, evanescent, changing according to one's point of view. This view of reality, it turns out, is well suited to photography, with its panoply of details that can be reinterpreted by the reader in many different ways. In this sense the ambiguity of the fashion photograph, not only its visual dynamism, has more in common with the newer journalistic image that tries somewhat less to define and more to raise possibilities.

The visual drama and complexity of

fashion photography offer strategies toward the articulation of this new understanding of the world. Fashion photographs are flexibly constructed, vibrant, and at times bend the frame while, in their imagined universes, using all of it. The expressiveness of fashion photography, its power of allusion, its acknowledgment of existential ambiguity, provide strategies that can be helpful to the journalistic image, allowing it to do more than rigidly settle on the "important," either visually or conceptually. These aspects allow for an image to engage in a vital dialectic with itself, both asserting and questioning.

Just as the fashion photographer struggles to vitalize an inert piece of clothing, the journalist is considering new ways of eliciting the dramas in the less attractive flotsam of human endeavor. Their muses, however, will never be exactly the same. □

contributors

WILLIAM EWING is an author and curator of fine photography whose most recent books include *America Worked: The 1950s Photographs of Dan Weiner* (Abrams, 1989) and *The Photographic Art of Hoyningen-Huene* (Abrams, 1986). His exhibitions have appeared at the Museum of Modern Art, the International Center of Photography, and the Centre Georges Pompidou in Paris.

ANNE HOLLANDER is an art historian with a specialty in the history of dress. Her books include *Seeing Through Clothes* (Viking, 1978) and *Moving Pictures* (Knopf, 1989). Currently she is writing *The Modern Art of Dress*.

RICHARD MARTIN is Executive Director for the Shirley Goodman Resource Center at the Fashion Institute of Technology, where he is also a professor. He is the author of *Fashion and Surrealism* (Rizzoli, 1987); *Historical Mode* (Rizzoli, 1989); *Jocks and Nerds* (Rizzoli, 1989); and, most recently, *Splash!* (Rizzoli, 1990).

GLENN O'BRIEN is the former editor of *Interview* magazine and was the New York editor for *Rolling Stone*. He has written a play, *Lotto,* that was recently performed at La Mama in New York, and is currently working on a feature film. O'Brien is a Pisces, Aquarius rising, and collects baseball caps (size 7 3/4).

VALERIE STEELE is the author of several books on fashion, including *Paris Fashion: A Cultural History* (Oxford University Press, 1988). She teaches in the graduate division of the Fashion Institute of Technology.

ANDREW WILKES is Book Editor at *Aperture*.

ANNA WINTOUR is the editor of American *Vogue*. She has been editor of *HG* and British *Vogue* and the fashion editor of *New York* magazine.

photographers

JOSEF ASTOR was born in Canton, Ohio, in 1959. He resides in New York City. His current photography work will involve a 19th-century porcelain mounting process for a Paris exhibition.

RICHARD AVEDON was born in New York City in 1923. He has published four books of portraits and a retrospective, *Avedon: Photographs 1947–1977.*

ENRIQUE BADULESCU was born in Mexico City in 1961. He divides his time between Mexico City and London. Badulescu's current work includes an abstract painting project for the National Council of the Arts in Mexico City.

LILLIAN BASSMAN was born in New York City. She was co–art director at *Harper's Bazaar* and *Junior Bazaar* from 1942 to 1947. In 1947, Bassman began taking and manipulating photographs.

CECIL BEATON (1904–1980) began taking photographs at age 11. He took portraits of the leading celebrities of the time, including society figures, movie stars, dancers, artists, and writers. He is best remembered, however, for his fashion work with Condé Nast in the 1930s.

ERWIN BLUMENFELD (1897–1969) was born in Berlin. He immigrated to New York in 1941 and became one of the most influential of the wartime influx of European photographers.

KOTO BOLOFO was born in South Africa in 1959. He left the country with his family at age 4 and lives in exile in London. Bolofo's current work includes producing and directing short films.

LOUISE DAHL-WOLFE (1895–1989) was born in Alameda, California. Dahl-Wolfe worked as a freelance advertising photographer for *Woman's Home Companion,* staff fashion photographer for *Harper's Bazaar,* and freelance magazine photographer for *Vogue* and *Sports Illustrated.*

PATRICK DEMARCHELIER was born in France in 1943. He lives and works in New York City and has been one of the most sought after fashion and beauty photographers of the 1980s.

BARON ADOLPH DE MEYER (1868–1949) was born in Germany. He moved from Paris to London in 1895 and gained recognition for his portraits of royalty and artists. In 1914 he was hired by Condé Nast in New York as the company's first staff photographer.

ARTHUR ELGORT was born in 1940 in Brooklyn. Though studio trained, he prefers to work outdoors. Elgort began work for British *Vogue* in 1971 and eventually returned home to become a leading photographer for American *Vogue*. Elgort lives and works in New York City.

JEAN-PAUL GOUDE was born in 1940 in Saint-Mande, France. He began his career as an illustrator and became art director of *Esquire* in 1970. In 1976 he became singer Grace Jones's manager and art director. Most recently he directed *La Marseillaise,* the celebration of the French Revolution's bicentennial, on 14 July 1989 in Paris, which featured Jessye Norman and 8,000 performers.

HIRO was born in Shanghai, China, in 1930, and later lived and studied in Beijing and Tokyo. He came to New York in 1954 to study under *Harper's Bazaar* art director Alexi Brodovitch. Hiro remained under contract with *Harper's Bazaar* until 1974. He lives in New York City.

GEORGE HOLZ was born in Oak Ridge, Tennessee, in 1956. Current projects include directing films and commercials and writing a book on black-and-white nudes.

HORST P. HORST was born in Weissenfels, Germany, in 1906. He immigrated to the United States in 1935. Horst worked with Hoyningen-Huene at the *Vogue* magazine studios in Paris from 1932 to 1935 and at American *Vogue* since 1935.

GEORGE HOYNINGEN-HUENE (1900–1968) was born in St. Petersburg, Russia. A self-taught photographer, Huene worked as a photographer at *Vogue* and *Harper's Bazaar* before his retirement from professional photography in 1945.

NICK KNIGHT was born in London in 1958. Knight is the commissioning picture editor for *i–D* magazine and resides outside London.

CHERYL KORALIK was born in Chicago and resides in London. Her current work includes an assignment with Action on Disability and Development in India and Africa.

KARL LAGERFELD was born in Hamburg, Germany, in 1938. In 1983 he became artistic director of Chanel. Lagerfeld took up photography in 1987 and recently published his first book, *Karl Lagerfeld: Photographer.*

JACQUES-HENRI LARTIGUE was born in France in 1894 and resided in Paris until his death in 1986. Lartigue took his first photograph in 1902 and became well known as a photographer, painter, and illustrator.

BARRY LATEGAN was born in South Africa, in 1935. He began working for *Vogue* in 1968, where he excelled as a beauty photographer in the 1970s. In recent years, he has directed commercials for television, and he currently lives in London.

PETER LINDBERGH was born in West Germany in 1944. He has lived in Paris for the last twelve years and he is currently working with Bruce Weber and Arthur Elgort on a book about Azzedine Alaïa; in addition, Lindbergh has also begun work on a book of his own.

SERGE LUTENS was born in 1942 in Lille, France. He has worked in a wide range of creative media, including theater, set and costume design, makeup, hairdressing, sculpture, jewelry, photography, and films. He turned to photography full time in 1968. He lives in Marrakesh, Tokyo, and Paris.

MAN RAY (1890–1976) was born Emanuel Radnitsky in Philadelphia. Since his death, three retrospectives of his work have been mounted; a current exhibition of fashion photography originated in New York City and will travel to Europe and Asia.

STEVEN MEISEL was born and raised in New York City. He has received wide acclaim at the Arles Festival in France, and most recently his work at the Danziger's Gallery's "Photographer's Muse" show drew admiration. Current projects include a book, a movie, and a gallery show.

JEAN-BAPTISTE MONDINO was born and lives in Paris. Mondino's wide range of work includes directing music videos (he has directed Madonna, David

Bowie, Prince, and Sting), commercials, photographs for advertising, and photographic conceptions of record sleeves for music albums.

SARAH MOON was born in 1941 in Paris. A former model, Moon took up photography in 1968. She has published several books of her photographs and worked for *Vogue, Harper's Bazaar,* and *Elle* magazines. She lives in Paris, where she is currently directing a feature film.

MARTIN MUNKACSI (1896–1963) was born in Hungary. He immigrated to the United States in 1934. A self-taught photographer, Munkacsi worked as a freelance magazine photographer until 1930, when he signed contracts with Hearst Newspapers. He signed with *Ladies Home Journal* in 1940.

HELMUT NEWTON was born in Berlin in 1920. After studying there, he moved first to Singapore and then to Australia, where he lived seventeen years. He now resides in Monte Carlo.

JEAN PAGLIUSO was born in 1941 in Glendale, California. She has supplemented her fashion photography with still assignments for such films as *Nashville, Three Women, American Gigolo,* and *Working Girl.* Pagliuso currently lives and works in New York City.

NORMAN PARKINSON (1913–1990) joined British *Vogue* in 1941 and was, with the exception of Horst, the magazine's longest-serving photographer. London's National Portrait Gallery mounted a large retrospective of his work in 1981.

GÖSTA PETERSON was born in Orebro, Sweden, and came to the United States in 1948. He currently resides in New York City.

PIERRE ET GILLES met in 1976. Their current projects include two exhibitions in New York. Pierre and Gilles reside in Paris.

BETTINA RHEIMS was born in Paris in 1952. Her most recent books, companions to exhibits, are *Fe'mal Trouble* (1989) and *Modern Lovers* (1990).

HERB RITTS was born in 1952 in Los Angeles, where he now resides. Ritts has photographed for major magazines and advertising campaigns in addition to directing movies and videos. He has also published the books *Herb Ritts* and *Men/Women.*

MATTHEW ROLSTON, a California native, graduated from Art Center College of Design in Pasadena. He divides his time professionally between Los Angeles and New York, and his work is currently focused on moving images.

PAOLO ROVERSI was born in Ravenna, Italy, in 1947. He began as a portrait photographer and later became interested in fashion photography. He has lived and worked in Paris since 1973.

SATOSHI SAIKUSA was born in 1959 in Nagasaki, Japan. He has lived in Paris for the last six years. Presently, Saikusa is shooting commercials.

DEBORAH SAMUEL was born in Vancouver, British Columbia, in 1956. Samuel's current projects include fashion photography, editorial portraiture, and entertainment work as well as fine-art photography and direction of music videos.

STEPHANE SEDNAOUI was born in Paris in 1963 and resides there. He began working with Jean Paul Gaultier as a runway model and later took up fashion photography.

EDWARD STEICHEN (1879–1973) was born in Luxembourg and moved to the United States in 1881. He was a master of the large-format camera and studio lighting and served as chief photographer at *Vogue* and *Vanity Fair* from 1923 to 1938.

MARIO TESTINO was born in Lima, Peru, in 1954. He moved to London in 1976 and he began taking photographs. After spending 1982–1985 in New York, Testino returned to Europe, where he divides his time between London and Paris. He is currently working on a book that includes portraits, nudes, and fashion.

DEBORAH TURBEVILLE was born in Maine. She started her career as a fashion editor at *Harper's Bazaar* and turned to photography in 1972. Turbeville has published several books, including *Wallflower* and *Unseen Versailles.* She lives and works in Mexico, New York, and Paris.

ELLEN VON UNWERTH was born in West Germany in 1954. She began her career as a model before becoming a professional photographer. Recently Unwerth directed her first movie. Her current projects include a book, an exhibition in Tokyo, and more movies.

MAX VADUKUL was born in Nairobi, Kenya, and currently lives in Paris. Although most fashion photography is shot in color, Vadukul has gained a reputation for working almost exclusively in black-and-white.

JAVIER VALLHONRAT was born in Madrid in 1953. He received a fine arts degree in painting from the Visual Arts Faculty of Madrid in 1980 and began to take photographs in 1984. Vallhonrat has exhibited widely and is currently at work on several photographic projects.

ALBERT WATSON was born in 1942 in Scotland. He studied at Dundee Art College and the Royal College of Art in London, where he earned an M.A. in film studies. He lives and works in New York City.

BRUCE WEBER was born in Greensburg, Pennsylvania, in 1946. He attended New York University's Art & Film School and the New School for Social Research. Weber has published several books of his photographs and has directed two feature films. Currently he is working on a documentary film on Diana Vreeland and a feature titled *Tongues of Angels.*

PETER ZANDER was born in 1956. He currently resides in Katonah, N.Y.

credits

Unless otherwise noted, all photographs are courtesy of, and copyright by, the artists. Front Cover: photograph by Javier Vallhonrat; p. 2 photograph by Jacques-Henri Lartigue, courtesy of Association des Amis de Jacques-Henri Lartigue and Mona Getner; p. 7 photograph by Louise Dahl-Wolfe, courtesy of Staley-Wise Gallery, New York; p. 8 photograph by Edward Steichen, courtesy of Vogue. Copyright 1933, 1935 (renewed 1961, 1963) by the Condé Nast Publications Inc.; p. 9 photograph by Baron Adolph de Meyer, courtesy of G. Ray Hawkins Gallery, Los Angeles; p. 10 photograph by Man Ray, copyright 1990, ARS New York/ADAGP; p. 11 photograph by George Hoyningen-Huene, courtesy of Vogue. Copyright 1933 by the Condé Nast Publications Inc.; pp. 12–13 photograph by Cecil Beaton, courtesy of Sotheby's London; p. 14 photograph by Martin Munkacsi, courtesy of Photofind Gallery, New York, and Joan Munkacsi; p. 15 photograph by Norman Parkinson, courtesy of Hamiltons Galleries, London; p. 17 photograph by Louise Dahl-Wolfe, courtesy of Staley-Wise Gallery, New York; p. 22 photograph by Richard Avedon, Penelope Tree, New York City, © 1967, 54¼ x 40¼, Collection of the Center for Creative Photography, University of Arizona, Tucson, p. 23 photograph by Richard Avedon, Penelope Tree, Paris, © 1968, 72½ x 73½, Collection of the Center for Creative Photography, University of Arizona, Tucson. All rights reserved; pp. 26—31 photographs by Erwin Blumenfeld, courtesy of Marina Schinz; pp. 34–35 photographs by Sarah Moon, courtesy of Barbara Von Schreiber; pp. 42–43 photographs by Serge Lutens, courtesy of Shiseido Europe; pp. 44–45 photographs by Deborah Turbeville, courtesy of Majka Lamprecht; pp. 48–49 photographs by Hiro. Copyright 1963, 1966 by Hiro; pp. 50–51 photographs by Cheryl Koralik, courtesy of Z Agency, London; pp. 54–55 photographs by Jean Pagliuso, courtesy of Barbara Von Schreiber; pp. 62–65 photographs by Nick Knight, for Yohji Yamamoto. Art Direction-Mark Ascoli; pp. 66–67 photographs by Pierre et Gilles, courtesy of Yannick Morisot; pp. 68–69 photographs by Satoshi Saikusa, courtesy of Catherine Mathis; pp. 71–73 photographs by Jean-Baptiste Mondino, courtesy of Yannick Morisot; pp. 74–77 photographs by Stephane Sednaoui, courtesy of Yannick Morisot; pp; 90–93 photographs by Herb Ritts, courtesy of Fahey/Klein Gallery, Los Angeles; pp. 97–99 photographs by Peter Lindbergh, courtesy of Marion de Beaupre; pp. 100–101 photographs by Ellen Von Unwerth, courtesy of Marion de Beaupre; pp. 102—103 photographs by Karl Lagerfeld, courtesy of Chanel; p. 104 photograph by Josef Astor, courtesy of Barbara Von Schreiber; p. 105 photograph by Deborah Samuel, courtesy of Jane Corkin Gallery, Toronto; pp. 110–111 photographs by Enrique Badulescu, courtesy of Camilla Lowther; pp. 114–115 photographs by Max Vadukul, courtesy of Spring Heel Jack; pp. 116–117 photographs by Mathew Rolston, courtesy of Fahey/Klein Gallery, Los Angeles.

acknowledgments

We would like to thank many people for their advice and assistance in assembling work for this project. In particular we wish to thank Fabian Baron, Lina Barzdukas, Rima Barzdukas, Marion de Beaupre, Paul Bob, Neville Brody, Wendy Byrne, Magi Caumon, Paul Cavaco, Fred Davis, Gilles Dufour, Diana Edkins, David Fahey, Sheva Fruitman, Mona Getner, Ziggy Golding, Howard Greenberg, William Grimes, G. Ray Hawkins, Lydia Cresswell-Jones, Nick Knight, Joan Kron, Anne Kurutz, Camilla Lowther, Patrice Lerat, Catherine Mathis, Tiggy McConchie, Yannick Morisot, Thierry Mueller, Joan Munkacsi, Marina Schinz, Mary Shanahan, Karen Simpson, Cecile Siraut, Etheleen Staley, Richard Tardiff, Barbara Von Schreiber, Elizabeth Watson, Charlotte Wheeler, and Taki Wise.

While Hasselblad has slept, Rollei has turned dreams into reality.

Hasselblad® has made essentially the same wonderful cameras for decades. Yet, technological advances have made much higher medium-format performance possible.

Rollei has turned these possibilities into realities and embodied them in the 6000 series cameras, extremely advanced Zeiss and Schneider lenses, and accessories that perform a vaster scope of tasks: with greater speed, accuracy, control and ease-of-use.

While Hasselblad has evolved dedicated flash and such, Rollei — in the new 6008 model — has introduced 13 medium-format "firsts." For superb accuracy, pick your spots: center weighted multi-zone, multi-spot, or tight-spot readings covering under 1%! Save time when you select auto-bracketing: ±²⁄₃ stop automatically. For situation versatility, switch "modes operandi": Shutter Priority AE mode; Aperture Priority AE mode; and Programmed AE mode; plus Manual Metering. For more exacting control, the leaf shutter

adjusts from 30 to 1/500 stops in ⅓ stop increments; with 2 increments beyond 1/500! Now see all and know all: all vital data is numerically displayed within your view yet not in the "live" screen viewing area.

Discover the benefits of auto ISO speed-settings; exposure compensation from −4²⁄₃ to +2 stops; open aperture metering; 2 frames/second motor drive; a removable action-grip for single hand operation. And more. New Rollei PQ lenses from Zeiss and Schneider (including 80mm 2.0 and 180mm 2.8 lenses!) make a total of 19 Rollei lenses. And every accessory (some enabling photographic "wizardry") is fully compatible between 6006 and 6008 models (except, alas, the neckstrap).

The stuff of dreams is ready to be put in your hands. Don't sleep on it — explore the possibilities at your Rollei dealer.

ZEISS
West Germany

Rollei
fototechnic

We're looking at things from your point of view.

HP Marketing Corp.
16 Chapin Rd., Pine Brook, NJ 07058, 201/808-9010

Hasselblad is a registered trademark of Victor Hasselblad Inc.

Linhof's World Views.

Linhof's yaw-free views.

The Kardan Master GTL and Kardan GT, with telescoping rails and tri-axial movement, yield yaw-free indirect as well as our traditional yaw-free direct displacements. Thus these large-format cameras are "yaw-free-er" than anyone's. And they are stable even under extreme extensions (8 x 10 with long bellows fully extended). 4x5, 5x7, and 8x10 models, with conversion and reducing kits to expedite format-changing are available. These are the most technically perfect view cameras you will see.

Linhof's large-format to go views.

The Linhof Technikardan 45 closes to only 8.5"x 10"x 4" (book size) — yet opens to 19" and uses lenses from 47mm to 600mm. It's a true large-format that goes outdoors and indoors. Rise, shift, swings and tilts are flawlessly performed. A unique Prontor shutter control allows aperture adjusting/reading from **behind** the camera. No fancy footwork required. And the TK 45 weighs only 6.5 pounds. Its smaller sister, the TK 23, weighs even less. The Technikardans are small in size but big in performance. See for yourself.

Linhof's widest views.

For large-format's exacting quality plus the convenience of roll film in a hand-held camera, Linhof's Technorama 617S and 612PC II are revelations. The travel/scenic, architectural, interior and industrial images they capture are breathtakingly unique. Both have an integrated spirit-level for exact camera positioning; brightline viewfinder with cross hairs; exposure times from 1 to 1/500 second and B; aperture settings from f5.6 to f45 in ½-stop increments; and more.

The 617S yields superbly detailed 87° shots in a film area 3 times larger than 2¼x 2¼; using a Schneider Super Angulon 5.6 90mm lens in precision helical focusing mount. The 612PC II has 2 interchangeable lenses, a 5.6 65mm and 5.6 135mm; a built-in lens pre-shift for perspective control; and takes up to 86 images twice as large as 2¼x 2¼. Both cameras give wide, wide views that are distortion-free with straight and no converging lines.

Consider Linhof's views at any authorized Linhof dealer.

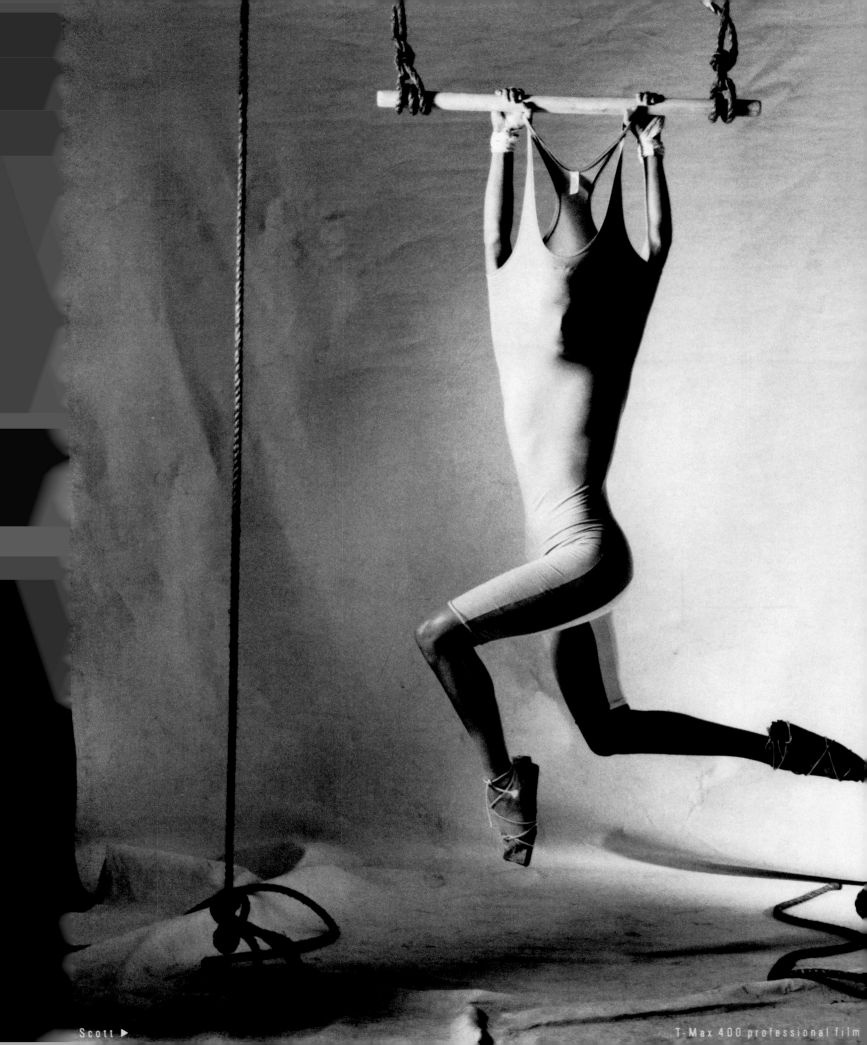

Revealing

By light,
through shadow,
one film
reveals the
full range
of creative
expression.

Kodak
professional
film.
Choice
of the
world's
top
photographers.

T-Max 100 professional film ▲

CHANEL